```
**********
 *******
  * **
   *
```

People
here and all over
want to know what
the MFDP finds and
does about the mur-
dering of Lee and
Allen; About quiet
nights and the
burning of crosses,
the hot days and
green pines.

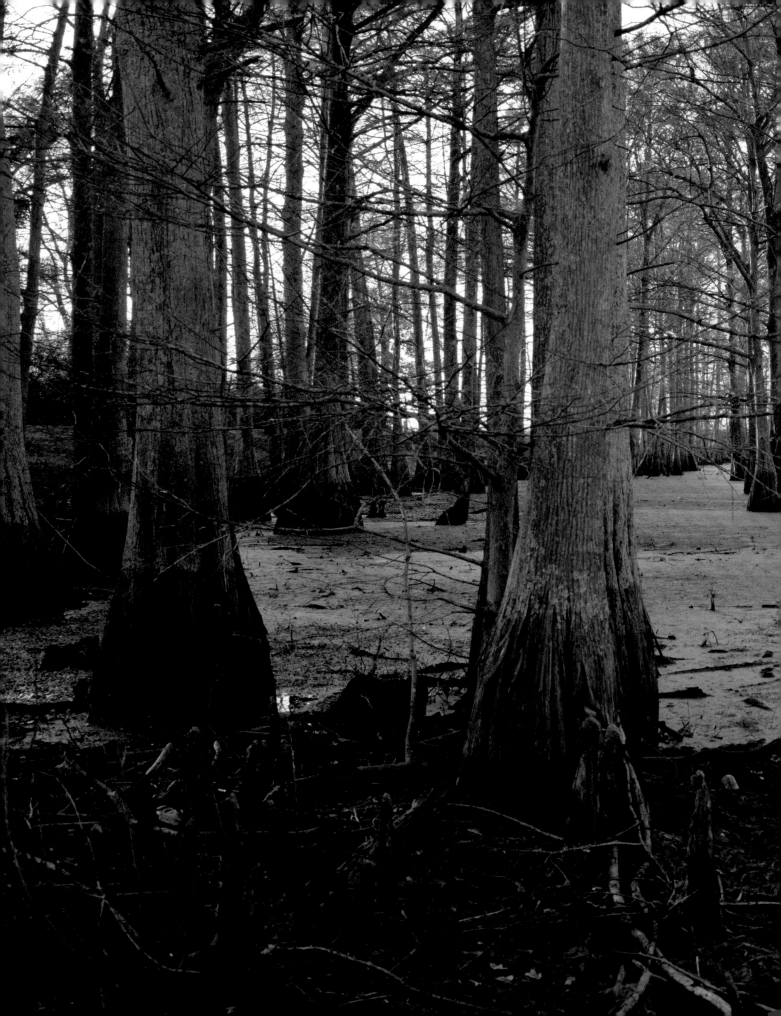

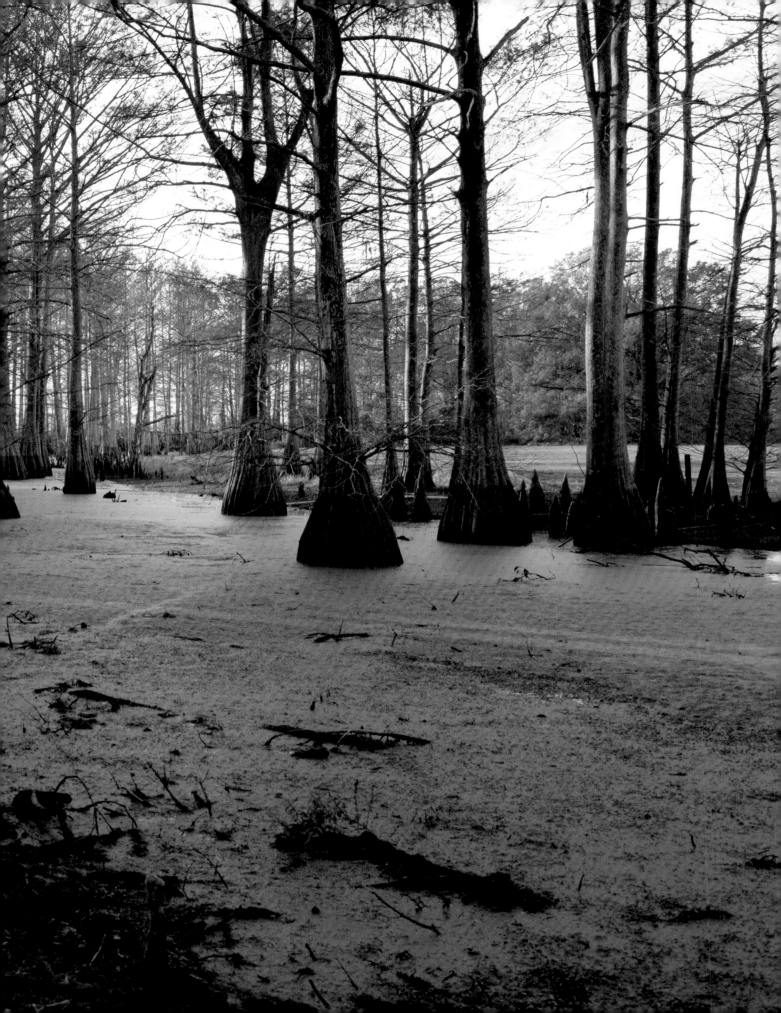

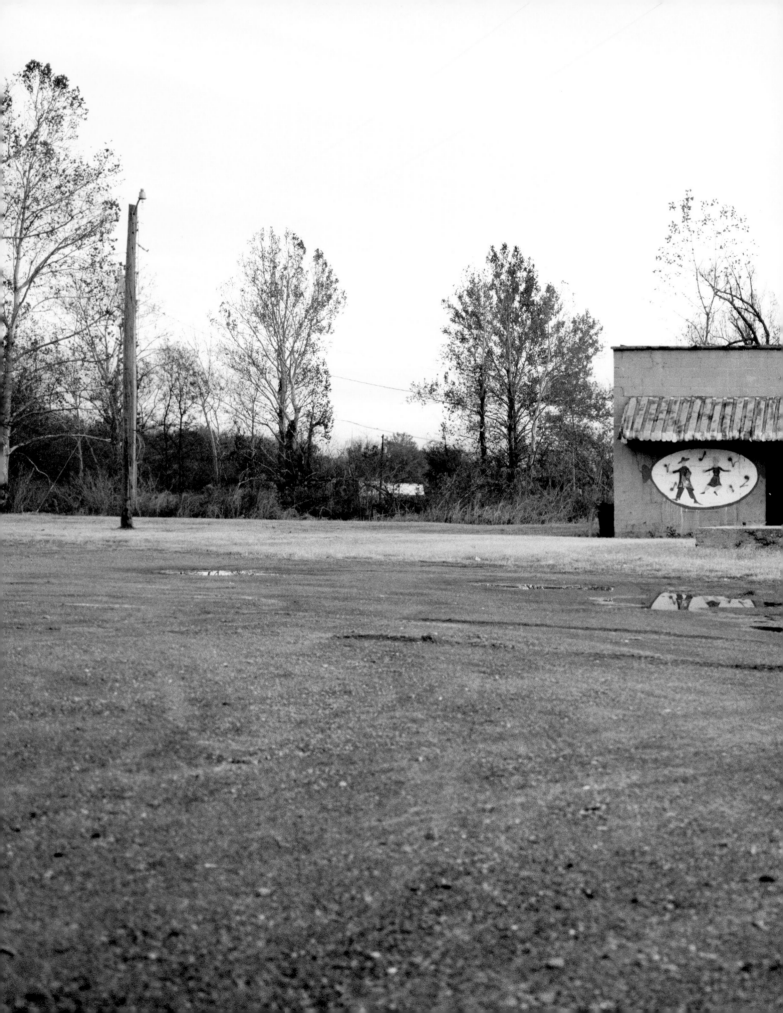

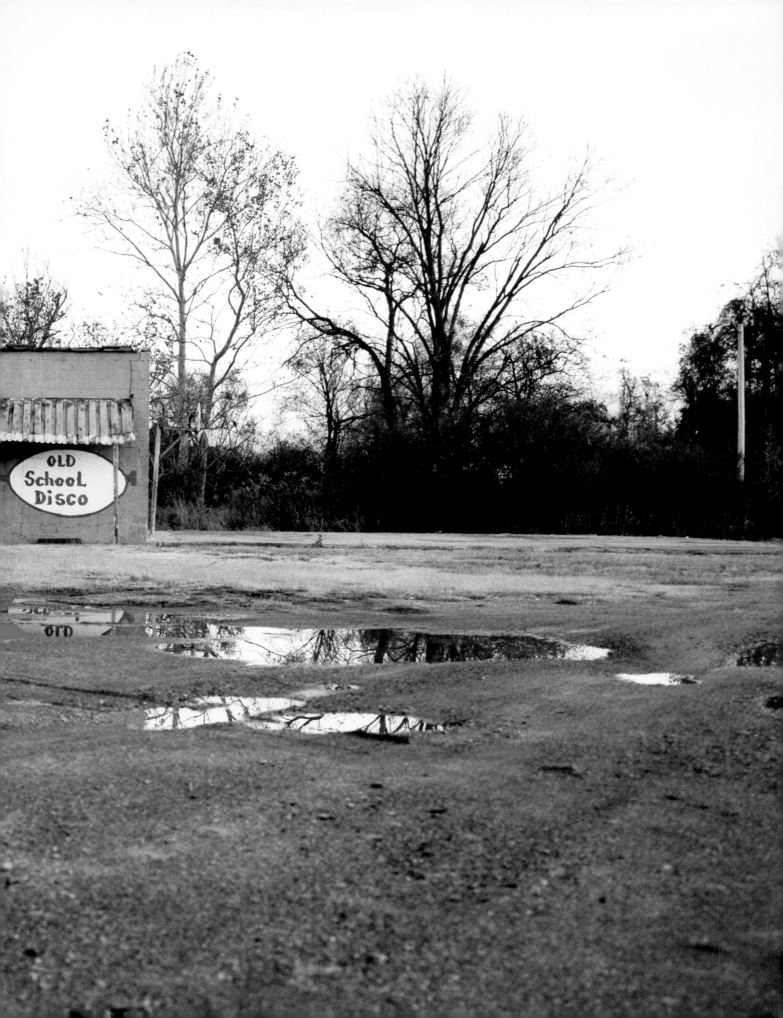

Swamp, Midnight, Mississippi, 2005.

Old School Disco, Humphreys County, Mississippi, 2005.

On April 12, 1970, **Rainey Pool**, a fifty-four-year-old, one-armed sharecropper from Midnight, Mississippi, was beaten by a group of white men and dumped in the Sunflower River. Police found Pool's body two days later. Four men were arrested and charged with assault and murder, one of whom confessed. The charges were dropped after the state court granted a nolle prosequi, a legal declaration in which a prosecutor declines to further pursue a case. In 1999, at the request of the Pool family, the case was reopened. Joe Oliver Watson pled to manslaughter and testified against the other men involved in Pool's murder, which resulted in James "Doc" Caston, his brother Charles Ernie Caston, and his half-brother Hal Spivey Crimm being convicted of manslaughter by a state jury and sentenced to twenty years in prison. A fourth man, Dennis Newton, was acquitted.

Pool's daughter, Betty Whitaker, responded to the verdict: "It's a happy day for me and my family. They didn't have to do that to my father. They got what they deserved."

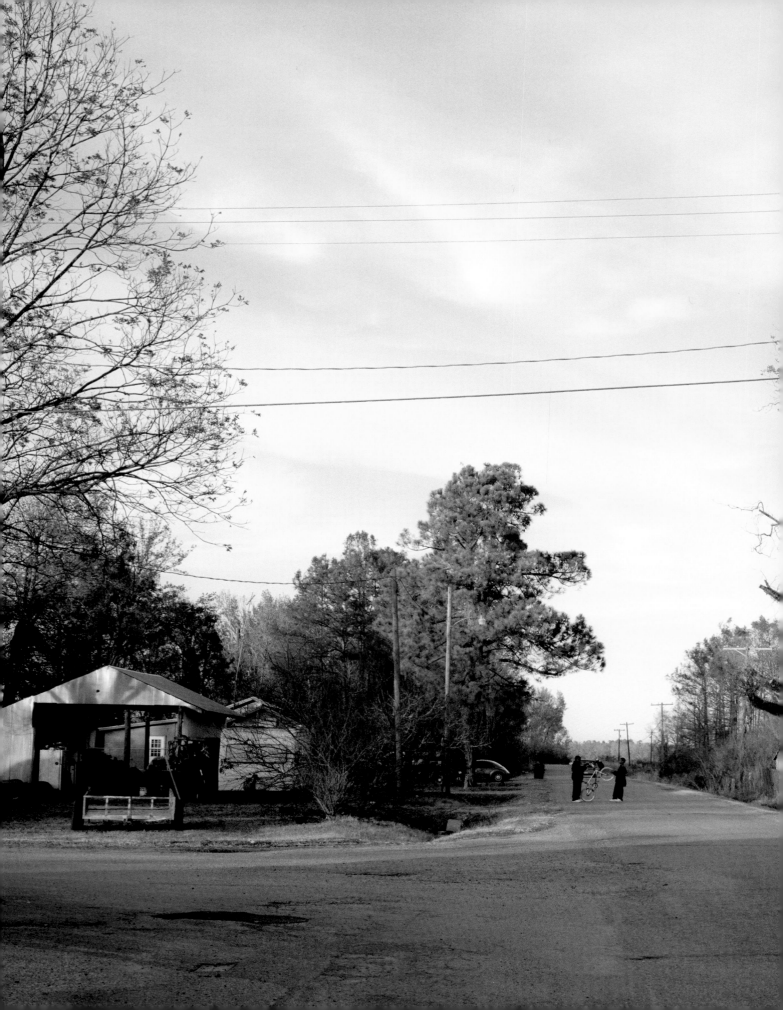

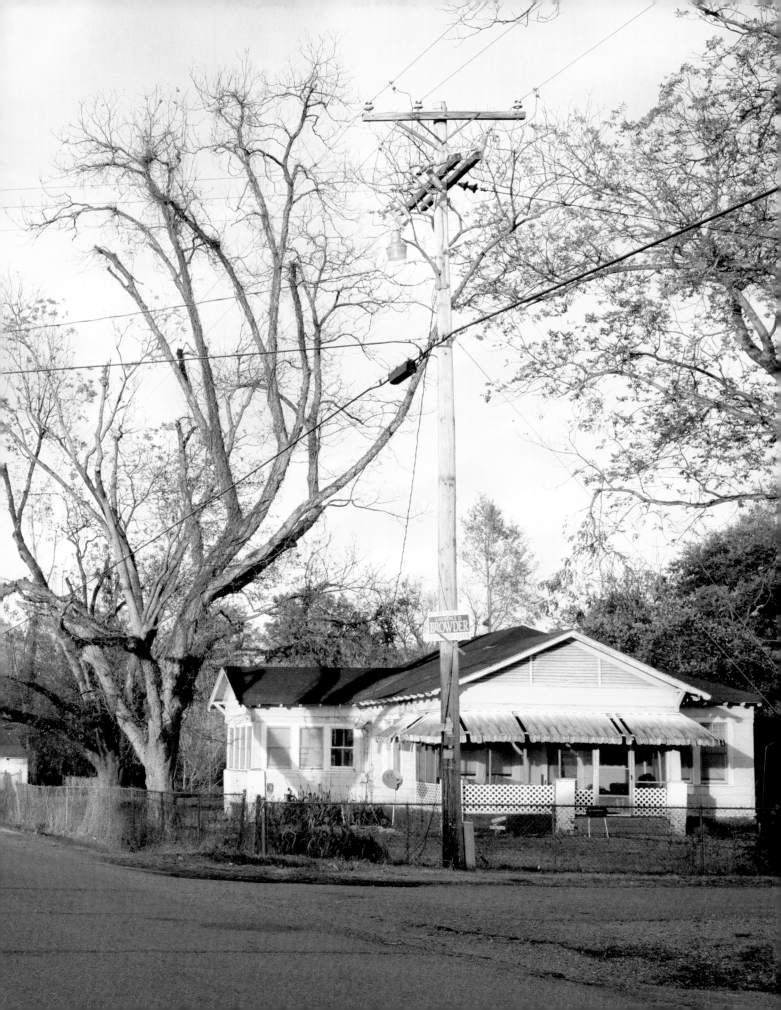

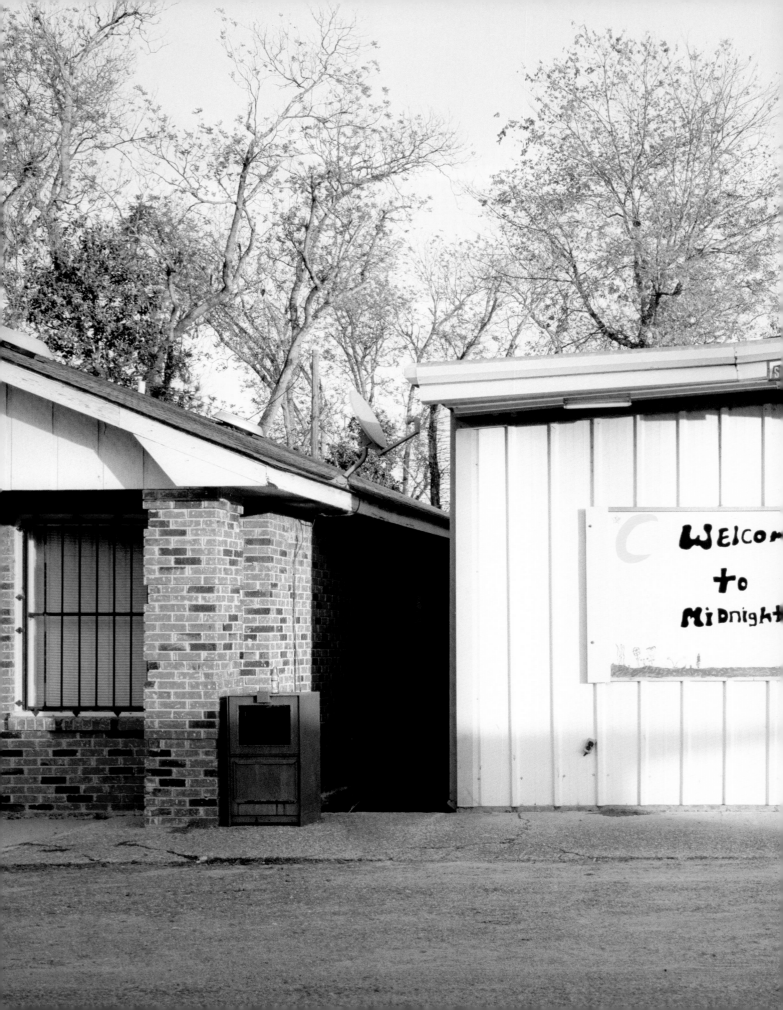

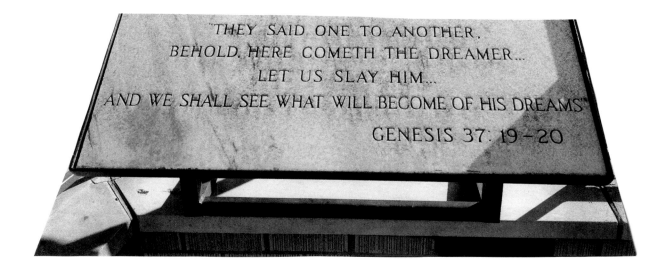

Published in association with the Center for Documentary Studies at Duke University

by the University of North Carolina Press, Chapel Hill

Road Through Midnight

A CIVIL RIGHTS MEMORIAL

Jessica Ingram

✳✳✳✳✳✳✳✳✳✳✳
✳✳✳✳✳✳✳
✳✳✳
✳

For my mother

Preface

This is an interpretive and suggestive work rather than a scholarly one. The history of this country is a racist one, and I wanted to reeducate myself about its creation by illuminating and illustrating histories of violence and resistance, where often there were no cameras or tape recorders. To try to understand an expanded history outside of the dominant and constricted telling, I had to understand the context in which these stories played out. Along with making photographs, I constructed this account by visiting sites that held histories of both racist violence and resistance to it and by assembling archival material from microfiche at local libraries, files at the Southern Poverty Law Center, ephemera kept by family members, and reports gathered by journalists.

I have been conscious of voices, the need to hear directly from those most affected—from family members as well as from journalists and investigators—about the complications of reporting and reopening cold cases from the civil rights era. I interviewed family members who lost loved ones to racist violence, journalists who reported on these events at the time, and those investigating cold cases now. The oral histories have been edited for clarity and concision; in preparation for publishing this book, I went back to those whom I had recorded, with the exception of Stanley Dearman, who passed away, so they could review their stories and give their approval for use in *Road Through Midnight*.

I am sharing what I have learned and come to know after traveling in these southern places and speaking with people there—how historical proximities and legacies of power are reflected in collective knowledge, in individual experience, and in the landscape. I want the viewer not only to experience these images and histories but also to understand place in relationship to the violence and resistance that happened there.

Jimmie Lee Griffith, a twenty-six-year-old man, was murdered September 24, 1965, while walking home from a friend's house in Sturgis, Mississippi. He was killed in a hit and run; the skid and burn marks on his body indicate that the car backed up over him. Griffith's suspicious death was investigated at the time by the state and by the Department of Justice's Civil Rights Division, but there were no indictments. The FBI reopened the case in 2008, after the Emmett Till Unsolved Civil Rights Crime Act became law, and closed it again in 2012. Page from undated FBI file, courtesy of the Southern Poverty Law Center.

Department of Justice simply because a Negro is involved,

b7C

From an Address by Myrlie Evers-Williams to the Crimes of the Civil Rights Era Conference, April 2007

You could hear the footsteps. We were seated, and the guilty verdict was read. How did I feel at that moment? I can honestly say that every bit of anger, every bit of hatred, of fear, escaped from every pore of my body when that verdict was read, and I felt free. But I also felt that America, my people, all people, were freer when that verdict was read.

Reporters from around the world asked questions. "How do you feel?" they asked. All I could say was, "Medgar, I kept my promise. It took thirty-plus years, but I kept my promise. Hopefully others will also benefit from that promise as well." The fear, the anger, and the willingness to live a full life, all of those things were coming together, and I felt, "I have done my job."

I kept my promise to Medgar, but my job was not finished, because more needed to be done. As we meet here, and talk about how to go about it, I have another concern. How do we, who have been there, and are dying off now, how do we, those who are the generations behind me, and behind them, transfer the dedication, the knowledge, the appreciation of all that has gone on before, to a generation now where so many see it as something long ago that does not impact them at all.

We not only have to remember the past, we also have to make the link to the next generation coming along. If we don't, we will find ourselves in another kind of civil war, another kind of horror that we will not know how to take care of. As someone said, community is so important. We must have a sense of that, of protecting our rights, of saying, "One who has will share with one who does not." And that includes knowledge. A promise was made; a promise was kept.

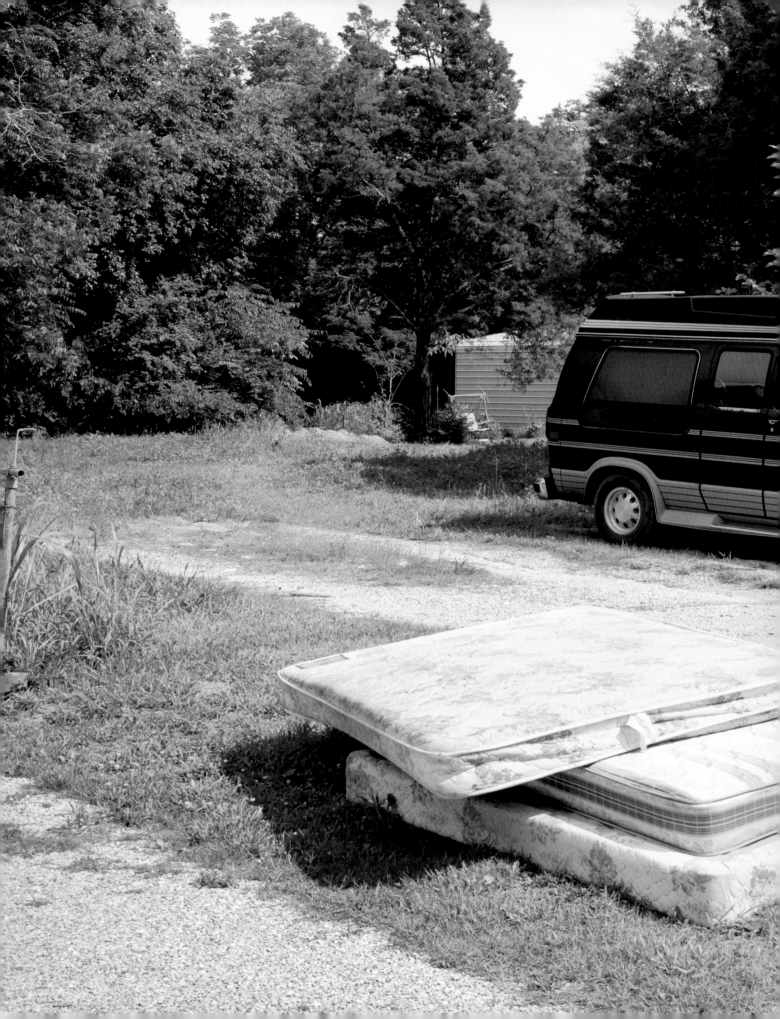

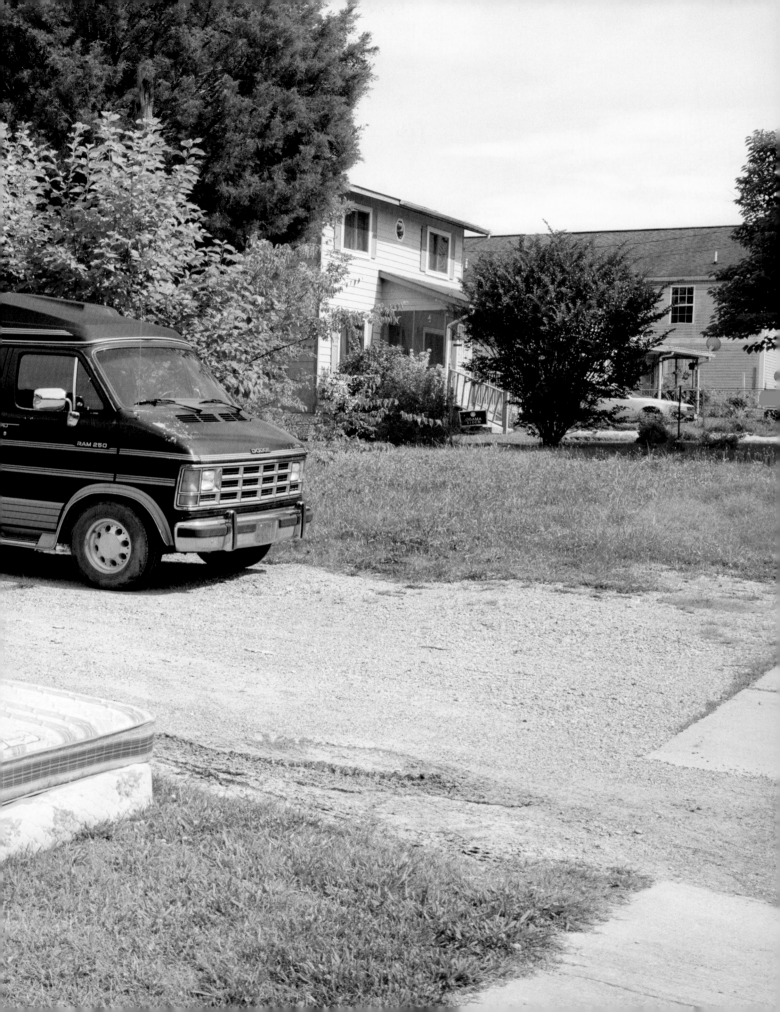

Mattie Green, a thirty-two-year-old mother of six, was murdered when a bomb under her house in Ringgold, Georgia, exploded on May 19, 1960, while she and her family were sleeping. The rest of the family survived. Two daughters, including Anna Ruth Montgomery, were staying at their grandmother's house a few blocks away. When she heard the explosion, ten-year-old Anna ran home; she remembers seeing her family's clothes strewn outside. No one was convicted of the crime, and the FBI closed the case after concluding that no federal laws had been violated. Montgomery recollects that the family knew who the murderers were—she remembers when her father, while reading the Sunday obituaries, would tell the family, "Another one's gone." When the FBI reopened the case in 2007, Montgomery told them, "Don't open it if you're not going to solve it." The FBI closed the case in 2009 due to a lack of evidence.

OPPOSITE

Atlanta Daily World, May 21 and 28, 1960. Courtesy of the
Southern Poverty Law Center.

Clues Reported Scarce By State In "Bomb" Death

ATLANTA DAILY WORLD

Viol. Ga.

25 Pounds Of Dynamite Used, Sheriff Estimates

By UNITED PRESS INTERNATIONAL

State Crime Laboratory experts Friday examined metal fragments found at the scene of the bombing of a Negro home in Ringgold Thursday but expressed little hope their investigation would lead to a quick solution of the blast that took the life of a Negro mother.

Dr. Herman Jones, director of the crime lab, said that investigators had "little to work on" in the case. He said, "We'll probably be investigating this one for six months.

"We're conducting tests on several things picked up at the scene."

He added it was not likely the state laboratory would be in a position to issue a report on its findings for some time.

The blast killed 32-year-old Mrs. Willie Green, mother of four. Her husband, Jethro, and the children escaped injury.

Catoosa County Sheriff J. D. Stewart said the bombers used an estimated 25 pounds of dynamite which they placed under the bed of the sleeping couple. He said the bombing apparently involved racial angle.

Jones said the metal fragments appeared to be part of a container in which the dynamite was placed.

An autopsy performed on Mrs. Green's body showed that she died of internal injuries received from the blast. Acting Police Chief Bill Shaw said that the autopsy had been requested because "We wanted to make sure."

The blast occured early Thursday morning as the family slept. Mrs. Green was crushed by falling timber when the dynamite went off in the bedroom.

Green, a mechanic, was said by Stewart to be law-abiding and caused no trouble with anyone as far as he knew. The incident was one of a series of racial incidents in North Georgia, East Tennessee in recent months. Two Negro homes were fired upon by shotguns recently in Chickamauga, miles from Ringgold.

The explosion sent flying debris, fragments of steel, flying through the house. It ripped a hole in the house, located on Street in a Negro residential section.

Local state and federal officers working on the case.

It Cannot Be Walked Away From And Forgotten

Viol. Ga.

A few short days ago, the state was shocked and the nation disgraced by the wilful bombing of a Negro home which resulted in the injury of members of the family and the outright killing of a mother. This happened near the little north Georgia town of Ringgold, up in the chennile spread mountains where this humble worker had made a living for himself and family working in the nearby city of Chattanooga.

The discovery was made that the simple cottage had been bombed, with the mother having died and the father left unconscious for a time.

Testimony rang from every section that the occupants of the home were peaceful citizens; that the head of the house had no known enemies, and the family status was of such as to convince those in the community that no one was immune from such an attack as was visited upon this humble home.

The governor of the state offered a reward for the apprehension of whoever committed the cowardly act.

It is earnestly hoped that this hoodlum ring, beginning attacks on innocent homes and killing and injuring the inmates, will be nipped in the bud; that no such practice is in order and that citizens should not be under such duress as renders their lives in peril.

The country belongs to the people; every citizen should be accorded equal privilege in enjoying whatever advantages or opportunities enjoined upon any other citizen.

Has the day come when a citizen cannot go to bed at night with the assurance that he will be awakened in his backyard, with his home in splinters, his wife dead, and children screaming and bleeding?

Such a condition cannot be talked about, probed, and walked off to be forgotten. Let us hope the guilty person will be found and punished to the extent that law permits.

Viol. – GA – 1960

The **Ku Klux Klan** was founded in Pulaski, Tennessee, on Christmas Eve 1865. The original historical marker, which has since been bolted to the wall backward, reads: "The Ku Klux Klan organized in this, the Law Office of Judge Thomas M. Jones, December 24, 1865. Names of the original organizers Calvin E. Jones, John B. Kennedy, Frank O. McCord, John C. Lester, Richard R. Reed, James R. Crowe."

Historical marker for Michael Donald, Mobile, Alabama, 2009. "On March 21, 1981, 19-year-old Michael Donald was abducted, beaten, killed and hung from a tree on this street by members of the Ku Klux Klan. He was randomly selected in retaliation for an interracial jury failing to convict a black man for killing a white Birmingham policeman. The lynching was intended to intimidate and threaten blacks. Two Klansmen were arrested and convicted. Morris Dees, cofounder of the Southern Poverty Law Center, and Alabama state Senator Michael Figures filed suit on behalf of Michael Donald's mother, Beulah Mae Donald. A jury awarded her $7 million, bankrupting the United Klans of America. In 2006, Mobile renamed Herndon Avenue as Michael Donald Avenue."

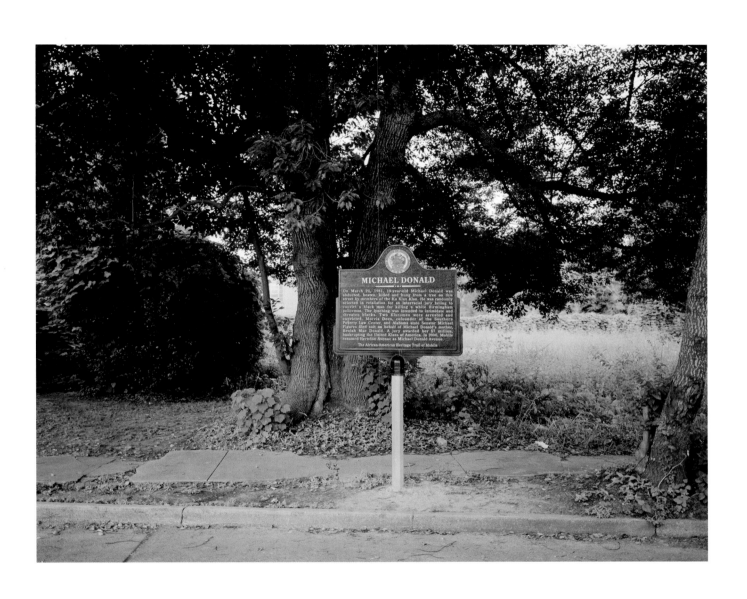

Jerry Mitchell
Jackson, Mississippi
June 28, 2010

I'm an investigative reporter for the *Clarion-Ledger*. I was covering courts in Jackson when I started writing about this stuff, which was in 1989. I had a press pass and went to see the movie *Mississippi Burning*. The movie itself was very powerful, and I was woefully ignorant about the killings or anything else about the civil rights movement. I saw it with two FBI agents who investigated the case, as well as a journalist who covered it. The FBI agents were Jim Ingram and Roy Moore, who was the head of the FBI in Mississippi, and the journalist Bill Minor.

After the movie, I'm standing there as these old men started talking. They start telling me stuff, you know, and it was the beginning of my education. I was horrified by the fact that none of those guys ever got prosecuted for murder. That just blew my mind. More than twenty people were involved, and nobody was prosecuted for murder.

About a month after that, I'm working the court beat and get a tip. The Mississippi State Sovereignty Commission records are all sealed at this point, and I got a tip that some of them had accidentally been included in an open court file. I went up to the courthouse, and there they were. It was a filing by the attorney general's office, and they had accidentally attached some of the files as an exhibit, and it should have been in the closed court file. I made a quick copy, went back to the paper, and did a story. What the files showed was that the commission had infiltrated this civil rights group here in Jackson and stolen a bunch of photographs and documents on incoming Freedom Summer volunteers, which of course included [James] Chaney, [Andrew] Goodman, and [Michael] Schwerner.

The Mississippi State Sovereignty Commission was a state-run segregation spy agency that operated from 1956 up to 1973. In 1977, all those records got sealed by the legislature until 2027. They were finally opened in 1998, but they were still closed during this period of time. That's what drove me to some extent. I always say, if someone tells me I can't have something, I want it like a million times worse. So I was like, well, what else is in there? I didn't set out on day one thinking, I'm going to reopen these cases. I didn't know that. I was just digging into the Sovereignty Commission, trying to get people to leak me stuff, and I eventually loaded up the back of my Honda hatchback with 2,400 pages of Sovereignty Commission stuff.

One of the leaks showed that at the same time that the state of Mississippi was prosecuting Byron De La Beckwith for the killing of Medgar Evers, this other arm of the state, the Sovereignty Commission, was secretly assisting the defense in trying to get Beckwith acquitted. My story ran on October 1st, 1989.

The trial for Beckwith was 1964. The killing of Medgar Evers was 1963. He was assassinated here in Jackson. That led me.

I called Myrlie Evers and asked if the case should be reopened, and she said yes. And so I did my initial story, then her story, and then we had an editorial calling for the case to be reopened. The Jackson City Council passed a resolution saying the case ought to be reopened. It's kind of one thing led to another—I always compare it to a snowball at the top of a very tall mountain. It began to gather speed over time, and by the time it hit the bottom, it was an avalanche. Beckwith got indicted. I went and interviewed him. That was an experience.

He was living in Signal Mountain, Tennessee, right outside of Chattanooga. I didn't go to do a "gotcha" interview. There were a handful of us that got in to talk to him. You had to pass the quiz: Are you white? Who are your parents and where did you grow up? What are their names and where did you go to college? Those kind of things. He loved my answers and so he let me come. My very conservative Christian upbringing came in handy. My background wasn't that different from his.

I was interested in how he became racist, and I think got the answer. He was an orphan by the time he was aged twelve and he joined everything. He didn't just join the Klan. He joined the Masons, the Shriners, the Sons of the American Revolution, the Sons of the Confederacy. He had a very deep-seated need to belong. To be fair to Beckwith, it wasn't like he was an aberration or something; he was very much a part of the white supremacist culture that was all around him. "White supremacist" gives the idea that everybody's got Klan hats on. A better description of it is a white segregationist, paternalistic view where every white, no matter how low on the totem pole, is above any black. And that's the way that Beckwith thinks. So he joins the Klan.

Beckwith was one of those men who wanted to be something. He never was anything before, and I think he thought he would be championed. You know, that whoever did it would be championed. He didn't want to make it publicly known, but he was certainly happy to let people know privately that

he did it. There were like six witnesses at trial that he had supposedly bragged to.

This has become, for lack of a better term, my mission. It's been called "ghosts of Mississippi," and it is. I mean, the ghosts of these people. It's a haunted state, unfortunately. We led the nation in the number of African Americans who were lynched between Reconstruction and the civil rights movement. If you take a map of where Klan violence was the worst during Reconstruction days, and you overlay it with where Klan violence was the worst in the '60s, it's virtually identical. The eastern prairie, and Meridian and Philadelphia, and the southwestern corner, Natchez and those areas.

I became more and more aware of other atrocities that took place. What made these cases so bad is not just that these guys got away with murder but the fact that everybody knew these guys were getting away with murder. That's what stuck in my craw. It bothers me that people get away with murder and other crimes, corruption or whatever. To be frank, I enjoy nailing people, exposing them.

So with Beckwith, I'm just pumping him for information, trying to see what he'll tell me. Although he figured out at some point that he didn't want to talk to me. In his last phone call, he said, "I'm going to be live to be 120. I don't know how much longer you've got. I'd hate for you to have a wreck or have somebody molest you. Do you know somebody who would do that?" I was like, "Do you?" I took it as a threat. I checked my car after that.

It's been a progression. When I first started doing this people were not happy with me doing it.

Vernon Dahmer Jr. and I met after Beckwith got convicted, and I told him, I'd love to write about your family's case. It had been reopened in 1991, but the D.A. got cold feet with it and decided not to run again. Then another D.A. came up, Lindsay Carter, so it was like starting over at square one. By the time I got a fellowship to Ohio State to get my master's, I get a phone call from Bob Stringer [who had worked for Sam Bowers, the head of the state's White Knights of the Ku Klux Klan]. So me and Vernon Jr. and Dennis Dahmer all meet Bob in a motel room. Of course, he wouldn't give us his name at that point. And eventually we found out that he had overheard a conversation that Sam Bowers had given the orders to kill Vernon Dahmer.

He was going through the Twelve Steps, and one of the twelve steps is to make amends for the bad stuff you've done in the past. He knew about me. He contacted Vernon first and got my number from Vernon. It was one of the most surreal experiences of my life. I think everybody had a gun except me. I had my pen.

Bob tells a story about growing up in Laurel and what that was like and about working for Sam Bowers as a kid. He would type the Klan propaganda. He was kind of Sam's protégé.

So the case got reopened. The guy who was a key witness back in the 1960s was a guy named Billy Roy Pitts. Pitts was involved in the killing and dropped his gun and got caught. Turned state's evidence. Pled guilty to murder and federal charges in the case. I knew there wasn't any record of his state time, but I'd always heard that was because he went into the federal witness protection program after doing about three and a half years

in federal prison. So I was talking to someone at the Federal Bureau of Prisons, detailing the exact amount of time that people do, and I said to her, I understand that after he left federal prison, he went into the federal witness protection program. And the woman said, that's impossible—the federal witness protection program didn't exist at that time. So that meant Billy Roy Pitts had never served a day of his life sentence, which really blew my mind.

No one knew where he was, so I got on Switchboard.com and typed in his name. Billy. Roy. Pitts. And up it popped. He was in Denham Springs, Louisiana, and I called him. The first twenty minutes of the conversation went like this: "How did you find me? How'd you find me?!" "It's on the Internet." "The Internet! I got an unlisted telephone number." "Well, I guess you have to take it up with them."

As a result of my story, the Mississippi authorities issued a warrant for his arrest. And he didn't care for that. He ran. While he was on the run, he sent me a cassette tape in the mail, and this is literally how the cassette tape began, "Jerry, I just thought I'd let you know you've ruined my life, but I promised if I talked to anybody, I'd talk to you, so here's this tape."

So on this tape he proceeds to tell me about his involvement in the killing of Vernon Dahmer, about his involvement in all this other Klan violence. Shortly after that, he turned himself in to the authorities, which led to the arrest of Sam Bowers. You know, you write a story and a warrant gets issued for an arrest. That's kind of cool. I could tell you so many stories about that case. Like about the Klansman who was arrested with Bowers was

named Deavours Nix, and his family wheeled him up in a wheelchair, with an oxygen tank. Tells the judge he couldn't go anywhere without oxygen. And so the judge says, I normally don't do this, but I'm going to let you out without bond. A dozen days later—this is like a reporter's dream—we catch him on the golf course. We had before and after pictures, in the wheelchair and playing golf, and we ran it. He got arrested.

* * *

That's the way I've done with these cases, taken them one at a time. Sam Bowers had done an interview, yet another thing that I couldn't get. It was sealed until he was dead. And I was like, well, by gosh, I want that interview. Eventually I got my hands on it, and in it he talks about the 1967 federal trial in the [Chaney, Goodman, and Schwerner] case. Bowers got convicted in that case, and he says—and this lets you know what a weird, strange, evil guy he is—he was "quite delighted to be convicted and have the main instigator of the entire affair walk out of the courtroom a free man."

He was referring to Edgar Ray Killen or, as they call him locally, Preacher Killen. So I called Preacher Killen up, and that was my first story about the "Mississippi Burning" case, in 1989. The authorities were looking at it at that point but never got serious about it. I took Preacher Killen and his wife out for catfish. I asked if he had anything to do with the killing of kids, and he said no. So I said, what do you think should happen to the people who were responsible? He says, I'm not going to say they're wrong. And then he proceeds to tell this story about himself. Martin Luther King was assassinated, and the FBI didn't know who did it, so

they sent out agents, and two of those agents showed up at the doorstep of Preacher Killen wanting to know his whereabouts on April 4th, 1968. He wouldn't talk to them, but the FBI agent left a card. So time goes on, and one day Preacher Killen calls the FBI agent and wants to know who killed King. The agent's like, why do you want to know? Killen said, man, I want to shake his hand.

You know, people say to me, Jerry, why don't you just leave these old guys alone? And I always tell them, these were young killers who just happened to get old.

The problem with all these cases is [the authorities] never really tried, and you can understand to some extent why they didn't try or gave up trying, because they'd present the cases, and all-white juries would let them go. I mean, of course I fault the prosecutors back then too, they didn't necessarily do a good job. But people like Bill Waller did an excellent job, and Beckwith walked away. I don't even blame the jury. It was one of those deals where the cop lied for him. We have to be real careful that we are honest in the way we look at things. I mean, back then a lot of people were complicit. You know, I'm going through the FBI files and that's one of the disturbing things, is how many people were complicit at some level. Society placed more value on the life of one person compared to the life of another, and cases just went away.

In telling the story of Vernon Dahmer, I explain who Vernon Dahmer was, and I explain what happened that night. I mention early on that he was involved in voting rights, and I get to the very end, weeks after this [murder] happened, and his voter registration card

came. The realization that this guy spent his whole life fighting for the right to vote and didn't get to cast a ballot himself.

Just after midnight on June 12, 1963, **Medgar Evers**, the first field secretary of the National Association for the Advancement of Colored People (NAACP) in Mississippi, was murdered outside his home in Jackson, Mississippi. His wife, Myrlie, and children found him dying in the driveway. Byron De La Beckwith was tried by all-white juries for the murder in 1963 and 1964—there was abundant evidence, including a fingerprint on the rifle left at the scene—but both trials ended in hung juries.

Evers led efforts against segregation at academic institutions in Mississippi, including organizing the legal team led by Thurgood Marshall that prevailed in desegregating the University of Mississippi, which made it possible for James Meredith to enroll in 1962. Evers had been denied admission to the University of Mississippi Law School in 1954, the same year the U.S. Supreme Court decided on *Brown v. Board of Education*. Evers had been receiving death threats, especially after he called for a new investigation into the 1955 murder of Emmett Till.

Investigative reporter Jerry Mitchell of the *Clarion-Ledger* in Jackson, Mississippi, discovered that the Mississippi State Sovereignty Commission, a state-run segregationist spy agency, was assisting the defense in Beckwith's trials in the 1960s. Myrlie Evers-Williams and Mitchell successfully got the case reopened, and Beckwith was convicted with new evidence in 1994. He died in prison in 2001.

Myrlie Evers-Williams was chairperson of the NAACP's board of directors from 1995 to 1998. She then established the Medgar and Myrlie Evers Institute in Jackson, Mississippi.

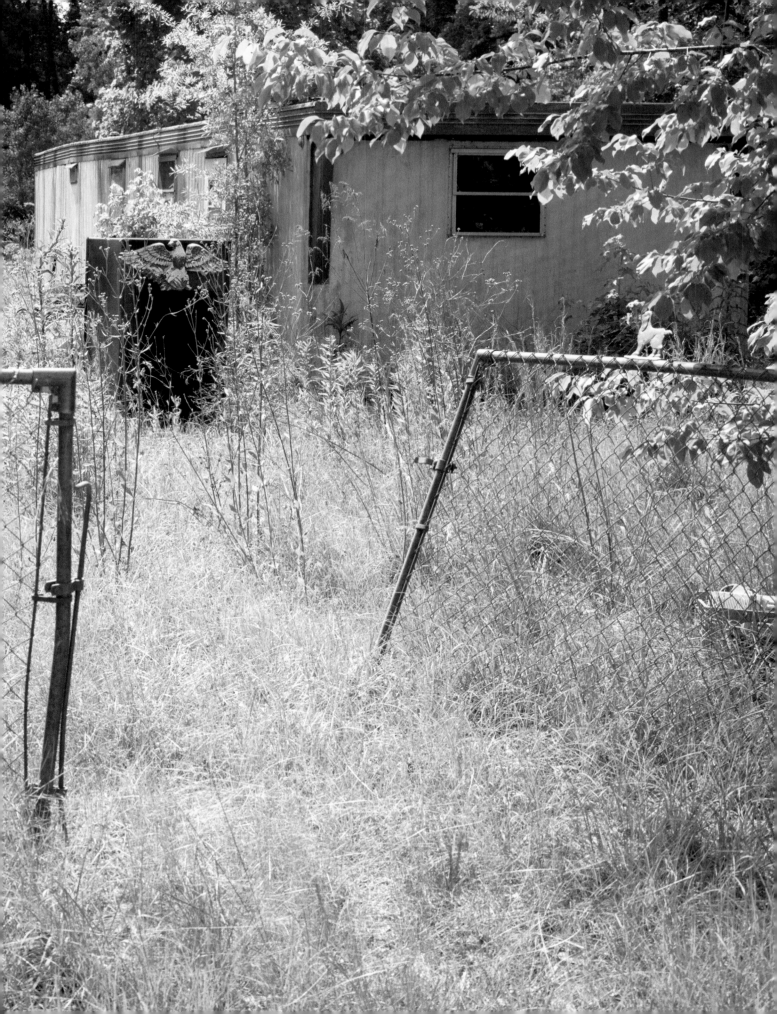

Thirty-eight-year-old **Isaiah Henry**, who with his wife, Lillie, helped neighbors prepare to take their voter registration tests, was taken from his home in Greensburg, Louisiana, on July 28, 1954. He himself had voted for the first time the day before. Beaten and left for dead on the side of a road, Henry suffered severe brain damage from which he never fully recovered. In August 1954, Third Ward police juror Lester Hornsby and St. Helena Parish sheriff deputy Carl Womack were brought in on charges of kidnapping and attempted murder, but neither was indicted. The case, which had been reopened as part of the Department of Justice's Cold Case Initiative, was closed in 2012. It was determined that there had not been a violation of federal criminal civil rights statutes since Isaiah Henry had not been killed and both alleged perpetrators were dead. Additionally, there is a five-year statute of limitations on nondeath violations of federal criminal law. Isaiah Henry passed away in 1973.

Charles Henry
Greensburg, Louisiana
May 20, 2011

I'm the son of Isaiah Henry. I was born in New Orleans's Charity Hospital, 1947, October 21st. But we actually lived in Greensburg.

Growing up there was hard. It was a farm. We raised cotton. Corn. Beans. Sugar cane. A garden that we ate out of twenty-four hours a day, if we ate. So it was tough. It was really tough. We learned to hunt and fish at an early age, and we were able to survive. My father, he did public work. Compared to others in the community, we did good.

My father, well, he would work in construction jobs part-time and build roads, and he would go on the cane farm where they had these big sugar mills and they would cut cane. He worked in the mills as we got a little older and started college so that he would have money to pay our tuition for us to go to school, the ones who were old enough to go.

My mother, Lillie, reared us and guided us. When my father was not at home, then my mother and grandmother were there, and we would all work together as a unit for the better of us all. The disciplinarian was the father when he came home. It was understood—that you had to have self-control, and you were motivated to go to school, because you didn't want to do that hard work all your life.

We as a family were close. There were ten of us kids. We don't talk about each other; we talk to each other. We stay in touch one with the other.

We lived in what they called the Rocky Hill community. The town of Greens-burg was somewhat off-limits unless you had business there. You didn't live in Greensburg unless you had a special place. Greensburg was, I don't know if you would call it Jim Crowish—whatever it was, it was a town where people didn't misuse you. If you went in town, you were treated fairly. But there were the typical race-type situations that you had to deal with. Even in the courthouse, you had the "white" bathroom and you had the "colored" bathroom, as they called it, and you had the white water fountain and you had the colored water fountain. And you had the little restaurants where they served hamburger, but if you were of color you had to go to the side or back door to get what you wanted to get. So I've been there, I've seen that, I've lived that. It's hard to go back and remember that and to not think deep.

I don't watch racial pictures. I don't watch *Roots*. I find myself being, I guess you'd say, torn apart by watching that. You know inside of us, inside of every man, there's a devil. And inside of every woman, there's also a devil. If you had to live torment, would you constantly want to be reminded of that pain? No. No. I find myself being haunted with the idea of prejudice.

In our community, my father was a go-to fella. He had a little sweetshop. We had a ballpark, and all the guys around the community would come and practice baseball. They would have a team, and he would take them off to compete with other teams. When I got big enough I was right there with him and I learned that I could hit a ball so far I couldn't see it. But getting back . . . we had a little sweetshop, and people would come and watch TV on Friday nights for the fight. A lot of people didn't have electricity and, well, just a place to go.

* * *

You know back during that time, blacks had to know a whole lot to become a registered voter. And back then you couldn't vote unless you could pass the test. I can imagine in my mind what kind of test the Caucasians had to take. I can remember my mother and father working with people, teaching them what they had to remember to go and register to vote.

I remember the preamble to the Constitution. I remember them going over and over and over it. You can't help but see how important it was to know and to learn by watching people struggle to be able to vote. And it hurts, because when you look at people today of a younger age, they don't care about voting—that their foreparents struggled and died and were beaten just to be able to go into that booth and cast that vote. To be a part of the governmental system was an important thing then. Today it hurts me that they don't care and are not motivated to do their civic duty. Our community was a caring community of people. Everyone would help see about everybody else; you didn't have to worry about your neighbor because your neighbor dwelled with you, like the Book say. You didn't have to lock your door. But today is different. Everything's different.

I like to see I'm alright, and you're alright. I don't like to see you all right and I'm wrong. I don't like that. I just, it just, it has haunted me since I was small. Basically all my life. When people misuse other people. I remember . . . cut it off. Cut it off.

* * *

The people who fought for civil rights have children who were affected. My

father—I look back over my family, those of us that were older when my father was young and strong—was able to give us those basic roots and foundation. All of us finished college. The ones after that, they had to struggle.

The community was very supportive when this happened to my father. They did what they could do.

When my father came back from the hospital, he got out the car and he had a shotgun with him. He said, "I'm going to live like a man, or I'm going to die like one." And he went in the house. I remember that just as clear.

It meant, to me he meant, look, stand up, be a man. Or you don't *be*. You just exist. After that, he had to compromise, he had to make some adjustments in life. It caused him to have to do some things he probably didn't want to do. In other words, he was the type of person I am—I just came out to the car when you came. He was that type of person. He just walked out to where they were, because people usually come to see him, come to talk to him. He didn't expect what was happening—what was about to happen.

* * *

I can only tell you what I was told. The night that it happened, someone knocked on the door and told Dad that someone wanted to see him. So, he walked out of the house to where they were. The next morning they found him in a ditch. In the ditch beaten. A little bit from death. I wasn't there; I didn't see it. I was too young to really comprehend all the things that happened.

My mother was highly upset; she went immediately to the hospital and stayed

with him a few days. He was in New Orleans's Charity Hospital. So she'd catch a bus and come home and then she'd go back. We had the grandmother, who was there; the auntie was there. My mother was in and out. And I had other older relatives around. I did say, good neighbors they dwell with you for a reason. We had good neighbors, and people were very supportive. Although you can't put a price on missing your father.

When he got out, well, things kind of leveled themselves back out. We had to keep living, we had to keep doing, so we did what we could do, did the best we could. He kept working and going. He didn't stop. But he had those headaches a lot of time, and he didn't like to sleep at night. His whole lifestyle changed when it came to rest habits. When everyone else was asleep, he was stirring. When he wasn't doing public work, he would sleep across the morning. His personality changed. It affected his speech. He wasn't the same outspoken, strong fellow. It affected his memory also, but he was still with us. He was still there.

* * *

We were told that it was two people who didn't like the way that the election [the Democratic primary on July 27, 1954] went. And nothing was done about it. At that time there was no law. The people who committed this crime were patted on the back—all they did was beat a black man: if he didn't act right, didn't do what we told him, we'd give him a good whooping. See, *that* changed me. And if I could change it, if I could straighten it out, I would, but I can't. We can't dwell in hindsight, we have to use wisdom, knowledge, and understanding and try to deal with it.

I was told that they went to the sheriff's department, sat down and drank coffee with the sheriff, and then left and went home. I try to block it out. Try to not let it control me. The memory. The pain of the things that happened as I had to grow up and look at these signs saying you are inferior. *I have to block that out.* These signs that say you're not good enough. *I have to block that out.* I have to go on and be good enough in spite of.

Both of those guys have moved on to the next world. They have to answer to the higher calling now. Like a lot of injustices that happened in the Jim Crow South, nothing was done. I feel like some of this still exists in the South. It takes a different shape and different form. I see it daily as I work and live.

When you deal with people, no matter who they are, you have to remember that they have feelings too. That they hurt like you. So the thing to do is to treat people justly, fairly, and love them.

I hope you use this story, because knowledge, in my opinion, is not any good unless it's shared. The people who this affected so much, my sisters, my brothers, myself, well, we are still left with these scars. The wounds may be healed, but the scars are still there.

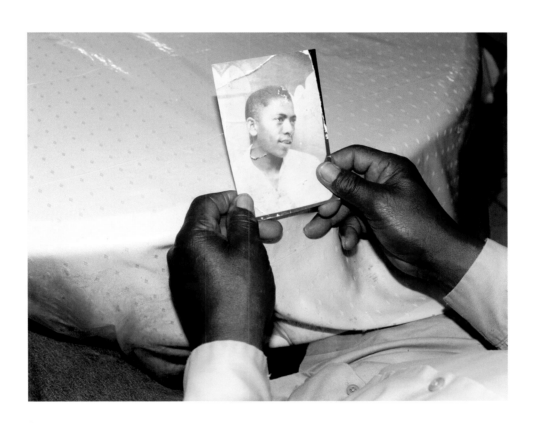

Charles Henry holding a photograph of his father, Isaiah Henry,

Greensburg, Louisiana, 2018.

Twenty-three-year-old **Mack Charles Parker** of Lumberton, Mississippi, was arrested on February 24, 1959, for the alleged kidnapping and rape of June Walters, a pregnant white woman. Parker was held in the Hinds County Jail, in Jackson, Mississippi, for his own safety and to undergo a polygraph, the results of which were inconclusive and not released. The woman Parker allegedly raped was not able to conclusively identify Parker in a lineup; she thought she recognized his voice but was not sure if it was the same man.

Parker's mother, Liza, hired R. Jess Brown, the first black attorney in Mississippi, to defend her son against these allegations. The judge was Sebe Dale, a member of the White Citizens Council and a charter member of the Mississippi State Sovereignty Commission. Brown petitioned for the charges against Parker to be dropped because the grand jury excluded black jurors, and he later tried to have the case dismissed because there were no black jurors at trial, depriving Parker of a jury of peers. Brown based his argument on the precedent set in Goldsby v. State. Robert Lee Goldsby had been convicted in 1954 for murdering a woman in Vaiden, Mississippi, and sentenced to death. In January 1959 a federal appeals court voided the conviction, requiring a new trial,

because the all-white jury did not constitute a jury of his peers.

Since Pearl River County had selected an all-white jury for the trial of Mack Charles Parker, R. Jess Brown was confident that he would be able to win an appeal of Parker's conviction using *Goldsby*. Judge Dale also refused a change of venue, insisting that Parker would receive a fair trial in Poplarville, even though residents were enraged not only about the alleged rape but also that two black attorneys, R. Jess Brown and his associate, Jack H. Young Jr., would be allowed to publicly question a white woman on the witness stand.

On April 13, Parker was moved from Jackson, Mississippi, to the Pearl River County Jail in Poplarville. Around midnight on April 24, Deputy Sheriff Jewel Alford gave the keys to the jail to a masked and hooded lynch mob led by J. P. Walker, a former deputy sheriff, who forced Mack Charles Parker from his cell. These men, including Francis Barker and Baptist preacher James Floren Lee, violently beat Parker in the jail and then dragged him from the building to Christopher Columbus "Crip" Reyer's car. Parker's screams were heard at the hospital across the street, and a nurse attempted to contact the local marshal, who,

once he had been reached, slowly made his way to the jail, arriving after everyone was gone.

FBI agents found Mack Charles Parker's body in the Pearl River in Mississippi on May 4. He had been shot to death and his chained body dumped from the Bogalusa bridge off Highway 26. The FBI investigators discovered the names of the men in the lynch mob and details of the murder but obtained no confessions. Despite the fact that anti-lynching legislation had been introduced in Congress dozens of times since 1882, it had never passed. Lynching was therefore not a federal crime. Because the FBI could not prove that the car carrying Parker drove over the Mississippi-Louisiana line, they could not prosecute a federal case for kidnapping.

A state grand jury was convened, presided over by Judge Sebe Dale, in the same building from which Mack Charles Parker had been forcibly removed. The FBI's report, the main piece of evidence, was withheld by Pearl River County district attorney Vernon Broome with the assistance of Judge Dale. The all-white jury brought no indictments.

The Justice Department's Civil Rights Division brought a federal case against the members of the

mob for kidnapping and conspiracy to deprive an individual of civil rights. Federal district judge Sidney Mize presided over the grand jury in Biloxi, Mississippi. There was one black juror on the twenty-two-man jury. During the grand jury, it was believed that Judge Mize gave jurors instructions on how to interpret the law to prevent indictments.

J. P. Walker was elected sheriff of Pearl River County in 1963.

The FBI reopened the Mack Charles Parker case in 2009, but it remains unsolved.

In 2018, senators Kamala Harris, Cory Booker, and Tim Scott introduced the Justice for Victims of Lynching Act to make lynching a federal crime and to distinguish it as a hate crime; it was unanimously passed by the Senate on December 19, 2018.

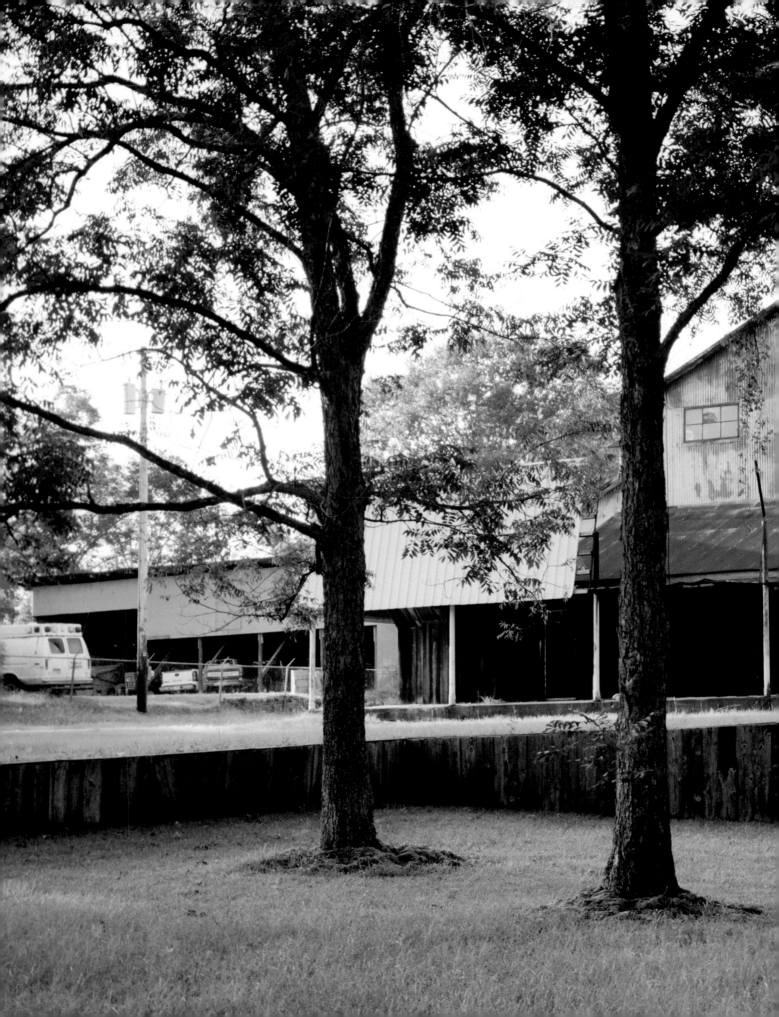

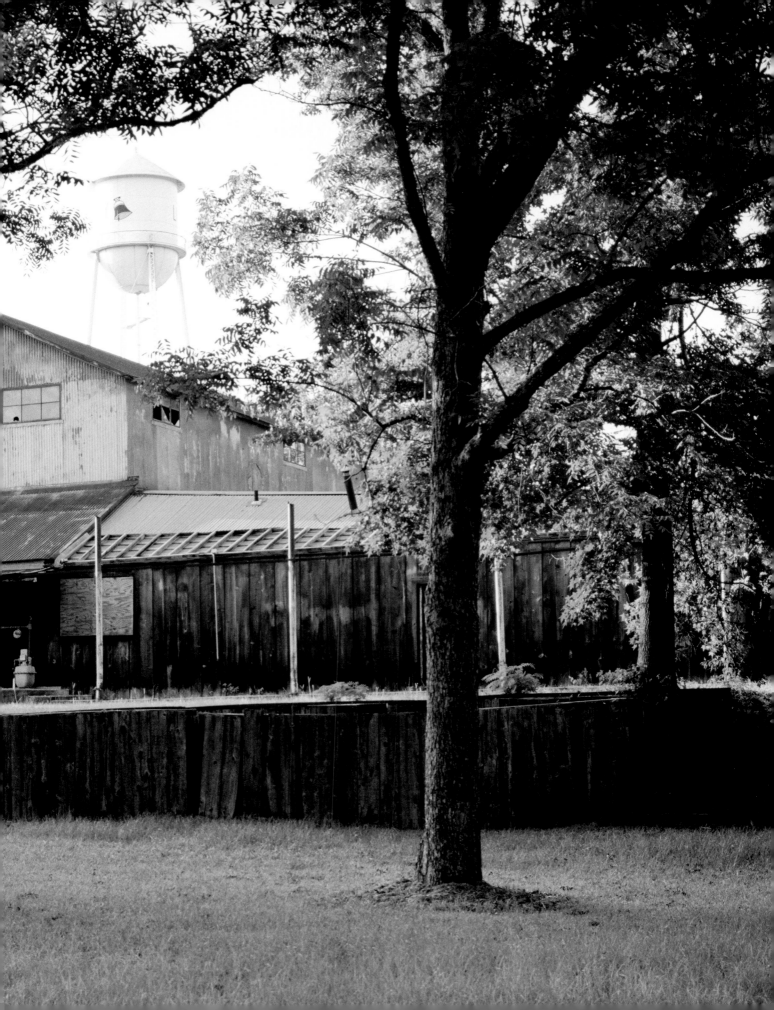

On September 25, 1961, forty-nine-year-old **Herbert Lee** was murdered by neighbor Eugene Hurst, a state representative from Amite County, at the Westbrook Cotton Gin in Liberty, Mississippi. A month earlier, Lee, a leader in the local NAACP and Student Nonviolent Coordinating Committee (SNCC), had escorted visiting civil rights leader Bob Moses, a SNCC organizer, in rural Mississippi to register black voters. Hurst claimed that Lee's death was accidental and that he had acted in self-defense.

Louis Allen, a black witness to the murder, was coerced by law enforcement to lie, saying that Hurst had acted in self-defense, and a coroner's jury supported that lie. Allen later came forward and told FBI agents that Hurst had deliberately shot Lee in the head. When word got out to county officials, Allen was harassed by local law enforcement, particularly by Amite County deputy sheriff Daniel Jones, the son of the county's Klan leader. Allen planned to leave the county, but on January 31, 1964, the night before he was to leave, he was shot three times. His eighteen-year-old son, Henry, found him dead in the driveway.

Daniel Jones, who had become sheriff, was assigned to investigate Allen's murder.

No one has been charged for the murders of Herbert Lee or Louis Allen.

Clinton Melton was shot to death at the service station where he worked in Glendora, Mississippi, by Elmer Otis Kimbell on December 8, 1955. Kimbell claimed he acted in self-defense, though the owner of the station and two other witnesses claimed that Melton was unarmed.

In response to the murder, the Glendora Lion's Club adopted a statement written by a local minister: "We consider the taking of the life of Clinton Melton an outrage against him, the people of Glendora, against the people of Mississippi, as well as the entire human family. We intend to see that the forces of justice and right prevail in the wake of this woeful evil. We humbly confess repentance for having so lived as a community that such an evil occurrence could happen here and we offer ourselves to be used in bringing to pass a better realization of the justice, righteousness and peace which is the will of God for human society."

Kimbell's defense called the chief of police, a deputy sheriff, and former sheriff H. C. Strider, who was a local plantation owner, none of whom had witnessed the murder. Kimbell was acquitted in March 1955 by an all-white jury in the Sumner County Courthouse, the same courthouse where six months earlier J. W. Milam and his half-brother Roy Bryant had been acquitted of Emmett Till's murder.

Two days before Kimbell's trial, Melton's wife, Beulah, and two of her children were run off the road and into a bayou. Beulah was killed in the car accident; Delores, Clinton Jr., Vivian, and Kenneth were raised by their aunt Mary Madison.

Deloris Melton Gresham
Drew, Mississippi
July 20, 2010

In 1955, on December the 3rd, my father was gunned down. He worked for Lee McGarrh at the service station in Glendora, Mississippi, and he had a customer to come in by the name of Kimbell, who asked him to fill his car up. Kimbell went into the store, and when he came back, he told my dad that he had only asked for two dollars worth of gas. The service station owner heard him and said, "No, you said fill it up." Kimbell told him that he had a "smart-ass nigger" working for him, you know, and told my father, "Don't be here when I get back."

Kimbell left, and the owner told my daddy that he thought it best that he go home, because this guy, Kimbell, was under the influence. My daddy was getting gas, because he was supposed to have taken my grandmother to Batesville to catch the train the next day, and while he was getting in his car to leave, Kimbell came back and he shot him through the windshield.

I was five then. I remember it was at night, and my aunt came in. She was running. She came in and told my mom that my dad had been killed. I remember that part of it, but after that it's sort of hard to remember anything else.

My father died in December of 1955; my mother died in March of 1956.

All I remember is that we were in the car with her, Clinton Jr. and I. We turned over in the river. At the bayou there was a house that sat up on the hill, and this lady saw the car when it went over. My mother's brother was passing by, and she told him the car had turned over down there. He came down and called my name and called to her. She couldn't answer though. He told me to open the door, and I told him the door was locked; I couldn't unlock it. Meanwhile, my brother was telling me that water was getting in his face and in his nose, and I was trying to pull him up. I finally found the lock on the door, and my uncle opened it. They got us out. And then they got my mom out, but she was already dead. They carried her to the house. I remember that. They laid her on that bed, and she was just wet all over. And after that, it was just, I don't know, it was just something. Everything was just foggy. Clinton Jr. was three, Vivian was two, and Kenneth was eight months old. I'm the big sister. I'm the oldest.

I've heard that we were run off the road. I've had some friends that I tried to get to hypnotize me to go back there. They won't do it. They say I might go and not come back. So I don't really know, but it was like two days before my daddy's trial.

My aunt adopted the four of us. She did the best that she could. None of us had to go to jail. We were fed. We were clothed. But there was always that part that was missing, you know, like when other children's moms and dads would come to their school programs and stuff like that. You sort of felt bad again. Then there are times when you go through things and you wish you had your mom or your dad to talk to. Even though somebody was there, it was not like having your parent.

I didn't understand until I was older what happened to my father. I started reading articles. I knew then that he was killed for no reason, that he was murdered. I knew my mother grieved for him a lot because I used to see her cry, you know. I used to tell my brothers and sisters that my mom died from a broken heart because she missed my daddy so much.

I wondered why this had to happen to my daddy. He didn't do anything to anybody. Why did he have to die?

If it had been a black man had killed a white man, hey, they probably would have killed him right on the spot. This was a white man who killed a black man, and nothing happened. Like Kimbell once said, "It is open season on niggers." I never understood that. Why any man that do a crime couldn't be punished for it. And those people that sat on the jury and those judges, those lawyers or whoever allowed this to happen, I'm thinking they should be behind bars too. I mean, they were sworn to enforce the law and they didn't.

My father's sisters and brother, his mother and father, they left and went to Chicago after that. My mother's sister stayed, and she raised us. You know how you get stuck in a place, and you can't get out of it? I got stuck here. My husband wanted to be here because of his parents, and so I stayed.

I was about twenty-five when my husband started asking me about different things that happened. I used to think about it a lot, you know, but I thought, it's done. Nothing has been done about it. Nothing will ever be done about it. So why dig in it? And then my husband tells me, there's a story to tell: your children and your children's children should hear, because that was their grandfather, their great-grandfather. So I started giving bits and pieces of what I remember, like I'm doing you now.

I got tired of going over the same thing over and over again. I mean, you do it once or twice and, you know, you're OK with it. And then at times it just brings back memories. And I don't like feeling sad. I like the happy times.

The only question that I ask myself, and will always ask, is why. Why my dad, and why my mother? But I guess God has a reason for everything. Life seems to be unfair, but then you look at other people. They have lost people too. It's been a good life. I mean at times it was burdensome. But I came through it, so I'm OK with it.

There's one thing that I'm ashamed to tell even now. There were times that I used to swear that every white person I saw, I was going to kill them, and look at me sitting here talking to you now. That was my way of thinking then, but I came to realize that there are bad people both black and white, so you can't do that. And God wouldn't be pleased with that either. That was my anger. I wanted to do away with every white person I came in touch with. But I've come to find out that some of my best friends are white, you know, that anger just smoothed along the way, you know. You can't stay angry the rest of your life.

I raised five kids, and in teaching, I first teach self-respect and respect for others. I think those are the most important things. Take time to listen to somebody sometime. I mean, sometimes all people need is just a listening ear and a shoulder to lean on. And I had plenty of people that I could lean on their shoulder, that I could talk to, you know, and I try to be that, the same thing to other people. Because God said that we are our brothers' keepers.

I graduated high school in 1969. In 1970, they integrated schools. It has changed a whole lot because, believe it or not, I remember when the kids were bused from one place to another. I remember the black water fountains and the white water fountains. You go to the doctor, there was a white waiting room and there was a colored waiting room, you know. So it has changed a whole lot. I remember a time when a black man would marry a white woman, and he was strung up in a tree or dumped in a river. It has changed. It has come a long ways, but still not as far as it should come.

* * *

Drew, Mississippi, is a very small community where everybody knows everybody; I enjoy Drew because I know everybody. Glendora is now a very depressed place. When I go there now, I still look to see that building there, even though it's torn down. But I seldom go. This region is in need of a lot of things. Matter of fact, in need of everything. There are no jobs, no factories. We need more schools. The only thing we got going for us is the state penitentiary, which is like seven miles down the road.

As a community, if we could get together, and pull together, it'd be much better. We need a lot of prayer and a lot of heart fixing for us to know we have to lean on each other in order to make it better, because anything divided, it doesn't stand. You need to pull together to put it together.

White people thinking they have more power over blacks comes back from slavery, and it continues today. You know, they still think that they're dominant. I think the justice system is much better that it was back then. I often wonder, why was it that they always thought they was so right about the things that they did? Did they not think God was going to punish them? Or maybe they just thought, "Oh, that's a black, and nobody cares nothing about them." How would they feel if somebody took them away from their family? How would their family feel? I wonder do they ever think about how another family feels to have a life snuffed out, just like that, for no reason at all. I wonder how could you hate people so bad? How could you hate these people, and teach your children to hate these people who took care of your children?

People need to learn how to love each other, whether they be blue, black, green, yellow, whatever color. Just learn to love each other and learn to embrace and help each other.

The importance of telling this story is so that our young people today can see the struggle that blacks have come through, for the generations to come, you know, especially my kids, my kids' kids. For them to know their family history. Maybe they can be better people, learn how to get along with people and love people. The greatest thing is love.

I don't care how long we live on this earth, you are still going to have racists out there, and it is something that won't go away. It's like a bad sore that gets deeper and deeper. It keeps spreading because there are still people out there who actually teach their children to hate different races, and it won't go away until we teach our children that God made us all, and he made us all in his image and we are

supposed to love each other and not fight each other. The world would be better if we could just love each other, and keep our arms around each other, and teach each other what we know.

Don't nobody else call me. I'm going to tell them, look, what you need to do is go and ask Jessica to let you hear everything she got on this tape.

To: FBI Washington

March, 1965

In regard to the death of Willie Henry Lee on Feb. 25, 1965. We the residents of Mississippi, who are all interested in knowing the reason for the killing demand an investigation. This man's body was found in Rankin County and nothing has been did about it, or no attempt to have been made for no sort of an investigation. We the residents of Mississippi don't feel that we can allow this sort of thing in Mississippi and nothing to be did about it. One of the things they did was they made his father move the car from where it was parked before any investigation or examination for finger prints and other facts. And they moved his body and embalmed it before the autopsy. So it is only fair that we demand an investigation for this killing.

NAME	COUNTY
1.	
2. Lessie P Smith	Rankin
3. Alsenia Watson	Rankin
4. Florence M Adams	Rankin
5. Delois Taylor	Rankin
6. Mary Longes	Rankin
7. Dorcla H W	Rankin
8. Onie Hopson	Rankin
9. Charles L Hopson	Rankin
10. Laura Evans	Rankin Co.
11. Sears Buckley Jr	Rankin Co.
12. Junior Simon	Rankin Co
13. Marie Thomas	Rankin Co
14. Rusby Lee Evans	Rankin Co.
15. Mrs Lessie Lindsay	Rankin Co
16. Mrs Sherman Chaffee	Rankin
17. Mrs Ruby Bilbro	Rankin Co.
18.	

Petition to the FBI to investigate the death of William Henry Lee, who was killed on February 25, 1965, while traveling home to Goshen Springs, Mississippi, from his work at the Storkline Factory, in Jackson, Mississippi. The case was reopened by the Civil Rights Division of the Department of

To: FBI Washington

March, 1965

In regard to the death of Willie Henry Lee on Feb. 25, 1965. We the residents of Mississippi, who are all interested in knowing the reason for the killing demand an investigation. This man's body was found in Rankin County and nothing has been did about it, or no attempt to have been made for no sor of an investigation. We the residents of Mississippi don't feel that we can allow this sort of thing in Mississippi and nothing to be did about it. One of the things they did was they made his father move the car from where it was parked before any investigation or examination for finger rints and other facts. And they moved his body and embalmed it before the autopsy. So it is only fair that we demand an investigation for this killing.

NAME	COUNTY
1.	
2. Curtis Thomas Jr	Rankin
3. Charlie Taylor	Rankin
4. Arthur Adams	Rankin
5. John I archie	Rankin
6. Eli Watson	Rankin
7. J P Smith	Rankin
8. Peter Miggins	Rankin
9. Mrs Pleasie Lindsey	Rankin
10. Floyd Temple	Rankin
11. Merril Hardy	Scott
12. Bonnie Tyler	Scott
13. carrie Belle pitts	
14. arilla lee gooyd	Scott
15. Louise S Smith	Scott
16.	
17.	
18.	

Justice in 2008, following the passing of the Emmett Till Unsolved Civil Rights Crime Act of 2007.

With no new information or leads, the Department of Justice closed the case in 2011, citing, "This matter does not constitute a prosecutable violation of the federal criminal civil rights statutes."

In regard to the death of Willie Henry Lee on Feb. 25, 1965. We the residents of Mississippi, who are all interested in knowing the reason for the killing demand an investigation. This man's body was found in Rankin County and nothing has been did about it, or no attempt to have been made for no sort of an investigation. We the residents of Mississippi don't feel that we can allow this sort of thing in Mississippi and nothing to be did about it. One of the things they did was they made his father move the car from where it was parked before any investigation or examination for finger prints and other facts. And they moved his body and embalmed it before the autopsy. So it is only fair that we demand an investigation for this killing.

NAME	COUNTY
1. Qiona Smith	Scott
2. Lorine Bilbro	Scott
3. Earleon Kincaid	Scott
4. Bonnie J. White	Scott
5. Chessie Ann Peterson	Scott
6. Mary Louise Smith	Scott
7. Pearl Lee Bilbro	Scott
8. Kattie E. Johnson	Scott
9. Eloise Smith	Scott
10. Calvin Davis	Scott
11. Christopher Peterson	Scott
12. Chistey Parker	Scott
13. Mrs. John Rufus Johnson	Scott
14. Lonnie Edward Reid	Scott
15. Leonard Kincaid	Scott
16. Ray Adams	Rankin
17. Joel Taylor	Rankin
18. Vera Hobson	Rankin
19. Nan Watson	Rankin
20.	
21.	

To. FBI Washington

March, 1955

In regard to the death of Willie Henry Lee on Feb. 25, 1955. We the residents of Mississippi, who are all interested in knowing the reason for the killing demand an investigation. This man's body was found in Rankin County and nothing has been did about it, or no attempt to have been made for no sort of an investigation. We the residents of Mississippi don't feel that we can allow this sort of thing in Mississippi and nothing to be did about it. One of the things they did was they made his father move the car from where it was parked before any investigation or examination for finger prints and other facts. And they moved his body and embalmed it before the autopsy. So it is only fair that we demand an investigation for this killing.

	NAME	COUNTY
1.	William Hardy	Scott
2.	Kirkland Kincaid	Scott
3.	Clarice Kincaid	Scott
4.	Lucille Peterson	Scott
5.	Lena mae Kincaid	Scott
6.	Albertia	Scott
	James D Buckner	
8.	Marie Younger	Scott
9.	Cassell Younger	Scott
10.	Curtis Younger	Scott
11.	Edna Younger	Scott
12.	Wear Klin Child	
13.	Lee Younger	Scott
14.	K.C. Bowie	Scott
15.	Rosalny Kincaid	Scott
16.	Willie Kincaid	Scott
17.	Charles Hardin Amason	
18.		
19.		
20.		
21.		

To: FBI Washington

March 1965

In regard to the death of W___ o Henry Lee on Feb. 25, 1965. We the residents of Mississippi, who are all interested in knowing the reason for the killing demand an investigation. This man's body was found in Rankin County and nothing has been did about it, or no attempt to have been made for no sort of an investigation. We the residents of Mississippi don't feel that we can allow this sort of thing in Mississippi and nothing to be did about it. One of the things they did was they made his father move the car from where it was parked before any investigation or examination for finger prints and other facts. And they moved his body and embalmed it before the autopsy. So it is only fair that we demand an investigation for this killing.

NAME	COUNTY
1. Dottie Marie Johnson	Scott County
2. W. D. Patterson	Scott
3. Jesse Smith	Scott
4. Bonnie Lue Bilbro	Scott
5. Minnie Lee Johnson	Scott
6. Cora Bennett	Scott
7. John Earl Bilbro	Scott
8. Brent Johnson	Scott
9. Kerry Lee Johnson	Scott
10. Ruby Lee Smith	Rankin
11. John Q. Adams	Rankin
12. ___	Rankin
13. Shelly Smith	Rankin
14. Henry Clanton	Rankin
15. John R Archie	Rankin
16. ___ Simon	Rankin
17. ___ Evans	Rankin
18. H. H. Simon	Rankin
19. John McIntyre	Rankin
20. Ethel McCoy	Rankin
21. Willie D. Donald	Rankin

To: FBI Washington

March, 1965

In regard to the death of Willie Henry Lee on Feb. 25, 1965. We the residents of Mississippi, who are all interested in knowing the reason for the killing demand an investigation. This man's body was found in Rankin County and nothing has been did about it, or no attempt to have been made for no sort of an investigation. We the residents of Mississippi don't feel that we can allow this sort of thing in Mississippi and nothing to be did about it. One of the things they did was they made his father move the car from where it was parked before any investigation or examination for finger prints and other facts. And they moved his body and embalmed it before the autopsy. So it is only fair that we demand an investigation for this killing.

	NAME	COUNTY
1.	Lewis Sanders	
2.	Eli Bilbro	Scott
3.	Clyde Clark	
4.	Ada Mae Johnson	
5.	Ernestine Harvey	Scott
6.	Willie Lee Harvey	Scott
7.		
8.		
9.		
10.		
11.		
12.		
13.		
14.		
15.		
16.		
17.		
18.		
19.		
20.		
21.		

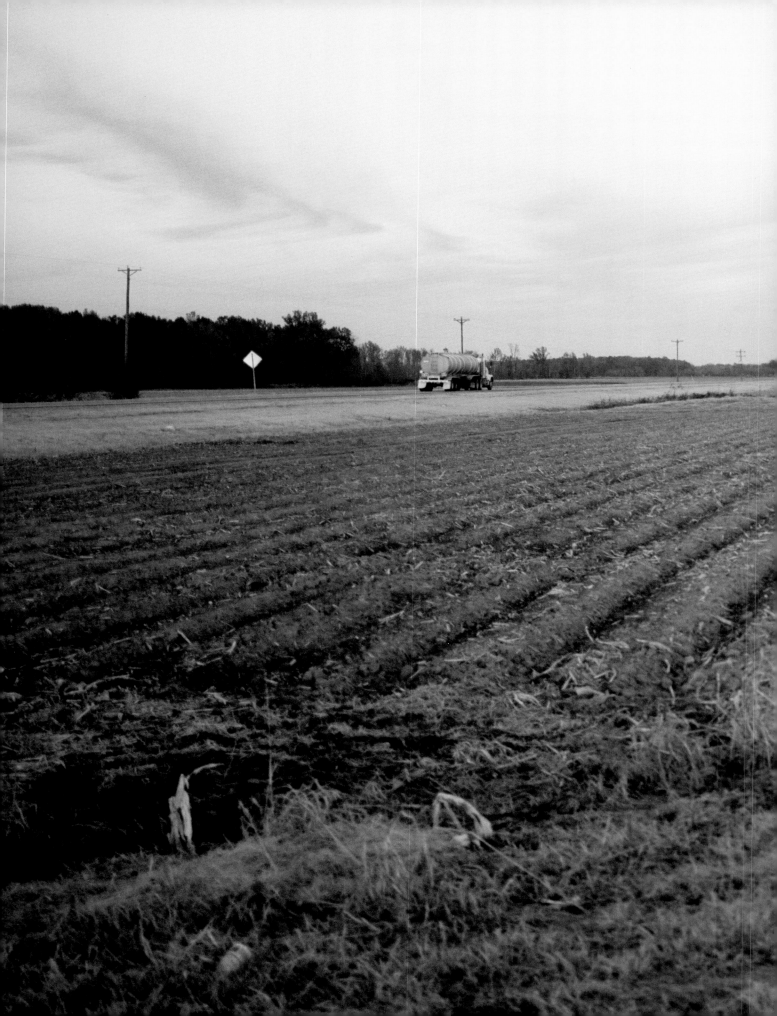

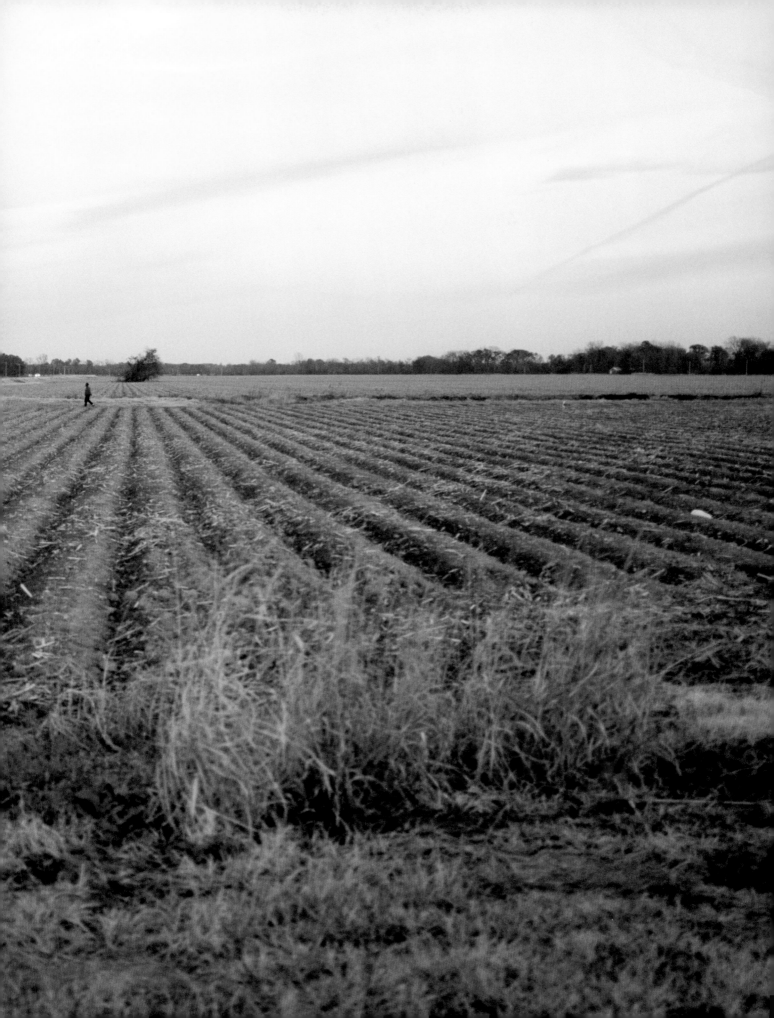

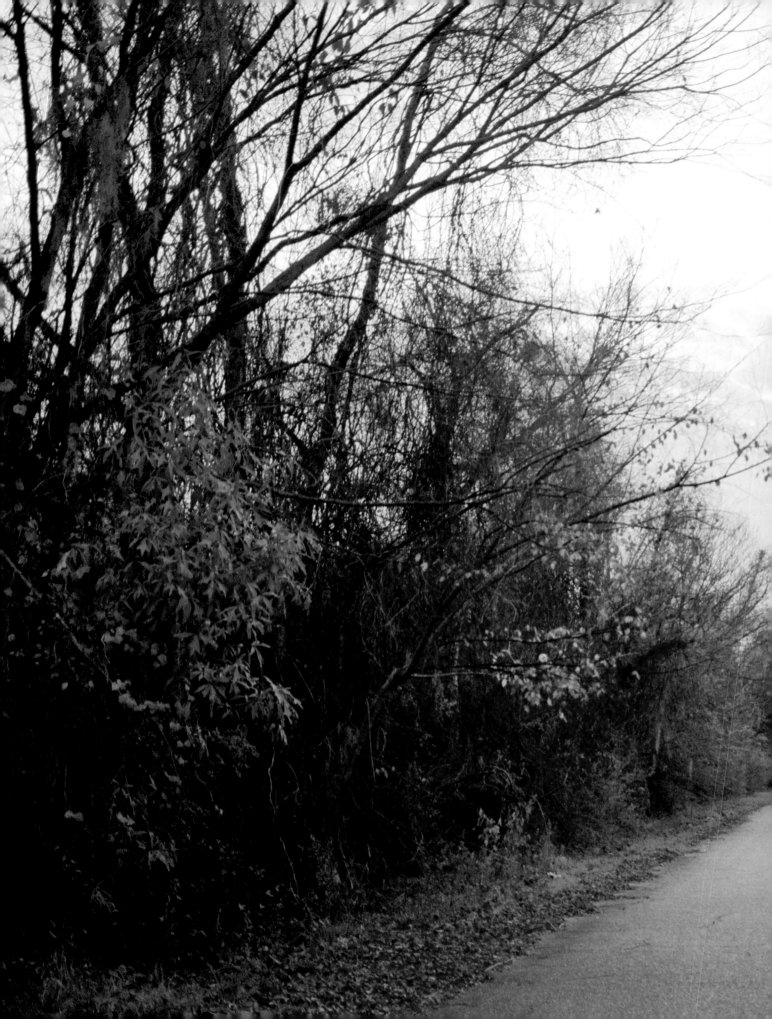

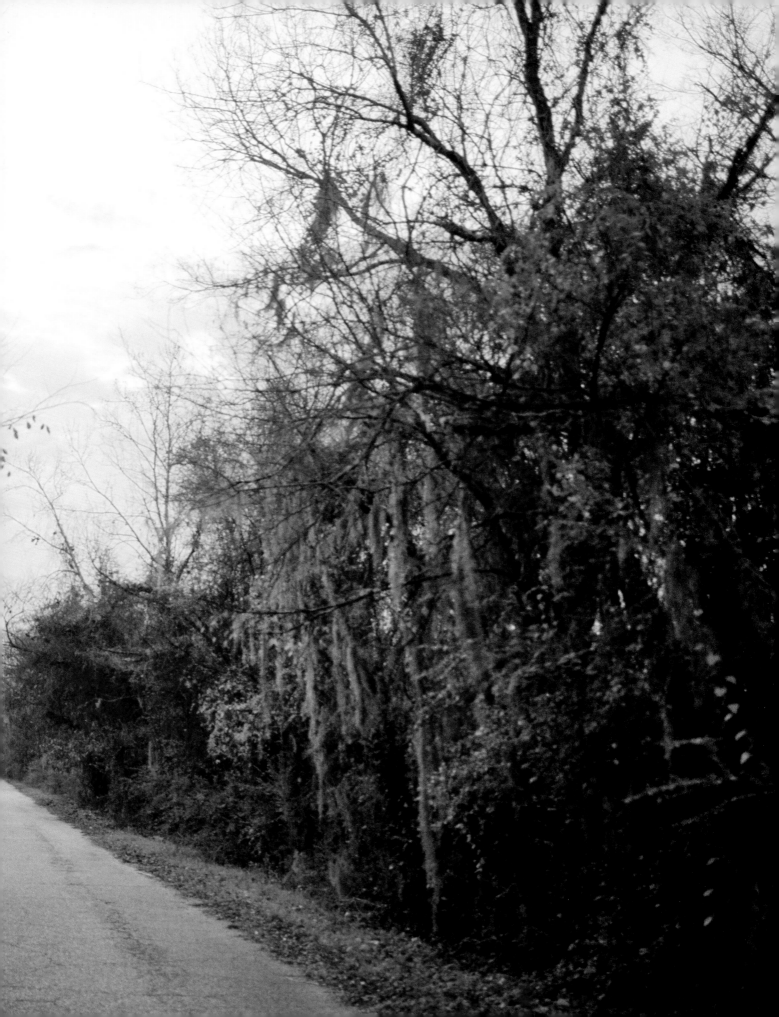

Crossing the field, near Midnight, Mississippi, 2005.

River Road, Montgomery County, Alabama, 2006.

On August 24, 1955, **Emmett Till**, a fourteen-year-old boy from Chicago, was dragged from his uncle Mose Wright's cabin in Money, Mississippi, beaten, shot, and dumped in the Tallahatchie River by two men who accused him of whistling at a white woman, Carolyn Bryant, in Bryant's Grocery and Meat Market in Money. Till was shot in the head, and his body was weighed down by a cotton-gin fan and dumped in the Tallahatchie River. His body was recovered on August 31. In that same year, Roy Bryant and J. W. Milam were acquitted of Till's murder by an all-white jury who deliberated for sixty-seven minutes. The two men later confessed to *LOOK* magazine in exchange for $3,000.

Both men have died, but the Justice Department reopened the case in 2004 to investigate whether anyone else had been involved. No new charges were brought, and the case was closed. In 2008, the Emmett Till Unsolved Civil Rights Crime Act was signed into law, uniting the FBI and Department of Justice in investigating civil rights violations that resulted in death before December 31, 1969. In 2008, Carolyn Bryant admitted to author Tim Tyson that her account of Emmett Till grabbing and threatening her was a fabrication. In 2018, the Justice Department reopened the case to investigate this new information.

NATION HORRIFIED BY MURDE

Mrs. Mamie Bradley and slain son, who was slated to enter 8th grade in Chicago this fall. He was her only child.

Aroused America's fi lynching in f years — the k naping and m der by three M sissippi white n of chubby, year-old Chica an Emmett Lc (Bobo) Till cause he whist at a white wom —leaders of b white and Ne groups deman "stern and immediate" action against the "barbarian

NAACP executive secretary Roy Wilkins wired M sissippi Governor Hugh White: "We cannot beli that responsible officials of a state will condone murdering of children on any provocation." Swamp with hundreds of similar protesting telegrams, G White answered: "Mississippi does not condone si conduct." Calling the Mississippi white people "h rified by the act," white Greenwood newspaper edi Tom Shepherd described the killing as "nauseatii and "way, way beyond the bounds of human decenc

The kidnaping episode came to a stark and shock end when the youth's nude body, weighted with a 2 pound iron gin mill fan, was discovered by a fisherr in the shallow waters of the Tallahatchie River. fan was wired around his neck.

Recovering the body, law officers found a "bullet h one inch above his right ear." The left side of his f was crushed to the bone.

Meanwhile, Leflore County police continued to h

o white men
rocer Roy Bry-
t and his half-
other, J. W. Mi-
) and pushed
search for the
er members of
e "lynch party,"
s. Roy Bryant
ho was whis-
d at) and an-
er unidentified
n. FBI officials
d in Washing-
n that they
ld not enter

Greenwood Sheriff John Cochran ex-
amines 200-pound gin fan that was
wired to neck of boy's nude body.

e case because it was "a local murder."

Recounting the boy's kidnaping from the home of
grandfather, 64-year-old Rev. Moses Wright. in
ney, 17-year-old Wheeler Parker, one of the three
icago cousins who were visiting in Mississippi, but

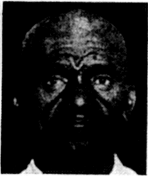

dened by boy's murder are cousins, Simeon, 12, and
rice Wright. 16, (l.) and 64-year-old grandfather Rev.
es Wright. He was not told about "incident" in town.

7

Boys Never Told Grandfather About 'Incident'

who escaped after the crime, told JET:

"When the men came, swearing and all, Grand[ma] tried to awaken Bobo and hide him outside. But [the] men stormed in and told her to get back in bed [and] shut up before they beat 'hell' out of her.

"Grandma knew about the 'incident' because [we] told her and not Grandpa, who would have go[tten] angry at us. We'd gone into town Wednesday and w[ere] watching some boys playing checkers in front of [the] store. Somebody said there was 'a pretty lady' in [the] store and Bobo said he was going inside to buy s[ome] bubble gum.

"After a while, we went in and got Bobo but [he] stopped in the doorway and whistled at the lady. [She] got angry and followed us out, then ran toward a [car]. Some one hollered, 'She's getting a gun' and we r[an.]

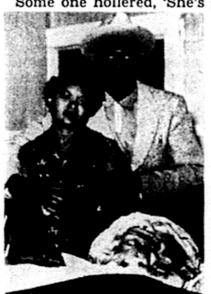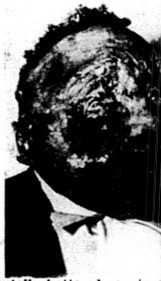

Mrs. Bradley got first look at brutally battered son in [under-] taker's morgue. More than 600,000, in an unending proce[ssion] later viewed body (r.).

8

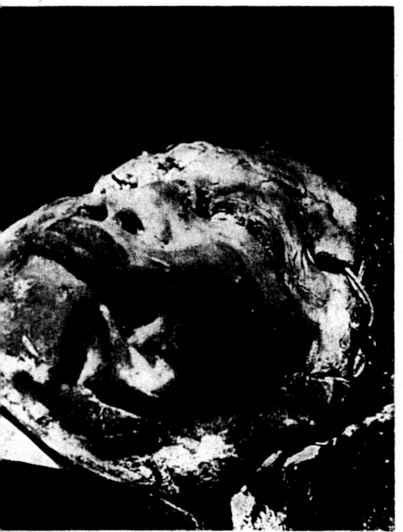

-up of lynch victim bares mute evidence of horrible slay-
Chicago undertaker A. A. Raynor said youth had not been
ated as was rumored. Mutilated face of victim was left un-
ched by mortician at mother's request. She said she wanted
"all the world" to witness the atrocity.

9

On June 10, 1966, three Klansmen approached **Ben Chester White**, a sixty-seven-year-old sharecropper, at his work near Natchez, Mississippi, and asked for his help in finding a lost dog. Ernest Avants, James Lloyd Jones, and Claude Fuller, head of the Cottonmouth Moccasin Gang, his self-created Klan splinter group, then drove White into the Homochitto National Forest, where they shot him repeatedly in the back seat of the car and dumped his body into Pretty Creek.

The Klansmen allegedly murdered White in an attempt to lure Martin Luther King Jr. to Natchez, Mississippi. Jones confessed and implicated Fuller and Avants, and all three were arrested. Fuller was never tried, and Jones and Avants were tried in state court in 1967, with Jones's trial ending in mistrial and Avants's in acquittal, despite confessions from both men and evidence of the crime.

In 2000, Avants was indicted and in 2003 convicted to life in prison, after the U.S. government determined that the crime had been committed on federal property and that the indictment did not violate his double-jeopardy protections. Avants died in prison in 2004.

In 1968, Jesse White, Ben Chester White's son, prevailed in a civil suit against the Mississippi White Knights, Avants, Jones, and Fuller. The jury awarded Jesse White more than a million dollars, though he and the family have yet to receive any of it.

to the Attn: Pat Clark
Ben Chester White, was killed,
(murder) by the Ku Klux Klan,
June 10, 1966. he was
~~lur~~ lured From his house
by three Klamans two help
them Fine a dog, he knew
these men, They took him
in a car to a creek and
murder him, he was Shoot
in the car 17teen times auto-
matic weapons. this act OF
violeance in order to assassinat
martin Luther King Jr. but
he did not come to natchez
in protest in Ben White death,

~~one oF~~ The last words
oF Ben chester White discribe
by the ~~Klamans tu~~ killers
was (lord what have I done
to deserve this.)

Letter from Jesse White, Ben Chester White's son, to
Pat Clark at the Southern Poverty Law Center. Courtesy of
the Southern Poverty Law Center.

UNITED STATES DISTRICT COURT
SOUTHERN DISTRICT OF MISSISSIPPI
<u>WESTERN</u> DIVISION

CIVIL ACTION NUMBER 1197

JESSE WHITE, ADMINISTRATOR OF THE
ESTATE OF CHESTER WHITE, DECEASED PLAINTIFF

Versus

THE WHITE KNIGHTS OF THE KU KLUX KLAN OF
MISSISSIPPI; ERNEST AVANTS; CLAUDE FULLER;
and JAMES LLOYD JONES DEFENDANTS

<u>J U R Y V E R D I C T</u>

[X] WE, THE JURY FIND FOR THE PLAINTIFF AGAINST

THE DEFENDANTS, THE WHITE KNIGHTS OF THE KU

KLUX KLAN OF MISSISSIPPI; JAMES LLOYD JONES;

CLAUDE FULLER; AND ERNEST AVANTS, IN THE AMOUNT

OF $ 22,150.00, AS ACTUAL DAMAGES PLUS THE

FURTHER SUM OF $ 1,000,000.00 AS PUNITIVE DAMAGES

FOR THEIR PARTICIPATION IN WRONGFULLY AND UNLAW-

FULLY KILLING BEN CHESTER WHITE ON THE EVENING OF

JUNE 10, 1966.

THIS, NOVEMBER ___13___, A. D., 1968.

1. Thomas E. Murphy 7. Ned Bohannon
2. Emily H. Griffith 8. Frank C. Lewis
3. Grace Harris 9. Milton W. Medley
4. Lillian C. Luster 10. Austin Haley
5. Mildred Fleming Durham 11. William N. Warren
6. Percy Carper 12. Willie Brown

Jury verdict in *Jesse White v. The White Knights of the
Ku Klux Klan of Mississippi*, November 13, 1968.

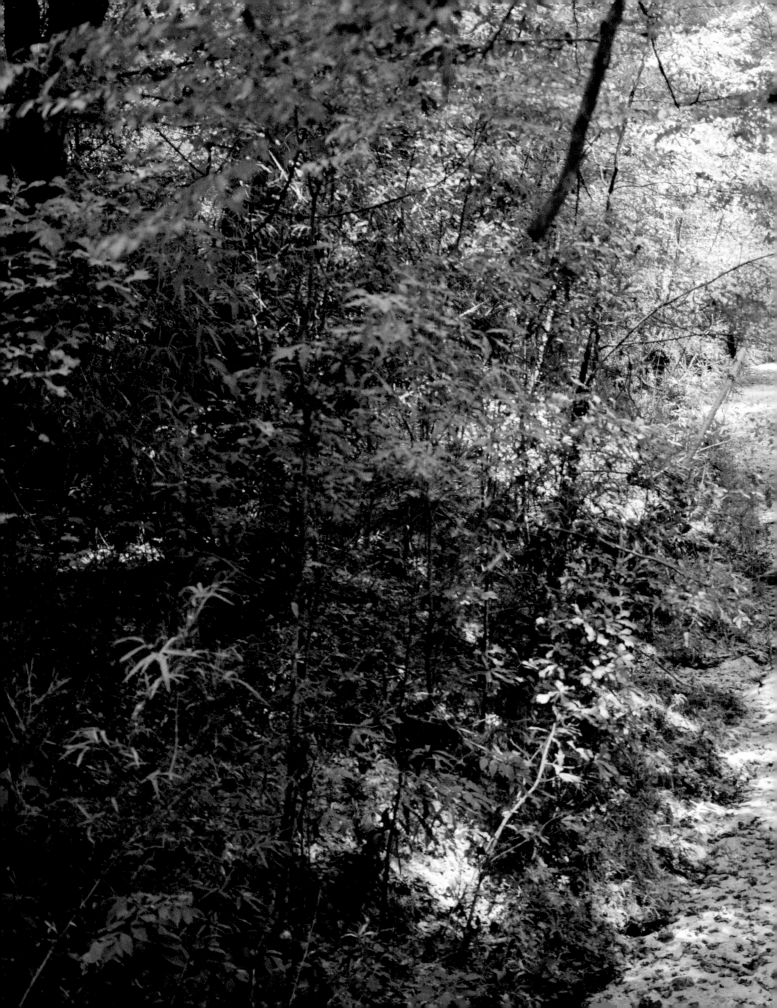

On February 28, 1964, twenty-seven-year-old **Clifton Walker**, a husband and father of five, was murdered by Klansmen on Poorhouse Road in Wilkinson County, Mississippi. Walker was on his way home from his job in Natchez at the International Paper mill, a known Klan recruiting ground with many Klan-affiliated employees. The men who murdered Ben Chester White worked at the mill, which had recently integrated its bathrooms, water fountains, and payroll line.

Walker's murder occurred two weeks after the White Knights of the Ku Klux Klan of Mississippi broke from the Original Knights and organized a secret racist militant organization under the direction of Imperial Wizard Samuel Bowers. (Bowers was convicted for civil rights violations related to the 1964 triple murder of James Chaney, Andrew Goodman, and Michael Schwerner, as well as for the 1966 murder of Vernon Dahmer.)

The Clifton Walker case was investigated in 1964; no one was charged. E. D. Morace, a Klan informant, named fellow Silver Dollar Group members James L. Scarborough, Tommie Lee Jones, and Thore L. Torgersen as the killers. The case was reopened by the FBI in 2009 as part of the federal Cold Case Initiative and closed with no new action in 2014.

In January 1957 **Willie Edwards**, a twenty-five-year-old husband and father of three, was stopped by four Klansmen while at work as a truck driver for Winn-Dixie. The men beat Edwards and then forced him at gunpoint to jump from the Tyler-Goodwin Bridge into the Alabama River in Montgomery County, Alabama. His decomposed body was found three months later by fishermen ten miles west of Montgomery. In 1976, Alabama attorney general Bill Baxley attempted to prosecute Henry Alexander, Jimmy York, and Sonny Kyle Livingston for first-degree murder; they were all implicated in the murder after Raymond Britt, the fourth man, confessed in exchange for immunity. Judge Frank Embry threw out the charges twice, stating that the cause of death was unknown: "Merely forcing a person to jump from a bridge does not naturally and probably lead to the death of such person."

The same year that Edwards was murdered, Henry Alexander was also charged for bombing the home of Reverend Ralph Abernathy, a civil rights leader in Montgomery. The charges were dropped.

In 1992, Henry Alexander was battling lung cancer and confessed to his wife, Diane, that he had instigated the murder of Edwards by falsely identifying him as having insulted a white woman. Of this confession, Diane said, "Henry lived a lie all his life, and he made me live it, too." Diane Alexander met with Edwards's daughter, Melinda O'Neill, in September 1993 to express her shame.

May 17, 1976

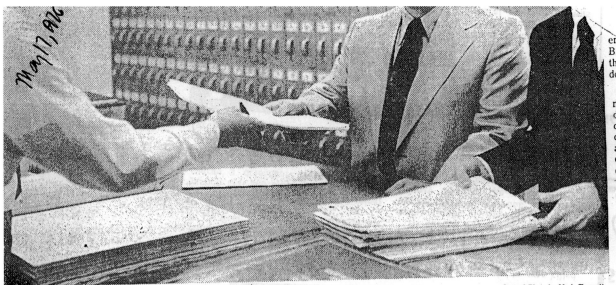

McPhillips (C), Winston Lett File Suit With Deputy Register Walter Graham

Judge Again Rules Indictments Against Alleged Klansmen Bad

By JUDITH HELMS

Circuit Judge Frank Embry has ruled for a second time that indictments charging three alleged Ku Klux Klansmen with murdering a black man 19 years ago are defective.

He said the indictments against William "Sonny" Kyle Livingston Jr., 38, Henry Alexander, 46, and James York, 72, are bad because they don't specify how 25-year-old truck driver Willie Edwards Jr. died.

Atty. Gen. Bill Baxley, who obtained the indictments from a Montgomery County grand jury, claimed the three men forced Edwards to jump from the Tyler Goodwyn Bridge into the Alabama River the night of Jan. 23, 1957.

Embry had quashed the indictments April 14 after a brief hearing but agreed, on motion of the state, to rehear the matter. The rehearing was last Wednesday.

Defense attorneys argued that cause of death, such as drowning, was necessary for the indictments to be valid. Prosecution attorneys said only the means, not the cause, need be stated.

Edwards' body was found floating in the river three months after the alleged crime and was in such a state of decomposition an autopsy failed to reveal cause of death.

Embry, in his order today, said," Merely forcing a person to jump from a bridge does not naturally and probably lead to the death of such person and therefore the court is of the opinion in these cases that the state

must aver that the forcing of the decedent from the Tyler Goodwyn Bridge resulted in his death by drowning or some other 'unnatural cause.'"

Montgomery Dist. Atty. Jimmy

Evans said at last week's hearing there is no way to prove Edwards drowned.

Embry noted that the indictments

(See Judge Page 2)

Demo Platform Panel Picks New Chairman

WASHINGTON (AP) — The Democratic party's platform committee today elected Minnesota Gov. Wendell Anderson as permanent chairman and began a final series of hearings on issues facing the nation.

Anderson's election came after Gov. Philip Noel of Rhode Island stepped down as temporary chairman because of criticism stemming from a statement he made about ghetto life.

"I thought I should not bring that issue and that controversy to the remaining days of the work of this committee," Noel said. He received a standing ovation from committee members when he announced his withdrawal from consideration as permanent chairman.

The panel will hear four days of testimony from some 85 witnesses, including politicians, union officials and civil rights leaders.

Alabama Gov. George C. Wallace, a presidential candidate, was scheduled to testify, along with Sen. Hubert H. Humphrey, D-Minn., Sen. Edward M. Kennedy, D-Mass., and the party's chair-

man, Robert Strauss.

Jimmy Carter, the frontrunner for the nomination, canceled his appearance to campaign in California, a committee spokeswoman said.

Others on the witness list include former U.N. Ambassador Daniel P. Moynihan, consumer advocate Ralph Nader, United Auto Workers President Leonard Woodcock, and representatives of the Urban League and National Association for the Advancement of Colored People.

AFL-CIO President George Meany urged the party to adopt economic programs that would give voters a choice between prosperity and Republican policies that he said foster unemployment.

In prepared remarks, the labor leader said, "The economic choice confronting America in this election year is between a continuation of the disastrous 'trickle-down' economics of the past seven years ... and the creation of a balanced, full-employment economy built on mass producing power, full production and general prosperity."

erie
Baxley
that. If "I
done."

In response to
nied any wrongdoing
deny that I have done
or violated any law wh
der said. "I am confic
all the facts are known
cated. I have great fai
can system of justice
ward to telling my story

Lowder and the Far
been strong supporters
ley's major political
Gov. Jere Beasley. In
Bureau lent Beasley a P
re-election campaign, a
cials contributed at lea
and worked for his re-el

Listed with Lowder
the suit are 10 of h
rations which either
land, borrowed mon
mortgages from the F
five Farm Bureau
panies and a subsidiar
named corporations
control which may
business with the Far

Five of the suit's
based on Lowder's re
tions with the Farm
complaint alleges vio
surance code. The s
ous Lowder compani
real estate, borrowec
tained mortgages fro
reau in violation of
laws prohibiting co
from holding a pri
terest in daily transa
ance company.

Each of the insu
tions contained in tl
been previously rep
bama Journal excep
the Hoover Mall in
der's three sons, acc
sold the completed
one Farm Bureau i
in January 1975 for
then leased the prop
pany.

Another count charg
mitted fraud by not
dealing to Farm
ders. Three more
gally directed the
violated his fiduciar
licyholders. The s
four Farm Bureau
$8.7 million in n
1973-74, but illegal
bulk of the money
$442,000 in dividend

Representing Far
holders in the suit
Louise McCartha,
farmers and long ti
Farm Bureau Fed
is a member of t
Farm Bureau boar
his wife is chair
farm bureau's won

Aiding the state
Robert E. Steiner,

** on Says He'd Prefer**

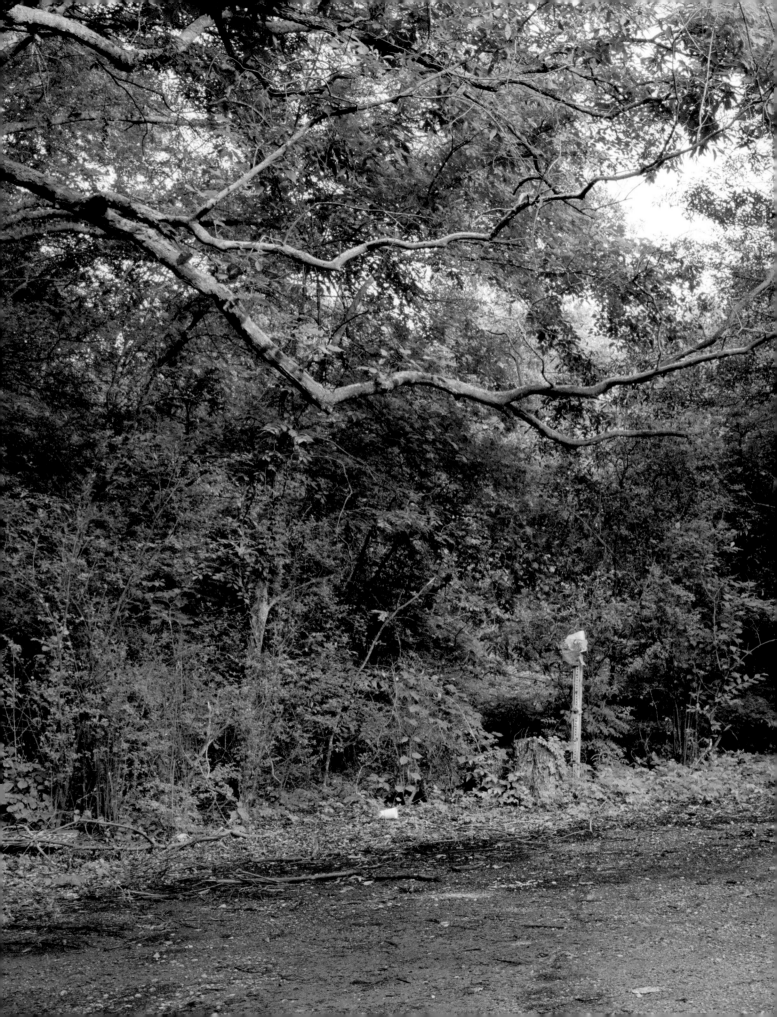

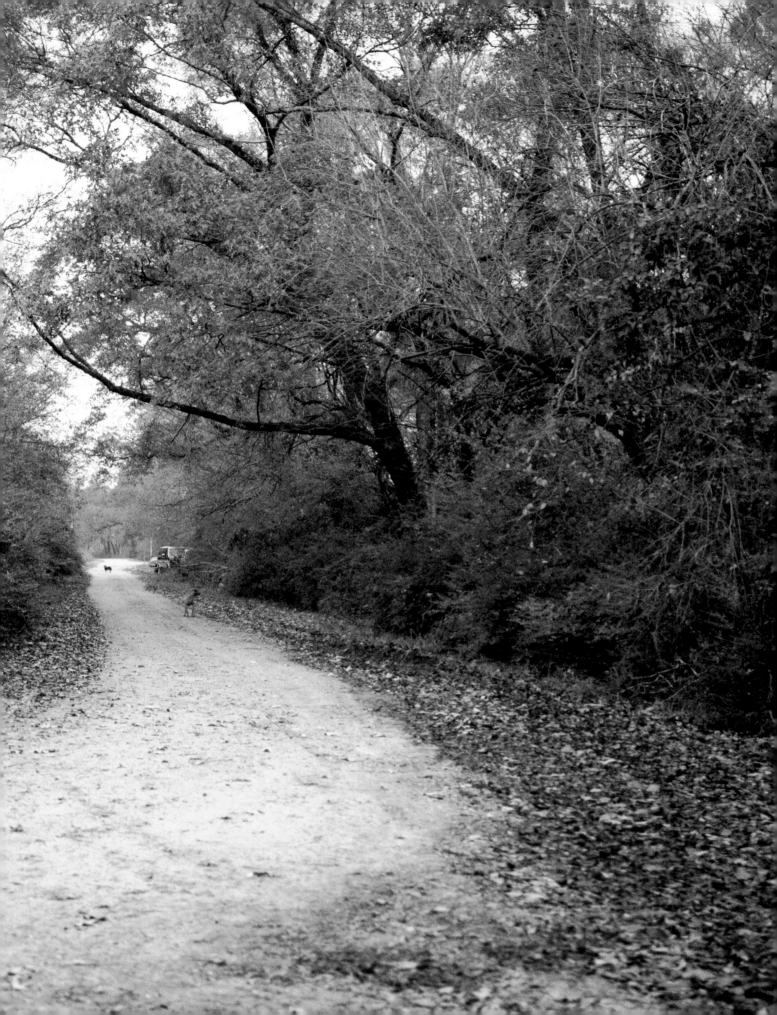

The Franklin

Advocating Continued Growth and Prosp

MEADVILLE, MISSISSIPPI Thursday, Janu

ormer Sheriff,
ble Near Meadville

tist Church for many years
attended Pilgrims Rest Bap-,
Church near his home. Since
retirement as sheriff, Mr. Cor-
had been employed as a
man by a local automobile
cy.

rviving in addition to his
, the former Eloise Wilkinson,
t. 3 Meadville, are:

mother, Mrs. Albert Corban.
, Meadville, two sons, Alec
an and Marvin Corban, both
t. 3 Meadville, a daughter,
Janice Corban, Long Beach,
, a step-son, Shelton Free-
Pascagoula, two brothers,
l Corban, Hattiesburg, and
Corban, Vidalia, La., and six
s, Mrs. W. J. Butler, Rt. 3
ville, Mrs. Cove Campbell
Meadville, Mrs. T. O. Ses-
Woodville, Mrs. Hattie Mc-
e, Wisner, La., Mrs. Hugh
, Monroe, La., and Mrs
ce Hinton, Richton, Miss.,
ree grandchildren.

rices were Sunday at 2 p.m.
grims Rest Primitive Bap-
hurch in Franklin County
urial in the Pilgrims Ce-
, Hartman Funeral Home
okhaven in charge.

Seal And Of Charge

Prosecution Says 'Others Involved'

Murder charges against two
Franklin county men were drop-
ped by the prosecution Monday in
a preliminary hearing before
Justice of the Peace Willie Bed-
ford in Meadville.

James Seale, 29, and Charles
Edwards, 31 of the Bunkley com-
munty south of Meadville, were
charged with the deaths of Charlie
Moore, 19, a student at Alcorn
A & M College; and Henry Dee,
19, a sawmill worker.

The bodies of the Negro you-
ths were found in the Missis-
sippi River near Tallulah, La.,
last July. This was during the
heat of a search for three miss-
ing "Summer Project" workers
near Philadelphia, Miss.

Federal and Sta
ed a pre-dawn "
of Seale and Ed
vember.

The hearing
small room ad
Franklin County
stairs in the c
ends, relatives
clustered outsid
There was room
close relatives
the hearing roon
Reading a motio
District Attorney
said:

"Your District
conference with l
Federal officials,
that other partie
defendants are
that additional tim
quired to complet
gation.

"That in the inter
an in order to full

Advocate

Chancery Clerk

Franklin County

965

SINGLE COPY TEN CENTS

dwards Freed In July Slaying

s pull-
arrest
t No-

in a
the
, up-
Fri-
arious
door.
a few
ds in

issal.
man

y in
and
med
hese
and
re-
esti-

tice
the

facts of this case, the affidavits against James Seale and Charles Edwards should be dismissed by this court without prejudice to the defendants or to the State of Mississippi at this time; in order that the investigaton may be continued and completed for presentation to a grand jury at some later date."

The motion was granted by Justice Bedford. He ordered $5,-000 appearance bond returned to the defendants.

No state or federal officials were evident anywhere near the courthouse, and none took part in the proceedings.

William Riley, of Natchez, attorney for the two men, told the Advocate, "These boys have been treated pretty badly."

"We don't care for the way they try to imply these little insinuations that they have something on them which

warrant further harassment of James and Charles."

"We hope this will put an end to any further harassment," Riley concluded.

Attorney Riley did not elaborate, but apparently referred to Seale's repeated claim that officers took him to a gravel pit and "beat me up." Seale claims this occurred immediately following his arrest in November, while enroute to Jackson for questioning.

The pair was held "incommunicade" in Jackson overnight and returned to local authorities the following day.

Both Seale and Edwards were expected to immediately return to work after the hearing. Seale is employed at a Roxie lumber plant, while Edwards works for a Natchez Paper Mill. Both are married and have several child

Nineteen-year-olds **Henry Hezekiah Dee** and **Charles Eddie Moore** were murdered on May 2, 1964, by a group of Klansmen led by James Ford Seale (who would later become a police officer), a member of the notoriously violent Silver Dollar Group. Dee and Moore were kidnapped and taken to Homochitto National Forest near Meadville, Mississippi, where they were beaten, and then taken into Louisiana, where they were bound by hay-baling wire, weighted, and thrown alive into a Mississippi River backwater.

James Ford Seale and Charles Marcus Edwards were arrested in 1964, and the charges were dropped. In 1965, brothers Jack and James Seale, along with their father, Clyde, the leader of the Franklin County White Knights, and Ernest Avants (who was convicted of Ben Chester White's murder in 2003), beat and murdered Earl Hodges, a white Klansman suspected of being an informant. According to the FBI, Jack Seale became a Klan informant in 1967 to provide information about the Silver Dollar Group and Wharlest Jackson's murder. Ernest Parker, Clyde Seale, and his sons James and Jack were all members of the Silver Dollar Group, a sect of the Klan operating in the Natchez, Mississippi–Ferriday, Louisiana corridor.

James Seale was never convicted of murdering Henry Dee and Charles Moore and was believed dead when many civil rights–era cases were being reopened in the 1990s. In 2005, Charles Eddie Moore's brother, Thomas Moore, returned to Mississippi with Canadian filmmaker David Rigden to make a film about his brother's murder. While there, he learned from a relative that Seale was not dead but living in a motor home on family property. Thomas Moore contacted the FBI, the case was reopened, and in August 2007, Seale was convicted on two counts of kidnapping and one count of conspiracy and received three life sentences. He died in prison in 2011.

Tasti Freeze, now the Westside Drive-In, the last place Henry Hezekiah Dee and
Charles Eddie Moore were seen alive, Meadville, Mississippi, 2005.

Thomas Moore
Colorado Springs, Colorado
July 28, 2010 & February 1, 2019

I'm the brother of Charles Moore and the good friend of Henry Dee, who were kidnapped and murdered in Franklin County, Meadville, Mississippi, on May the 2nd, 1964. This story is about a unique case for many, many reasons—a brutal thing that happened in a town that I love. It has been with me some forty-six years.

I was born on the 4th of July, 1943, the first of two sons to Mazie and Charlie Moore. Some thirteen months later, Charles Moore was born, on August the 10th, 1944. My mom often told us how proud our dad was of us. On March the 23rd, 1946, he passed away. Mama stayed with us. We lived in an old house that only had three rooms, with one room for me and Charles. His nickname was Nub—why they gave him that name, I don't know. There was our bedroom and then Mama's room, which was the little room, and then the kitchen. No electric lights, no running water, no gas, no paint on the house.

With all of my life, and for the rest of my life, I will think of that little place as the place where all of my values and all of my everything—my character and everything—was developed.

In April 1964, I was drafted into the army. (I retired from the United States Army in 1994 after thirty years and fifteen days at the rank of command sergeant major, the highest enlisted rank.) When I left, Charles Moore was in college. When I came home, in June 1964, I was met with the information that my brother had run away from home. They said that he went off to Louisiana to look for work; I said, that don't even make sense, even though we had relatives in Louisiana. Mom said that the last day she had seen him was the 2nd of May. She was on the way to the doctor, and the two of those boys were hitchhiking, and she said when I get through with the doctor, I'll pick them up. This was a normal thing, we did that all the time. When she came from the doctor's, they were gone. But something told Mama that things wasn't right. That Monday morning she went to the sheriff's office, which was a brave act for a fifty-two-year-old African American woman in that part of town, and said he was missing, and that is when the stuff started. I stayed around Meadville for about two weeks, before I went back to Fort Hood, Texas.

I was down in the day room, where we shot pool and played Ping-Pong and stuff like that. The news said they'd found two bodies in the Mississippi River.

Everybody in the world thought it was the three civil rights workers, Goodman, Chaney, and Schwerner, and they emphasized that the body was white. You know, I'm a young guy, I'm not concentrating on that; I was still angry with Charles Moore for leaving. I went to my room, and sometime that night the commander sent for me. He said, do you have a brother missing? I said, yes, I do. He said that one of the bodies they had found had been tentatively identified. I said, I gotta go home, I'll take the bus, and he said, no, I will take you to the airport tomorrow. I'd never flown in an airplane in my life.

I have been asked, what were your thoughts when you were told that Charles Moore's feet were tied together? Hell, I don't know what I thought! What the hell is going on? Because we were well liked. We were two of the more liked kids in that town. We plowed gardens for the whites—for judges, lawyers—we plowed their gardens in the spring.

* * *

I got the funeral arranged. I didn't have no transportation, so I went and told as many people as I could that the funeral was going to be that Saturday.

The anger began to set in. A possible plan to get revenge. I said, Mama, I want you to leave and go to New Orleans. She had a twin sister, Daisy, down there. She said, what you going to do? I said I'm going back to Texas and I will steal some machine guns and I'll get everything I can and steal a truck and come back and kill everything on the 84 Highway. I will poison the water tank in Meadville and kill everyone in Franklin County. She said you stay in the army. She said the Lord will make a way. I said, Mama, what are you talking about? That's all we knew. So I said OK. I went on and stayed in the army and got some money to send back to her.

You are hearing something that I have not told anybody. Because they write a story about what happened in the trial but they don't know what Thomas Moore went through, and you're going to hear that. Whatever I am today, life was a struggle. And at sixty-seven years old, I am so satisfied with who I am because I know where I came from. I came from a family that was so poor we were getting government food. As I was growing up in school, my friends had to see me standing in line with the croker sack to get blocks of cheese and stuff. Not have fifteen cents to buy lunch and go all day without eating. And see where I am today, retired military.

From 1964 to 1998 my job was to stay in the army. I went to Vietnam, Germany; I went to Korea twice, and Panama. I was stationed at several army posts in the United States. It was a journey that I didn't enjoy, but it was something that I had to do. Me and Mama stayed tight. I got a phone call in 1977 from a cousin saying you need to call home. Aunt Daisy had moved up from New Orleans to live with Mama. She says, your mama's sick. I said, I will be there. I drove from Fort Benning, Georgia. When I got to the house, I see cars out there. Aunt Daisy was sitting at the steps as I walked up. I say, Aunt Daisy, how you doing? I'm doing fine, baby. We hugged. I said, well, how is Mama? She said your mom is dead. I said, *what*? Your mama told me that if anything ever happened to her to not tell you until you got here. I haven't cried one day since Mama died in her sleep.

I used to go home, visit, and I'd be in my room over there. I would wake up at night, and she'd be praying and crying sometimes. I used to catch her sitting on the porch. I'd say, Mama, what are you doing? She'd say, one day I know he's going to walk up the road. Mama, he ain't coming back. So she died; she was sixty-four years old, a good-looking woman. I was thirty-three then. Things began to fall in place. I had quit drinking, she knew that. I was in college, she knew that. So I was on my way. I started picking up soldiering, making my rank.

What I'm trying to talk about here is what I went through. Anger, frustration, guilt, pain, loneliness. Shame. Guilty because I walked around there mad at Charles Moore, and he's laying up at the bottom of the Mississippi River. Anger because I wasn't there. Anger because these people did this

to my brother for no reason. Frustrated because I didn't know what the hell was going on. Loneliness because I didn't have nobody to talk to after Mama died. She lived thirteen years from the time he died.

When they built that memorial down in Montgomery [the Southern Poverty Law Center], they contacted me, invited me down. During that time this lady from *Newsday*, Stephanie Saul, got in contact with me. She went out to Franklin County and did an interview with [Charles] Marcus Edwards. I didn't know who any of these guys were. She interviewed me on the phone in 1989; that's when I got the picture of Marcus Edwards. I said, I'm going to kill him. I know who he is now. I made up my mind to do something about it. I said I've been through a lot in my life, and you know, in Vietnam I dreamed Charles Moore came to visit me, and I had nightmares. I went through hell, and I say I've just about got used to it. I've got used to the pain. I ain't got over it, but I got used to it. If I open this case up, it's going to reopen some old wounds, and it's going to open wounds on other people who never had wounds on them before.

I went to my attorney in Colorado Springs and asked him to write a letter to the attorney general of that district [in Natchez] expressing my interest to look into the case. They played around that thing for a couple years, and then finally the U.S. attorney came back and said we closed the case because we can't figure out who has jurisdiction. In the meantime, the Ben Chester White stuff was coming around. Old [Ernest] Avants got convicted because he opened his mouth, saying, yes, I shot the nigger, and they said, where'd you shoot him at, and it was the Homochitto National Forest [fed-

eral land]. That's why the government came in and prosecuted him. So they were trying to tie that in with Charles Moore and Henry Dee.

* * *

Charles Moore was staying with some cousins up in Bude, Mississippi, which is about six miles from Meadville. He went to a school party that Friday night with a friend from Bude. He hitchhiked from Bude to Meadville the next morning, Saturday, May 2nd, and ran into our classmate Henry Dee. They walked through Meadville, and James Seale spotted Henry Dee. They had targeted Henry Dee. They had his picture. Henry Dee was about six feet tall, bony, built, real, real black. Smooth skin. White teeth. Back then, some of the black kids, we fixed our hair, what they called processed. Henry Dee's hair was one of the best I'd seen. Nobody could touch this guy. In order to keep that hair that way, you mostly had to keep it tied up until you went out. It was hard. You couldn't fix it. You wore a head rag.

Henry Dee was going from Kirby, Mississippi, a community in Franklin County, to live with his sister in Chicago. This was Freedom Summer. They identified Henry Dee as being Muslim because of his head wrap and because he was in and out of Chicago.

James Seale called Charles Marcus Edwards, who was about ten miles away. Says you need to come down here, because Marcus Edwards lived in the same community, in Kirby. In the meantime, Charles Moore and Henry Dee are walking down through Meadville. When Edwards came down and identified Dee, James Seale said, OK, y'all get in the truck and follow me. They roll by Charles Moore and Henry

Dee and ask them, y'all want a ride? They said no.

See, me and Charles Moore had already practiced at this stuff, so they told him no. We had already said, look, when we catch a ride, anything suspicious, you sit in the front, and I'm going to sit in the back, that way if they don't let us out down the road, I'm going to choke them to death, and you just guide the car off the side of the road. We already planned that. Seale was in a Volkswagen. He went on down the road a little bit and then backed up and said, look, you guys get in this car. I'm a federal agent. I need to talk to you about some bootlegging. So they get in.

James Seale picked Charles Moore and Henry Dee up around eleven o'clock in the morning. Marcus [Edwards], Curtis Dunn, Archie Prather, and Clyde Seale, James Seale's daddy, followed him. He was supposed to take a right to go down to our house, but he took a left, went down into the Homochitto National Forest in Bunkley. When they got to the place, Seale got out first. When he came around that Volkswagen, he met them with a sawed-off shotgun. They beat them up and interrogated them, beat them with bean sticks, the ones beans can run on, like butter beans.

Klansmen Ernest Parker and James Seale's brother Jack came over around four or five o'clock in the evening. Charles Moore and Henry Dee were badly beaten and bleeding. They said, well, we don't want to get the blood of these two niggers in our car, so they wrapped them up in plastic. So, Parker and Jack and James Seale put them in the trunk and took them to this place near Natchez on the Mississippi River in Louisiana they call Parker Landing, Ernest Parker's property. They tie weights to Henry Dee and put him on a boat. Row him out and dump him overboard. Meanwhile, Charles Moore is on the bank guarded by no other than James Seale. They tie an engine block to Charles Moore, take him out, and dump him overboard. Still alive.

* * *

This old fisherman and his wife are offshore on the river, out there fishing, and they seen this thing floating down that looks like part of a human. This was July 12th, 1964. They pull it in, call the sheriff from Tallulah, Louisiana. The body was only from the waist down, feet still tied together, in blue jeans. They identified it as Charles Moore based on the dormitory keys from Alcorn College. The media flew in. They thought they done found the civil rights workers. The next day, Henry Dee's body floats up. They identified his body by the selective service card.

Henry Dee was nineteen. Charles Moore would have been twenty had he lived to August.

David Rigden from Canada got interested because he was down there covering the Edgar Ray Killen trial in 2005. He wrote me a letter. I was tired of talking to people, so I didn't answer David. As I'm watching Edgar Ray Killen, all this stuff is kind of coming together, so I open the letter. It'd been there about six to eight months. I called him, and he asked me if I would go to Mississippi and help him make a documentary. I said, what am I going to do? There was a report that James Ford Seale was dead; Jerry Mitchell reported that.

I agreed and I said, we may get the truth, and well, that will probably help. Me and David went down there on 6th of July, 2005. And, boy, I tell you, every move we made was a good move. It took time. We must have made some ten to eleven trips to Mississippi from July 2005 until August 2007.

When I would visit Mississippi, I'd go by and see Jerry Mitchell. We talk periodically. When I went down in '98 or '99, we had some catfish in Jackson, and he gave me five to seven copies of FBI documents, and all the names had been blackened out. They didn't make sense. On this trip in 2005, we were sitting there talking, and on the floor down there was a box. Jerry Mitchell looked at me and said, Mr. Moore, he said, you can have those records. Nine hundred pages. FBI, Mississippi Highway Patrol, investigative records of my brother's murder. Details, pictures, you know, drawn pictures of the engine block. The skull of Charles Moore, and all of that.

When David and I first got to Mississippi, we went over to Natchez and stayed at the hotel there. The goal the next day was to go into Franklin County. Start our investigation. This is the 7th or 8th of July. On the way to where we were going, we stopped at Roxie, which is about nine miles from Meadville. They got a store there at the BP. While I'm in there, here comes this guy, a cousin of mine by blood and a nephew by marriage. Named Kenny Byrd.

"Hey, Unc, whatcha doing?"

"We're down here trying to see if we can find any kind of truth out," I said. "Too bad that one of the guys is dead. This guy by the name of James Ford Seale."

He says, "Dead! No no no, he be right down there. I mean, I'm talking about

right down there." So, one day we rolled by, and he was outside, helping his wife get the groceries out of the car. David had all these high-power lenses and stuff. He zeroed in and took a picture.

We went out to the community and asked, "Who is this right here?"

"That's James Ford Seale."

We went to the *Natchez Democrat*, and they printed a story about a brother on a mission. The *Jackson Free Press* wrote about a brother seeking justice.

We still felt that Charles Marcus Edwards was our target. James Ford Seale and Charles Marcus Edwards were arrested for the killing of Charles Moore and Henry Dee in November 1964. They stayed in jail overnight. Who bails them out the next day? Clyde Seale, Archie Prather, Ernest Gilbert, all these guys who helped do this. Seven guys: five from Franklin County, two from Allen County. Five hundred dollars bail. That was it, from 1964 to 2005. It took me one day forty-five years later to find the autopsy report that was locked up in the University of Mississippi [Medical Center] in Jackson.

So I'm thinking, we've got to go see Marcus. I've got to confront this guy. We knew that Charles Marcus Edwards was a deacon of the Bunkley Baptist Church. So I said, "Now, David, I don't know how the white churches do it down here, but black churches, the deacon goes and unlocks the church. He's the first one there. This is a chance we've got to take."

* * *

I said, "Hey sir, are you Charles Marcus Edwards? I have something for you."

He said, "What is this? . . . Who are you, fella?"

I said that my name is Thomas Moore, the brother of Charles Moore. First thing he said is, "I didn't kill your brother."

"I didn't say that you did, but the FBI says you were there to pick him up."

He said, "No, I didn't have nothing to do with that. Look, I ain't never been up on that Mississippi River."

"Ain't nobody said nothing about the Mississippi River," I said. So he confessing right there.

I had called the U.S. Attorney, Dunn Lampton. We started talking and come to find out that he was part of the Mississippi National Guard. I was a command sergeant major there at Fort Carter. They attached his unit to my brigade to fight in Desert Storm. I never met him, but that came up in our conversation. He said, "I haven't read the file, but I will do it. We will shake every leaf in Franklin County. I owe that to my old sergeant major."

So I called Dunn Lampton again and said, "You need to go and talk to him, 'cause he's nervous." Dunn went down and talked to him. And then the Civil Rights Division of the Department of Justice in D.C. got involved. They sent down Paige Fitzgerald, and boy, she's sharp too. They put him on a lie detector. They eventually offered him immunity—we had to have somebody who was there. Marcus turned on

Seale. Testified, brought in the Klan Constitution, told about everything that happened, the sheriff's involvement, all of that.

The defense attorney was trying to paint the picture that Moore and Dee was killed before they crossed the Mississippi River. That is what made it a federal case, because they took two live bodies across the Mississippi River and murdered them in Louisiana.

Paige Fitzgerald, she said, "Your honor, why would you tie a dead man's feet together?" Meaning that Charles Moore was still alive when he was brought across that river: the case then became not where it happened, the Homochitto National Forest, but that they drove across the state line. Kidnapping. That's why James Ford Seale was sentenced to three life sentences for conspiracy and kidnapping, not murder. We were in court when we found out that he put them in the river. If we had known that before then, he would have been sentenced for a murder charge. But we couldn't change the indictment, you see.

During the trial, on the first day, after the jury was dismissed, I'm sitting fifteen feet away from Marcus, and he asks if can he address the court. He stood up and looked at me. He said, "Mr. Moore, I wish to apologize for what I was involved with"—Seale was sitting right over there listening—"forty-three years ago. I haven't rested one single night. I ask your forgiveness."

I believe in the Bible too. The next morning I came forward with my family, my relatives that was there at the trial. We went out there, knocked on his door. He came out, and I quoted the verse that says you must forgive

your brother not only seven times but seven times seventy times. I shook his hand.

The truth has been told. And the chains of guilt and all of that have left me. And not only did we get some justice in a criminal trial; we also got it in a civil trial. Based on the testimony of Marcus in 2007, we filed a lawsuit in 2008, alleging that Franklin County knew about it, had been part of it, and we went and interviewed other people that had been mistreated by the sheriff's department in Franklin County.

And it's over. I feel good.

I've done some great and wonderful things, some heroic things in the military, but there is nothing I did or will ever be able to do on this earth, in this life, to equal what I did with that case. Nothing. To be able to do that and to talk about it, to know that it was a God-blessed thing. It was a struggle. And it made me stronger. To be able to walk around and say, I forgive. I could not talk about this story if it hadn't been for David Rigden. He protected me so much. He would read through the files and see, like, the skull of Charles Moore. He would wait two to three years to tell me, because he knew I wasn't ready to see that. So we have adopted each other as brothers.

I think about Charles Moore often and how Mama struggled to get us through school. To struggle for eighteen years to get your kid through high school, and then in less than one year he's gone. My mother was devastated.

I do believe that the dead know what you're doing. I believe that they are so glad. I believe that Charles Moore and Henry Dee can rest up now. You know

I'm working on my thing, my salvation, but I'm looking forward to that day that I can meet them again. I went to the cemetery, and I told him I did all I could do. I said, "You know, Charles Moore, I promised you that I'd try to do all I could. I have finished the task so I hope that you can rest in peace and that one day we'll get together and me, you, and Henry Dee will walk around the throne saying Glory Hallelujah." About two or three weeks later I had a dream where Charles Moore came and told me, "Tom, you go on and live your life." And I have. I got two bachelor degrees. The degree that I got in social work, just before I walk across the stage the guy asks me, "What's your name?" I say, "My name is Charles Moore." I dedicated that degree to him.

I loved Charles Moore and I miss him. I went and fought for this country. God said men are created in his own image. You know in war I didn't treat the enemy the way they treated Charles Moore and Henry Hezekiah Dee and other people. So I said, why do we have people that can do these things and get away? We still have our problems dealing with individual people based on race, so it's important to set the record straight no matter how long it takes. Family members need to have closure. Only then can you start talking about reconciliation, after you get the truth.

Roadside memorial for Henry Hezekiah Dee and Charles Eddie Moore,
Meadville, Mississippi, 2009.

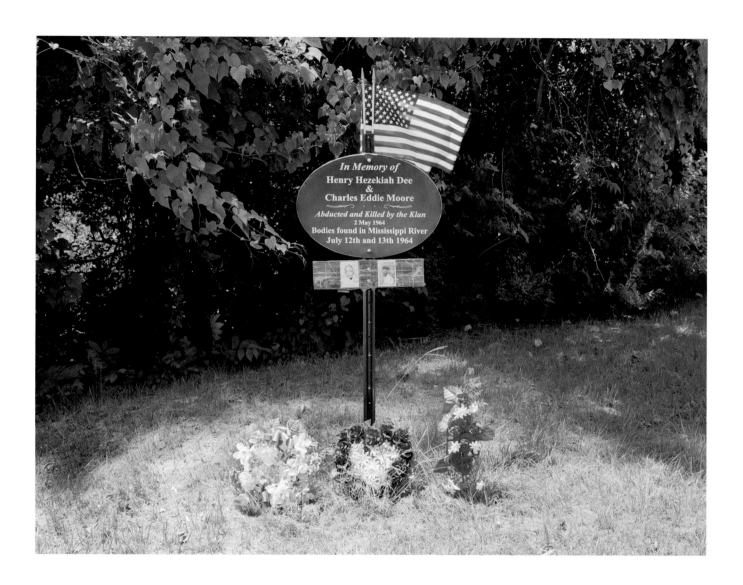

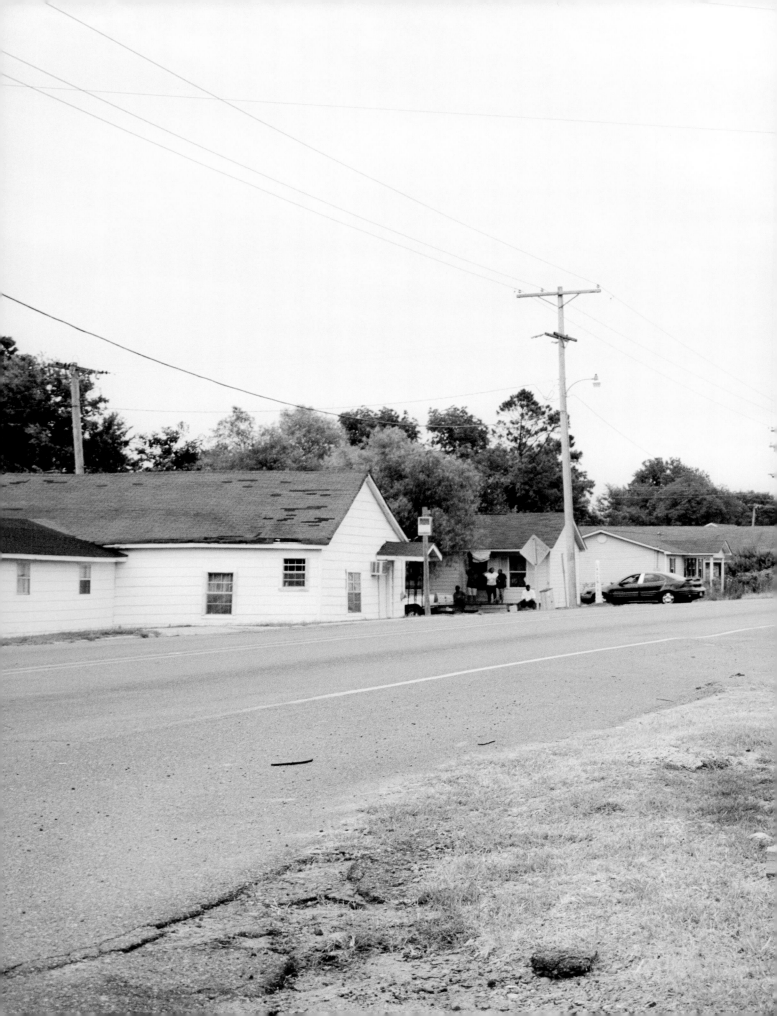

Reverend George W. Lee, a Baptist preacher and grocer, ran a small printing press in Belzoni, Mississippi. In 1953, he founded the Belzoni NAACP with fellow grocer Gus Courts. They organized to encourage black voter registration and payment of the poll tax (a fee for voting later outlawed by the Voting Rights Act). When the sheriff would not accept Lee's and Courts's poll taxes, they took him to court. Local white racists organized a White Citizens Council to retaliate against those who had registered to vote, and Lee received threats. On May 7, 1955, Lee was driving home when men in a convertible pulled up next to his car and fired at him. Lee's jaw was shattered from buckshot, and he lost control of the car. He died on the way to the hospital.

Sheriff Ike Shelton did not investigate, claiming that the incident was a traffic accident; he said the lead pellets in Lee's face were dental fillings that had come loose when the car went off the road.

A few weeks before his murder, Lee had given a speech to 7,000 black people at the Regional Council of Negro Leadership meeting in Mound Bayou, Mississippi—a meeting that Medgar Evers also attended. He said, "Pray not for your mom and pop. They've gone to heaven. Pray you can make it through this hell." For Lee's funeral his widow, Rosebud, insisted on an open casket so that her husband's disfigured face would be seen, and images of Lee in the casket were published in the *Chicago Defender*.

A year later, white gunmen shot Gus Courts in front of his store after he refused to remove his name from the voter registration list. He survived and moved to Chicago.

In 2000, newly released FBI files revealed the names of two suspects who had been investigated at the time: Marion "Peck" Ray and Joe David Watson, members of the White Citizens Council. The FBI reopened the case in 2008 but closed it again in 2011, because Ray and Watson had died in the mid-1970s.

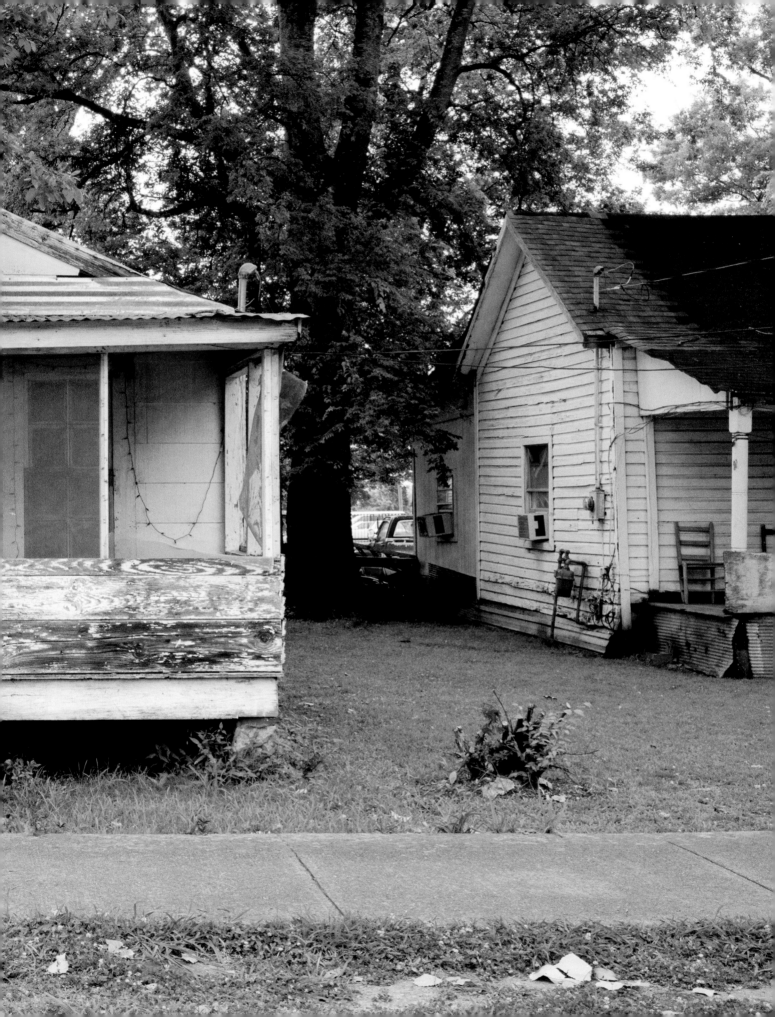

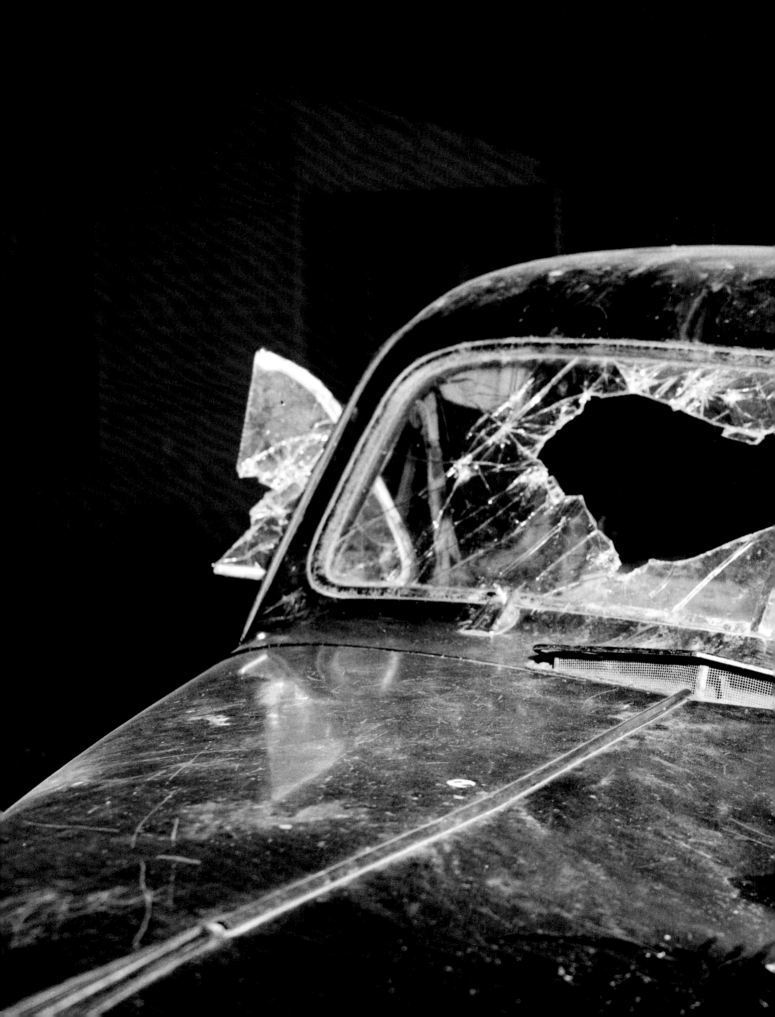

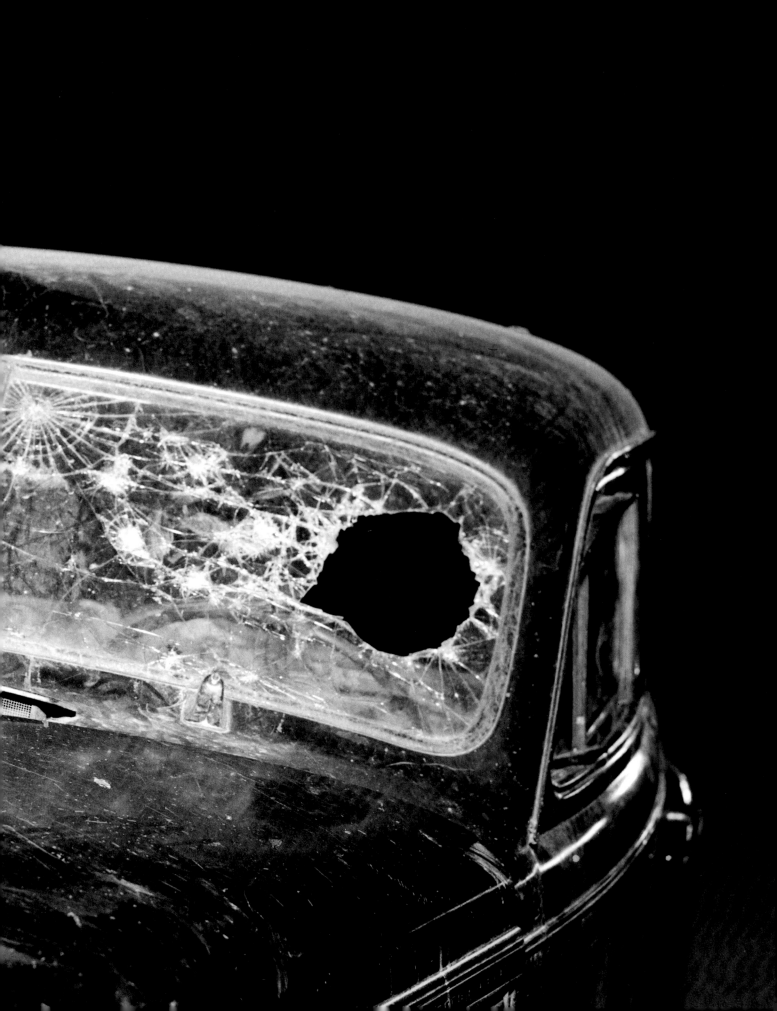

IN THE BLACK

No flame burns for me,

No gun points my way

A gun from out of the weeds should crack

 at my side..

I have no flame burning for me.

My face is dark like the highways.

My hands are a little hard.

But let me hold on; let me love..

I have no flame burning for me.

Let my feet rest and the chimney smoke.

I'm old; Ive walked - I knew no other way to

 to be free.

Now, let the guns crack and the highways go.

Give me your hand somebody; so in the night

When the snow falls, and my toes are cold,

 my heart hungry,

There will be a flame burning for me.

 * * *

Civil rights workers **James Chaney, Andrew Goodman,** and **Michael Schwerner** were arrested and jailed for a traffic charge by Neshoba County deputy sheriff Cecil Price in Philadelphia, Mississippi, on the afternoon of June 21, 1964. While the three men were being held, members of the Meridian and Neshoba County Klans mobilized to kill the three men, with Price's help. Chaney, Goodman, and Schwerner were released at 10 P.M. On the outskirts of town, Klansmen, including Price in his police car, followed the station wagon Chaney was driving. After a car chase, the civil rights workers were overtaken. They were then driven to a remote location on Rock Cut Road, on the outskirts of Philadelphia, where they were murdered. Schwerner and Goodman, who were white, were shot once, and James Chaney, who was black, was severely beaten and shot multiple times. A search for the missing men lasted from June 22 until August 4, when they were found buried face down side by side in an earthen dam on private property.

Though the state did not prosecute anyone for the Chaney, Goodman, and Schwerner murders, in 1967 eighteen Klansmen were charged with federal civil rights violations in relation to the murders. Eight were ac-

quitted; Imperial Wizard Samuel Bowers, Cecil Price, and five other men were convicted and given sentences ranging from three to ten years; and three others, including Edgar Ray "Preacher" Killen, believed to be the primary organizer of the murders, were released after their all-white juries deadlocked.

Jerry Mitchell, an investigative reporter at the *Clarion-Ledger* in Jackson, Mississippi, was instrumental in discovering Killen's involvement, as well as evidence that Bowers had ordered Schwerner's killing. Bowers, convicted in 1967 for civil rights violations related to the murders, had served six years (and in 1998 was sentenced to life in prison for the 1966 murder of Vernon Dahmer). In 2005, Edgar Ray Killen was convicted on three counts of manslaughter and sentenced to sixty years in prison. Mississippi officials closed the investigation into the murders in 2016 with no additional convictions. Killen died in prison in 2018.

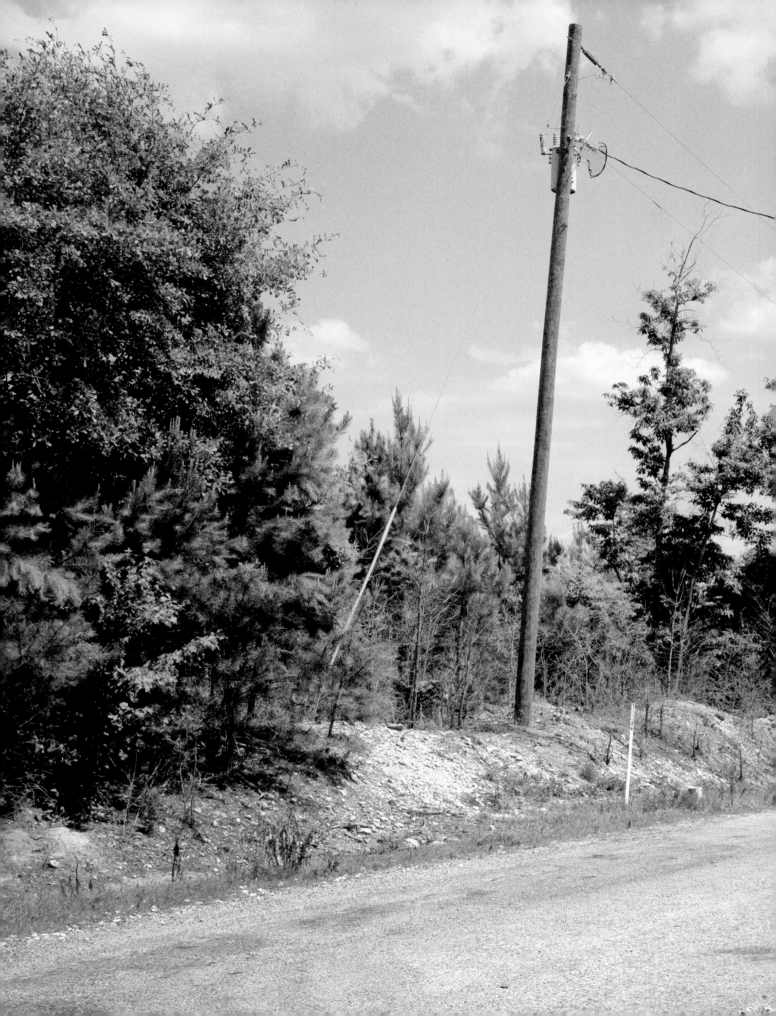

Sheriff or Highway Patrol
after 6:00 p m
Phone 656-2131
24-Hour Service

Missing Auto of Trio Found By FBI Tuesday

been associated with the industry all of their life. Pat was a maid in last year' milk maid contest. Their parents are Mr. and Mrs. Bob Calvert.

Recipe Contest
e Named Saturday

heriff Rainey Asks Cooperation
r All Law Enforcement Officers

"s keep the peace and help in every way we can to solve tfortunate incident," said Sheriff Lawrence Rainey Wednesday.

..tead with the people of our county to cooperate in every .ssible with every law agency, local, state and national, the sheriff. "We have many of our neighboring counts is here to help, plus the Highway Patrol and FBI, and they're everything possible to get to the bottom. It is our duty to em all assistance when we can."

..w enforcement officer are .. up there to do the job, and any .ne to their efforts will only hinder the strife," said Rainey.

..nding around and talking about the situation won't help .. and I ask that everybody go about their work and jobs .ny semblance of violence should come to be in the making .. ave it to the law enforcement officers," added the Sheriff.

no Executive Comm.,
trict Delegates Named

..ates from 23 of the .. in Neshoba County .d at the courthouse .y of this week and elec- .. 15-member Democratic .ve committee and named .s to the district conven- Decatur on July 2.

.d chairman of the county C. Peebles, with Johnny .ry as vice-chairman and Tannehill as secretary- .er. Peebles succeeds .., Jackson, and Tanne- .eeds Lamar Salter.

.d as delegates to the .. Convention in Decatur Herman Alford, R. C. .s and Lamar Salter. Al- .s are W. H. Sanford, Williams and Ray O.

.rt Barrett was elected .ary chairman of the .y meeting and Mrs. Bar-

..bara Board temporary secre- .ars.

.delegates from the five dis- .trict of the county met .separately and named three .each to the Executive Commit- .tee, from which were named .the permanent chairman, vice- .chairman and secretary- .treasurer.

The Executive Committee will .be composed of:

BEAT ONE: R. C. Peebles, .Jack L. Tannehill, Johnny Whin- .nery.

BEAT TWO: Claude May, Jim .Cumberland, G. A. Fulton.

BEAT THREE: George Posey, .A. C. Harbour, H. D. Smith.

BEAT FOUR: Thomas Pil- .grim, Carl Watkins, Oden White.

BEAT FIVE: Hay Parkes, .Otis Farrish, Everette Alexan- .der.

Full-Time Pastor
Now at Southside
Methodist Church

The Southside Methodist .Church of Philadelphia is no .longer a charge but is now a .full-time church with 158 mem- .bers. The change was made at ...

Four Negroes of various integration groups met with local, state and federal officials in the Neshoba County courthouse Wednesday afternoon to discuss the investigation of the missing three "civil rights" workers who disappeared after being arrested here last Sunday night.

In the group to meet with the officials, left to right, John Lewis, Chairman of the Student Non-Violent Co-Ordinating Committee; George Raymond, field secretary of CORE; Dick Gregory, who said he was here in no specific capacity; and James Farmer, National Director of CORE.

The group met in the witness room at the courthouse while hundreds of newsmen, law enforcement officers and FBI men waited in and around the building.

The four were accompanied to Philadelphia with about 40 others who waited at the city limits while the conference was in progress.

There were no incidents before, during or after the meeting, although there was a tense feeling in the air as Highway Patrolmen kept spectators and newsmen as far from the group as possible. - (Democrat Photo).

THIS STARTED IT ALL LOCALLYThis pile of tin rubble is what is left of the Mt. Zion Negro Methodist church near the Longdale community in the eastern part of the county. Fire of undetermined origin destroyed the old building Tuesday night of last week. It was this fire that the three integrationists were sup-

posedly investigating when they were arrested for speeding here last Sunday night. The three, Andy Goodman and Michael Schwerner, both white, of New York, and James Chaney, Negro, of Meridian, have been missing since released by local officials after paying a $20.00 fine. (Democrat Photo).

The car driven by three integrationists who disappeared after being arrested last Sunday night here has been found by Federal Bureau of Investigation officers about 13 miles from Philadelphia, in the northeast corner of Neshoba County.

The car, a 1963 or 1964 Ford station wagon, was located in heavy sweetgum growth on Highway 21, about 100 feet from the Bogue Chitto creek and about 100 feet off the highway. The station wagon had been burned.

The whereabouts of the three persons arrested in the car Sunday night, Andy Goodman, 20, and Michael Schwerner, 24, both white, of New York, and Negro James Chaney, 21, of Meridian, is still unknown. FBI agents, the Mississippi Highway Patrol and the Neshoba County Sheriff's office are continuing the search for the three who were arrested for speeding Sunday night about 6:00 o'clock and fined $20.00. Chaney was driving the car when stopped by Deputy Sheriff Cecil Price. The three paid the fine and were released about 10:30 p. m., said Deputy Price.

He said they signed a release slip at the county jail and that he followed them to the intersection of Main Street and Highway 19, the route to Meridian, from where the trio had come Sunday. The two New Yorkers and Meridianite said they were here to investigate the burning of the Mt. Zion Negro church last Tuesday night.

The search for the three has been underway since they were reported missing by the Congress of Federated Organizations (COFO) in Meridian Monday morning. It has not been established yet what caused the church to burn. Three Negroes were reported to have been beaten by about 300 white persons the same night, but no report was made to local law enforcement officers, either about the fire or the beatings. The church is located about 12 miles east of Philadelphia near the Longdale community which is predominantly Negro.

After finding the burned station wagon about 2:00 p. m. Tuesday, the FBI roped off the area and took every clue from the car and area which might give them a clue as to what might have happened to the three occupants. Impressions of footprints near the car were made and the contents of the burned car were carefully collected by the agents. They would not reveal how they found the vehicle, or what led them to its location. Rumors were that a passerby found it and reported it to the Meridian office of the FBI. There were other rumors that a helicopter located it and still another was that a resident in the area notified the officers.

At one time there were between 12 and 15 FBI agents investigating the car and immediate area. After they were through scrutinizing the vehicle, about 5:30 p. m., they started a search in the area for the three missing men. However, it was becoming cloudy and rain started to fall and most of them came back to their autos on the highway.

The automobile had a Hinds County tag, number H25503, and was reported to be registered to CORE (Congress of Racial Equality) in Canton.

Neshoba County Sheriff Lawrence Rainey was not present when the trio was arrested. He was in Meridian where his wife had undergone an operation a few days before.

Out-of-town and out-of-state newsmen began pouring into Philadelphia Monday and con- ... yesterday

Show
ners Told

.pet show at the Philadel- .ementary School last Fri- .s attended by over 90 .n with some adults also .g the fun. Pets were .in ten classes with three .being awarded in each

JP Proceedings

For June 12-26

Justice of the Peace, Leonard Warren, reports that due to a misunderstanding in the June 12 Democrat concerning JP fines and court costs, there have been several misconceptions made by defendants who have been assessed. In last week's report only the fines were mentioned and there was no mention of the court costs that are included with every fine. These fines and costs are a set amount but subject to change under extenuating circumstances.

Speeding up to 75 M.P.H. - $12.00; Speeding from 75 to 85 M.P.H. - $17.00; Speeding from 85 to 100 M.P.H. - $39.00; Reckless driving - $34.00; Reckless driving (drag racing) - $115.00; Driving while intoxicated - $171.00; No driver's license or expired driver's license - $12.00; No tag or expired tag; $17.00; Following too close - $12.00; Public drunkenness - $15.00; Public drunkenness and disorderly - $30.00; No inspection sticker - $17.00; and Improper parking $12.00. There is a $1.00 addition to all fines and costs when a defendant is put in jail.

Those fines assessed by the court in the last 2 weeks are: Albert Stokes for reckless driving fined $34.00; Joseph Tubby for public drunkenness fined $16.00; Gillespi Moody for improper brakes fined $17.00; James Ray Warren for improper

parking fined $12.00; Gaston W. Barrett for reckless driving fined $34.00; Keythel Barrett for possession of alcohol fined $160.90; Joe Frank Hall for improper parking fined $12.00; Ralph K. Price for speeding 75 in a 65 m.p.h. zone fined $12.00; Laymion Callaway for no driver's license fined $16.00; J. C. Stevens for improper lights fined $17.00; J. C. Stevens for no driver's license fined - $12.00; J. V. Duncan for public drunkenness fined $20.00; Luceline Jim for public drunkenness fined $20.00; Freeman Finely Brown for speeding 75 in a 65 m.p.h. zone fined $12.00; Willie P. Bates for speeding 56 in a 50 m.p.h. zone fined $12.00; John P. Evans for speeding 73 in a 65 m.p.h. zone fined $12.00; Roy James Steve for public drunkedness fined $16.00; C. L. Stallings for speeding 70 in a 65 m.p.h. zone fined $12.00; Billy McKay for public drunkenness fined $20.30; Billy McKay for disturbing the peace fined $20.30; James Cheney for speeding 65 in a 35 m.p.h. zone fined $20.00; James N. Brown for speeding 71 in a 65 m.p.h. zone fined $12.00; Olen L. Smith for expired driver's license fined $13.00; Olen L. Smith for no muffler fined $18.00; Harold C. Wills for failing to yield right of way fined $12.00; Collins Billy for speeding fined $12.00.

CAR OF MISSING TRIO......The rear of the burned 1963 or 1964 Ford station wagon of the three missing integrationists who disappeared after being arrested here last Sunday night, rests on the ground after the tires were burned off. The inside was completely destroyed and all the windows are out. The left front tire was the only one not completely destroyed. Evidently, most of the fire was inside and to the rear of the car and the melted paint can be seen peeling off. Investigating officers said the car was probably driven to the place and burned sometime late Sunday night or early Monday morning. -- (Democrat Photo).

Last Rites Held For C. N. McGaugh

Funeral rites were held for Cornine Nason McGaugh, 55, Friday, June 19, at the Holy Rosary Cemetery by Father Vernon. McGaugh was a native of Choctaw county but moved 30 years ago to the Tucker community in Neshoba county. He was a veteran of World War II and a member of the Catholic Church. The pall bearers for the service were: Joe Holland, James Thaggard, Leonard Duncan, Edd White, Willard White, and Alex Haney.

McGaugh leaves a brother, Alvin McGaugh of Eupora. Funeral arrangements by McClain-Hays.

State Employment Service Has Office In Philadelphia

The Mississippi State Employment Service now has a full time office in Philadelphia. The office is located in the old Neshoba County Hospital building on Center Ave. The office is open from 8 A. M. to 12 noon Monday through Friday to accept applications for employment and orders for workers from employers. Application for employment and orders for workers in all fields of work are accepted: professional, clerical, domestic, farm work, skilled, semi-skilled and unskilled. There is no charge for any service offered by the Employment Service. If anyone is seeking employment or employee's, they are invited to contact the Mississippi State Employment Service office. Call R. C. Thaggard at 656-2811 for information regarding employment.

W. G. Davidson, Dies in Jackson

Funeral services were held for Walter Grady Davidson, 65, of Walnut Grove, Route 2, June 22 from the High Hill Baptist Church and interment was in the church cemetery. Officiating ministers were the Rev.'s Kelly Damper, John Hooper, V. B. Rone of Madden, and Rev. Arzone Burns of Forest.

Davidson died Sunday, June 21, after a lengthy illness at the University Hospital in Jackson. He was a native of Leake county and a retired barber. Survivors include his wife, Mrs. Myrl Gilmore Davidson, three daughters, Mrs. Bobbye Whittington of Morrow, La., Mrs. Jane McNair of Jackson, and Mrs. Peggy Thaggard of Carthage, one son, Pelton Davidson of Pine Bluff, Ark., 2 sisters, Mrs. Lois Sharp and Mrs. Betty Upton both of Walnut Grove, and 3 brothers, Eber Davidson of Union, Mississippi, and Clyde and Doyle Davidson of Walnut Grove.

The pall bearers for the service were: Bob Davidson, Jack Davidson, Melvin Sharp, Gerald Davidson, Wayne Davidson, and Jim Davidson.

Funeral Rites Held For Alex Rich

Burial services were held for Arthur Alex Rich, 74, of 569 Holland Ave. in Philadelphia, Monday, June 22 at Cedar Lawn Cemetery. Rich was a native of Green county, Alabama, but had lived in Philadelphia since 1944.

To Be Expanded

Dr. J. D. Slay, District Superintendent of the Meridian District of the Mississippi Conference of The Methodist Church has announced ground-breaking ceremonies will take place at Green Hill Methodist Church, Pearl River Reservation Area near Philadelphia on Friday, June 26th at 2:00 P. M. All friends and interested persons are welcome to attend. Bishop Marvin Franklin who retires in July after serving 16 years as bishop in this area will preside.

The present sanctuary was acquired by The Methodist Church in 1918 and has had two class rooms and a steeple added in the past eight years. The current building program, made possible through funds received from the Board of Missions of The Methodist Church, Philadelphia, Pennsylvania, will include hard-surfacing of the church drive, renovation of the church sanctuary and a fellowship hall.

Rev. Bonson Wallace, transfered from Oklahoma Indian Mission Conference in 1956 has served as the first fulltime pastor. During his pastorate new congregations have been established at Nanih Waiya Methodist Mission east of Noxapater and at Red Water Reservation Area.

Miss Dorothy Clark, deaconess, assigned to Choctaw Indian Work in Mississippi by the Woman's Division of Christian Service of The Methodist Church as Church and Community Worker has been assisting Rev. Wallace since September 1963.

Barrett Child Buried Here

Miss Leslie Carrol Barrett, 4 year old daughter of Mr. and Mrs. W. W. (Billy) Barrett of Akron, Ohio died June 19 in Children's Hospital, Akron, following an illness of several hours.

Survivors in addition to the parents include a brother, Walter Leigh Barrett and a sister Lisa Barrett both of Akron; grandparents, Mr. and Mrs. Andrew Barrett of Dothan, Ala., and Mr. and Mrs. H. L. Majure of Philadelphia and a great grandmother, Mrs. Mariah Wells of Union.

Last rites were held in Philadelphia Monday morning at 10:30 at the McClain-Hays Funeral Chapel with the Revs. Clay Lee and Jack Ross officiating. Interment followed in Cedarlawn. Mike and J. R. Barrett, James Homer Leigh and Jimmy Parks were pall bearers.

G. C. Hill Buried Wed.

Grover Cleveland Hill, 77, RFD 6, Philadelphia died June 22 at the Neshoba County General Hospital following a long illness. Mr. Hill, a native of Neshoba County was a retired farmer. He was the son of the late Mr. and Mrs. E. Y. Hill. He was a member of the Oak Grove Baptist Church.

Survivors include two brothers, J. T. Hill, Sr. and S. L. Hill both of Philadelphia and a number of nieces and nephews.

Last rites were held at the Oak Grove Baptist Church at 10:00 a. m. Wednesday. The Rev. M. M. Waltman officiated. Interment followed in the Oak Grove cemetery. Nephews served as pall bearers, John T., R. B., Mack, Ed, and Earnest Hill and Lois Thornton were pall bearers. Daws Funeral Home was in charge of arrangements.

Missing Auto

Continued from Page One

reporters from the Associated Press, United Press International, the New York Times, Chicago Tribune, Minneapolis Times, Newsweek, Life, CBS and NBC television, WDSU-TV New Orleans and several others.

The two missing white men are both from New York, Goodman from Queens and Schwerner from Brooklyn. Schwerner has been in Meridian for about six months. They were reported

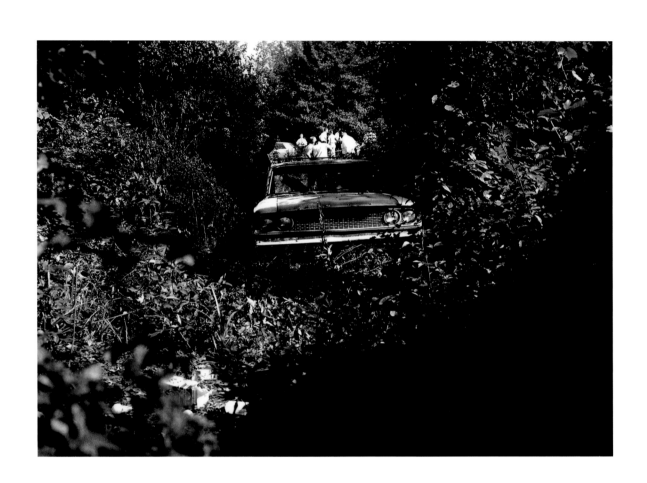

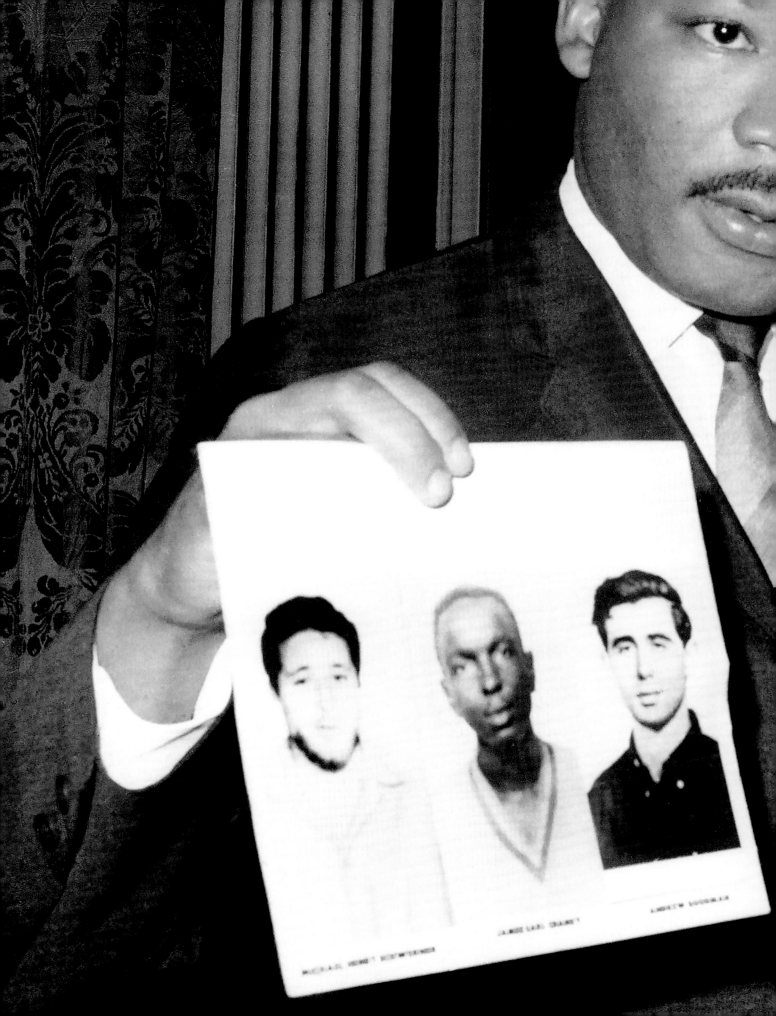

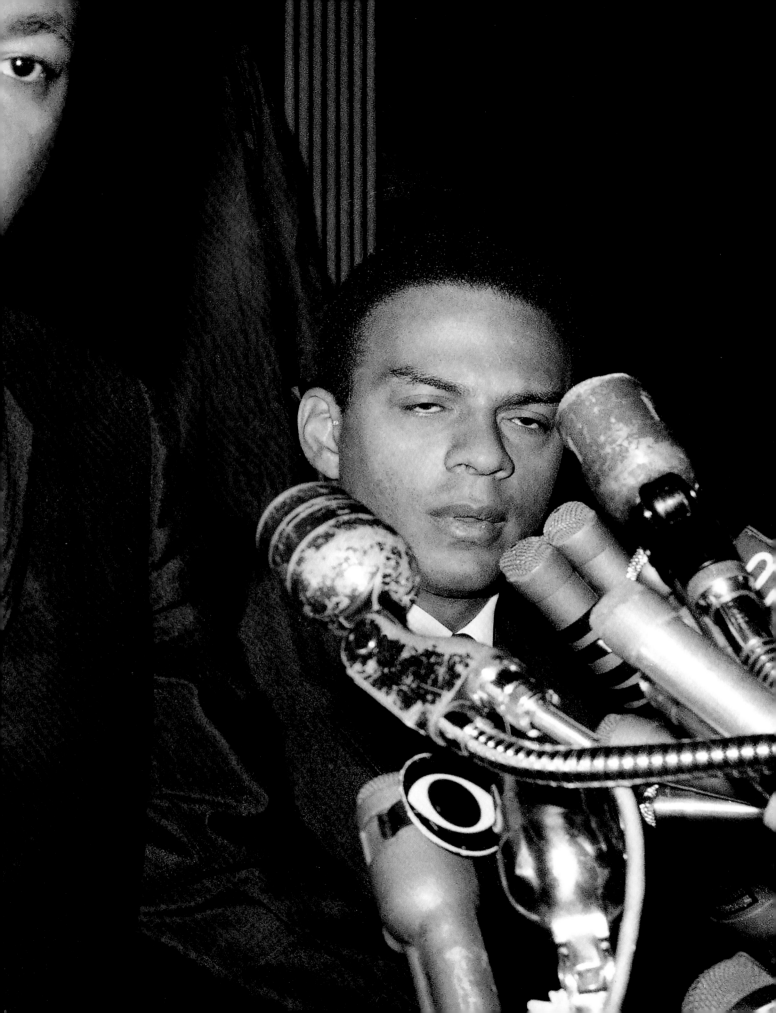

The Neshoba Democrat

Fair
Aug. 8-14

an Institution in Neshoba County PHILADELPHIA, MISSISSIPPI, THURSDAY, JULY 2, 1964 83rd Year 1881 1964 Number Twenty Seven

of Mr. and Mrs. Victor Fulton
ned 1964 Dairy Princess of Ne-
a, daughter of Tommie Fulton
anne will represent this county
a graduate of Neshoba Central
ing East Central Junior College
to continue her education there

Mayor Harbour Issues Statement

Mayor Al Davis Harbour of Philadelphia, in commenting on the possibility of a visit by people from other areas of the United States to engage in "civil rights" activities, had this to say on the matter:

"They can do irreparable damage to the friendly relations that exist among all of our people, and regardless of how well meaning their intentions might be, such activities tend to create tension among the citizens of our city and state.

"It is the earnest desire that no harm should come to these young people, and your city officials urge that these young people who have come into Mississippi on the summer project, sponsored by the National Council of Churches and others, go immediately to the Chief of Police and register with him, in order that precautions may be taken by local officials in their behalf."

Rev. Warren to be At Dixon Revival

The Dixon Baptist Church will sponsor a revival, beginning Sunday, July 12 at 11 o'clock and continuing through the week until Friday with the services being held at 7:30 P. M. The Rev. E. L. Warren of the North Calvary Baptist Church will be the speaker for the entire week.

Investigation Lull; Search Continues

ROAD BLOCK Federal and state agents throw up road blocks on the road near the scene where the burned car of the three missing COFO workers was found. Motorists were asked if they could shed any light on the car burning or whether they had seen any activity which might give them leads in the case. Plans were to question all workers going to at least two major industries here, Wells-Lamont glove factory and U. S. Electrical Motors. However, both plants are closed for their annual vacations, which has always been taken the week of July 4.

No conclusive evidence of what happened to the three "civil rights" workers who disappeared over a week ago here after being arrested for speeding has turned up yet, but rumors have floated around fairly regularly that witnesses have been found that saw two men near the station wagon before it was burned and that another witness has revealed valuable information to officials and has been rushed out of the state for safe keeping.

The three missing COFO workers, Mike Schwerner, 24, Andy Goodman, 20, both white men from New York, and James Chaney, 21, Negro of Meridian, disappeared after being released by Deputy Sheriff Cecil Price on Sunday night, June 21. Their station wagon was found burned about 13 miles northeast of Philadelphia on Highway 21 on the following Tuesday afternoon about 2:30 by the Federal Bureau of Investigation.

On Thursday of last week about 200 sailors from the Meridian Naval Station joined the FBI agents, Mississippi Highway Patrol and the Neshoba County Sheriff's office in a county-wide search for the three missing men. Since that time the number has been increased to about 400, with the search expanded to adjoining counties. The FBI has broadened its search into four other states, Louisiana, Alabama, Arkansas, and Tennessee.

During the past few days the terrain search has been in the Sebastopol, Edinburg, Linwood and Neshoba areas, in addition to questioning motorists in the vicinity of the area where the car was burned.

It has been established by officials that the station wagon was burned sometime between 11:00 a. m. and 5:00 p. m. on Monday. Persons who pass the spot every day, plus the fact that a truck was repaired at the spot Monday morning, say they never saw the car at all.

About 80 to 90 newsmen from newspapers, radio and television have covered the story. Over the past week-end and first part of this week many have been moved out since no clues and new information have been released by officials. The State Highway Patrol moved its communications truck to town last week-end and the public relations office of the highway patrol has remained operative, but with very little news to give out.

FBI, State Highway Patrol and local officers started dragging lakes, ponds and the Pearl River last Saturday, but turned up nothing which might help solve the disappearance of the three men.

One other bit of information that has been reported to officials centers around Corinth, Miss. Chief of Police Art Murphy in that town reported seeing a man fitting the description of Schwerner at a cafe there Sunday. He said the unidentified man had been on ... en route from Mem ... hassee, Florida ... said he ... after he ...

bility of Locating lting Plant in County

US crops, the pickle business will be very favorable to a section such as ours where the family can grow and harvest an acre or two of cucumbers. It was stated that the grower can expect $200 - $300 per acre out of the crop, which is about the same figure given out by the Mississippi Agricultural Experiment Station.

"These men were very favorable impressed with Neshoba County," said Mr. Norton, "and if we can assure them acreage sufficient to justify them building a plant, we feel sure they will locate here."

Mr. Norton said the county agent's office would be getting out more detailed information on the project which will be published in your local newspaper.

Reports from JP Court for 22-29

Fines in Justice of the Peace Court for the week of June 23 to 30 are as follows, reports JP Leonard Warren.

Jack McLeon for improper passing fined $12.00. Harmon C. Hasha for speeding fined $12.00. Jimmie R. Jones for speeding fined $12.00. Silmon Wesley for no driver's license fined $12.00. James B. Moffet for speeding fined $17.00. Malcolm Perry for public drunk fined $15.00. James R. May for public drunk fined $10.00. James, R. May for disturbing the peace fined $10.00. James R. May for resisting arrest fined $10.00. John Miller Graves for speeding fined $12.00. Joe Lee Jones for no driver's license fined $12.00. Jimmie Bell for public drunk fined $16.00.

Bids Asked On Football Fields

Bids will be received for furnishing labor, supplies and equipment for lighting two football fields for the Neshoba County School Board on Monday, July 20, it was announced this week.

The two fields are located at Neshoba Central High School and George Washington Carver High. The plans and specifications are on file in the Neshoba County Superintendent of Education office.

Dairy Day Winners Told

Mrs. B. C. Peden, Mrs. Otis Nicholson, Sr., Mrs. Jesse Cox were first place winners in the dairy foods contest held last Saturday by the dairy day committee at the kitchen in the court house. Second place winners were Mrs. R. F. Hays, Mrs. J. C. Bates and Mrs. Roy Nicholson.

The dairy day program was pronounced a success by Bill Ethridge, chairman. Serving on the committee were Mrs. Gully Yates, Mrs. Carmen Williams, Mrs. Will Hardy, Odie Smith, R. B. Moore and Grover Estes. Assisting this committee were Mrs. Bruce Holman, Miss Jo Beth Clark and over-all dairy committee chairman Chamber of Commerce, Clifton Rhodes.

Following the selection of 1964 Dairy Princess, Miss Dyanne Fulton and Miss Sherry Fulton as alternate, refreshments were served compliments of Pet Milk Company and the Chamber of Commerce.

Byars Furniture Store furnished the deep freeze used in the contest and prizes awarded were given by Pet Milk, La Vel, Borden, Brookshire, Bush and Sealtest distributors. The cash awards presented the Dairy Princesses were donated by Bank of Philadelphia, Neshoba County Gin Association, Neshoba County Cooperative, Riverside Industries, Central Electric Power Association, Farm Bureau Insurance and Citizen's Bank.

Auxiliary Police Force Organized

An auxiliary police force has been organized in Neshoba County, through the cooperation of the Board of Supervisors and the City of Philadelphia.

The organizational meeting was held last Saturday morning, at which time uniforms were distributed to some of the members. City Police Chief Bill Richardson has obtained helmets and night sticks to be used in an emergency.

However, it was pointed out that the auxiliary police will not be used unless an emergency arises and then for such things as traffic and non-

Full Week of Entertainment At 74th Annual "Mississippi Houseparty"

The seventy fourth annual Neshoba County Fair will officially open August 10th, at the historical old fairground, eight miles from Philadelphia. It is called the Neshoba County Fair, but for years it has been the adopted pride and joyful event for the entire Mississippi Community.

Tradition is paramount in the production of fair programs. Monday, the "Miss Neshoba County" pageant heads the long list for opening day. Harness races and grandstand acts will preceed the late Monday beef cattle show, the day will be complete with the late show at the Pavilion.

Tuesday is always Veterans' Day; amateur talent night; first appearance by a series of outstanding Gospel Singers and daily horse races with grandstand acts.

Wednesday, for many years has been set aside as "Meridian Day." The Meridian Chamber of Commerce goes all out to present well received programs. This is also the day of the Dairy Cattle Show. Always

a feature for Wednesday at the fair is the appearance of many of the State and National leaders on the pavilion speakers program. Racing, free acts and late shows continue on into the late hours.

Thursday at the Fair is Jackson Day. The Jackson Chamber of Commerce never leaves undone anything that will produce a better program for the fair throngs. Sixteen full hours of programs are scheduled for the day, including the Jerry Lane Band, WSM "Grand Ole Opry" stars, Gospel singers and much more.

The 1964 Fair will close late Friday night after a full day of grand finale entertainment. After a day of racing, and awards, the highlight of the Friday schedule is the annual "Grand Ole Opry", Gospel, Country Western and talent shows that night.

Every effort is being made to enlarge the fair program to include informal opening entertainment for Saturday August 8th. A heavy entertainment cost

and new building program may necessarily delay this feature for another season.

Aged Man Dies Of Heart Attack On Country Road

Henry Sadler, 75, was found dead on a country road near his home about three miles north of House Monday morning. A doctor who examined him said he died of a heart attack.

Mr. Sadler, who had been in failing health since earlier heart attacks, was walking along the rural road about a quarter of a mile from his home about 11:30.

He fell in the middle of the road and was found by Danny Williams, about eight or nine years old, who immediately notified neighbors, who said Mr. Sadler very seldom ever left the premises of his home. He is survived by his wife.

ys of the rights on wh ore!

$1.99

He run

It is of op that the in Neshoba ... So far, the fr ... seems to bear o ... bility that the men ... found by the searchers; b ... must come from people who are questioned in the case. Other than the questions put to motorists at the roadblocks and the

Bodies of Missing Trio Found Buried in Levee

The bodies of three missing civil rights workers who disappeared here on June 21 were uncovered in a dam of a pond by Federal Bureau of Investigation agents about 6:30 p. m. Tuesday. Michael Schwerner and Andrew Goodman, both white, of New York, and James Chaney, Negro, of Meridian, were last seen leaving Philadelphia on June 21 after paying a fine for speeding.

The bodies were found buried about 17 feet under the levee of the pond. It was learned that the dragline was moved into the area sometime Tuesday, thereby leaving the impression that the agents were fairly sure of what they would find.

The bodies of Schwerner and Goodman were positively identified by the FBI, and Chaney is expected to be shortly, it was learned. The FBI office in Jackson said the intensive search by agents, the Highway Patrol and sailors from the Naval Air station in Meridian helped lead to the discovery. The fact that the dam was built only recently caused the agents to concentrate their search at the spot.

As soon as the announcement was made that the bodies had been found, a blockade of FBI agents and Highway Patrol was thrown up around the entire area.

Coroner Fulton Jackson empanelled a jury Wednesday morning and visited the scene, but the bodies by that time had been removed to University Hospital in Jackson for examination. The coroner's jury was composed of Jack Thrash, H. C. Breazeale, E. C. Parker, Jack Weatherford, Joe Coghlan and S. B. Simmons.

Coroner Jackson said he would not release any information or make any announcement as to the cause of the trio's death until the report from Jackson was furnished his office.

It is believed that the trio was shot, either with a rifle or pistol, and it was learned that bullets were found in each of the three bodies. This information was learned by a very reliable source, who's identity cannot be revealed at this time. The bodies were not mutilated in any way, the source said.

The FBI would not say whether any arrests would be made at this time and would not name any suspects.

The first word of the finding of the bodies was heard over television about 6:45 Tuesday evening, when the regular program at that hour was interrupted.

The farm on which the bodies were found is known as the old John Townsend place, now owned by Mr. Burrage.

The FBI said an announcement would be made as soon as possible on the exact causes of death, which would come some time after the completion of the autopsy in Jackson.

73rd Annual Neshoba County Fair Opens Monday; Lasts Thru Friday

The 73rd annual Neshoba County Fair, "Mississippi's Giant Houseparty", will officially open Monday at 1:00 p. m. at the pavilion in the square.

Although the official opening is Monday, programs will be held Saturday and Sunday. At 7:00 p. m. the Central Mississippi Roundup, western and pleasure horse show, sponsored by the eight riding clubs of Louisville, Goodhope, Carthage, Madden, Kosciusko, Union, Philadelphia and Plattsburg -- 14 big events -- will be staged at the grandstand.

On Saturday at 1:00 p. m. the Mississippi Antique Car parade and display will be held at the grandstand, and at 2:00 p. m. the western horse show and rodeo for all amateur entrants of the riding clubs will be held.

Of course, the big event on opening day will be the beauty pageant Monday night when "Miss Neshoba County for 1964" will be selected.

Tuesday will be Veteran's Day at the fair with a memorial service at the monument at 1:15 p. m., directed by Col. Herman Alford.

The judging of the competitive exhibits will also be held on Tuesday, and the harness racing will get started that afternoon at 3:00 p. m. and continue each day through Friday.

Wednesday is Meridian Day, along with the opening speeches by various political personalities, highlighted by an address by Gov. George Wallace of Alabama at 1:30 p. m.

Thursday, the biggest day of all, when all business places in the city close so that all can visit the fair, will be Jackson Day. Barry Goldwater, Jr., representing his father who is the Republican nominee for president, will speak, as will former Governor Ross R. Barnett, Congressman Arthur Winstead, Secretary of State Heber Ladner, State Supt. of Education Jack Tubb, Attorney General Joe T. Patterson, Highway Commissioner Felder Dearman, and Prentiss Walker, Republican candidate for Congress.

Closing day on Friday will feature Grand Ole Opry jamboree at the grandstand and the free drawings and give-aways.

Rev. Stanley B. Barnett, formerly of Neshoba County, will be the evangelist for Enon (Golden Grove) Baptist Church revival services August 9-14. Song Director for night services will be Rev. James Allen, pastor of Union Baptist Church. Morning services will begin at 10:30 and night services at 7:30. The pastor at Enon is Rev. J. W. Grice. Everyone is urged and invited to attend.

Reverend Stanley B. Barnett became pastor of the Oakland Heights Baptist Church, Meridian, Mississippi, beginning November 1, 1962. He came to Meridian from the Sunny Hill Baptist Church, McComb, Mississippi, where he was enrolled in the New Orleans Baptist Theological Seminary, graduating in the spring of 1962, receiving a B. D. Degree.

PHS Football Practice Begins

Coach Posey and Coach Terry are announcing football practice sessions to Monday morning, August 10. This is in accordance with state athletic regulations.

All old and new members of the squad are to report to the new Philadelphia High School gymnasium at eight o'clock. The first week will be spent in conditioning with no pads worn.

The opening game of the Tornadoes will be September 4 at Starkville with the Starkville High School.

Pool Closed

The swimming pool at the Philadelphia High School will be closed during Fair week. Coach Hodges stated that the pool will close Sunday, afternoon after the session that day and will reopen Friday, August 15.

Irby Majure Is Guest Speaker At Rotary Meet

In an address to the Philadelphia Rotary Club Monday of this week, State Representative Irby Majure of Neshoba County said the most impressive thing he noticed about floor action in the legislature was the protection afforded to a minority by the rules of the House.

"The House rules are hardest thing to learn and even members who have served several terms do not know all of them, he said, much less know how to use them and all the tricky variations.

He said three bills in the last session, the school teachers bill, sales tax and the gasoline tax were the three hardest fought bills.

"I voted for the one-half cent sales tax increase because I figured it was the only tax measure which could get the three-fifths vote required for final passage. Some wanted four cents across the board and refund the municipalities, others wanted to tax soft drinks, cigarettes, etc. and still others wanted to peg

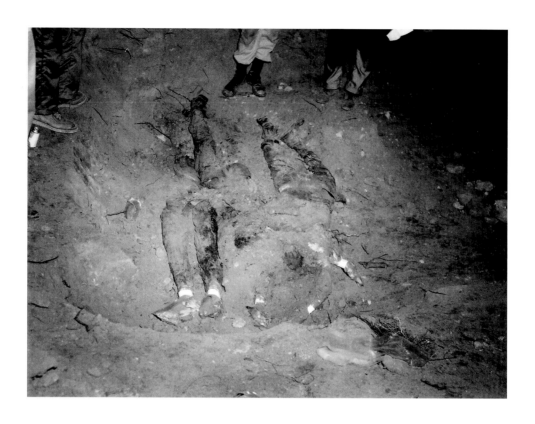

Motley and James Meredith and R. Jess Brown, one of only four black lawyers in Mississippi at that time, walked in was supposed to go in residence on campus was when the riots occurred. There were newsmen from all over as full human beings and full citizens with the right to their own dignity and their fair shake. My attitude broadened

and changed. One thing that affected me was when I went in the navy. At the age of nineteen I got out of Mississippi and saw some other parts of the world. It gave me a broader outlook. When I came back to Mississippi and started trying to get an education and got into journalism and news reporting, I grew up and matured. But it was an ongoing process. I had to work out this black-white issue as a white man, a southern white man.

* * *

You know, certain dates stick with you: June 21st, 1964, between 10:30 and midnight. The next morning at six o'clock, I went into work—at the newspaper in Meridian we had an early deadline. And when I got in, into the office, the managing editor, Frank Long, told me that Michael Schwerner and two other young men were missing and had not returned from Neshoba County the night before. He gave me the story. Of course I knew who Schwerner was; he had been in Meridian about six months running the CORE office, Congress of Racial Equality. He had a headquarters in Meridian, and he worked the surrounding area from Meridian, which included Neshoba County, trying to get African Americans to register to vote, holding voter registration schools. So I used to see Schwerner around Meridian. The last time I saw him, I remember it so vividly. I was across from the *Meridian Star*. I went out the front door to get in my car, and I saw Michael Schwerner and James Chaney walking hurriedly up the street on the other side toward the post office. That's all I have, just that image of them.

My editor told me to go to Philadelphia and talk to the Neshoba County author-ities. I drove up to Philadelphia and went in the Neshoba County Courthouse. The only person in there was Deputy Sheriff Cecil Price. He gave me this story about how [Chaney, Goodman, and Schwerner] were arrested for speeding and held. He said they were held because they were trying to get in touch with the justice of the peace to set the fine, and they couldn't get him to until a good bit after dark. We know this was bogus. Law enforcement was directly involved. Price had it so well. It was a smooth story. We know that there was that time delay from when they were arrested in the afternoon, until they were released from the jail about 10:30 at night.

Chaney, Goodman, and Schwerner had come up here to investigate about Mount Zion Church that had been burned the Tuesday night before. Somebody in that community, we've never known who it was, sent the word, and Cecil Price heard that they were here. So they were arrested as they got into town in front of the First Methodist Church, taken in for questioning. Cecil Price told them to get out of Neshoba County. He didn't tell me this but said he had followed them down Holland Avenue and turned right at Rose Street to come back to the jail. The last he saw of them was their taillights going down Holland Avenue, which is the same as Highway 19, the state highway that goes to Meridian.

They were held in jail long enough for the Klan in Meridian and the Klan in Neshoba County to mobilize and decide what they were going to do. We also know now, and knew early on, really, that after the arrest was made Cecil Price joined in the chase. So there were cars outside of town just waiting for the blue station wagon to pass. They engaged in a real wild chase, up to a hundred miles an hour, as fast as the car would go. Chaney was driving. He knew all the highways around here, and down about twelve miles he took a right turn to go toward Union. He was trying to elude them, but they saw him. They caught him a mile and a half after he had turned and brought them back to the crossroads and back toward Philadelphia about a mile and a half, just a short distance up a little side road. Up the top of a hill, that's where the murders occurred.

Schwerner hadn't made any effort to hide or anything like that. The Meridian Klan knew about him, and they discussed it. He was a thorn in their flesh, and they got sort of fixated on him. He was a symbol of the change that they wanted to stop, and so they had a meeting and voted to eliminate Schwerner, to kill him. The Meridian Klan didn't want it to happen on their doorstep or in their county. They already knew Edgar Ray Killen; he was the liaison, you might say, who took the word back to the Neshoba County Klan. That Sunday it was Killen who contacted the Meridian Klan. I don't know whether there was even a meeting or not. Some have told me that just a few people decided among themselves that this would be done. That if they found Schwerner in Neshoba County they would apprehend him and carry out the project. Killen drove to Meridian to get the Klan mobilized, and the Meridian Klan came up here and did the murders.

Edgar Ray Killen lived on down that rural road where they were killed, so he knew there weren't any houses around there and that there was a little fork in the road. A wide place in the road is where they were murdered. They were

shot in the head. Alton Wayne Roberts from Meridian is the one who shot Schwerner and Goodman. Another man from Meridian shot Chaney. Killen lined up a bulldozer operator who was building a farm pond on Olen Burrage's property; there was an earthen dam that was under construction. So the bodies were put in there and covered up.

There was a lot of speculation about what happened. The FBI entered in force in Neshoba County and Meridian. They used some of the sailors from the Meridian Naval Air Station to fan out and search foot by foot across certain pieces of property and on farms, looking for freshly turned earth. They dragged the swamp and the Pearl River. There was a big manhunt on. It was very tense. People knew pretty well by then that they were dead, but it was a relief to know what happened. It was then a question of who did it and how the government would go about holding them responsible.

There wasn't a federal murder statute then. The only thing the federal government had to indict men on was an old Reconstruction statute about depriving somebody of life and liberty without due process of law. And that's what they got them on, conspiracy to deny due process of law. They had a trial in 1967. I believe seven men were convicted out of nineteen, and nobody served over six years. Killen had a hung jury. An old lady who didn't believe a preacher could do such a thing voted not to convict Killen. She later regretted that after some other things he did, according to her son. In 2005, when the state finally got around to holding a grand jury hearing, Killen was the only one indicted. The judge gave him the maximum for three counts of man-

slaughter: twenty years plus twenty years plus twenty years, to serve consecutively, not concurrently. Which means he'll be out in time for his 143rd birthday.

Some of the other men came back here after they had served their time. Cecil Price came back and had various odd jobs. You'd see him around now and then. That crime followed him, even in Neshoba County.

The big stigma for so many years was that the state of Mississippi did not bring murder charges against these men—that was the thing that stuck with you. When the twenty-fifth anniversary of this thing came in 1989, that's really when efforts began and gradually accelerated. There were so many years when it appeared that this thing was dead and nobody would ever do anything about it. It looked absolutely impossible. We had a triracial group that planned the observance, and the city of Philadelphia, Pennsylvania, helped with it. People started changing their attitudes toward what happened and talking about it more. We formed what we called the Philadelphia Coalition, a group of thirty people. One of our initial resolutions was to bring about prosecutions in this case. The Goodman family came down here from New York, and we had a meeting with the state attorney general and the district attorney. We asked them to do what they could to open the case; there was a lot of effort on the part of a lot of people to get something moving before it was too late. Even after Killen was convicted and serving his time there were accusations like, they just made Killen a sacrificial lamb and they are just doing this for show, and this is just one case, there are still others out there. And certainly there

are others. There are four or five others that still could be prosecuted.

Authorities have to do something. A regular citizen can't really do anything about this, it has to be somebody in an official capacity. We joined as a group to work toward prosecution. And we did manage to get them to call a grand jury session.

* * *

When Killen was convicted, people you never thought would have expressed themselves came out of the woodwork. They were glad it happened. It's time, they said, but they had never said anything before. There was a time when people were afraid. When people are afraid to express themselves is when they *should* express themselves, because otherwise, how do you change it? In the black community here, they felt that at last they were getting some justice. Of course, there was disappointment among a lot of people that there should have been more than just one person convicted. The family members felt like there was some measure of justice, but it was only partial.

I tried to cover everything in the community, and people are used to the paper covering what happened here. Every now and then I'd hear from somebody who'd say something about the way something was covered, that we were just making matters worse. They thought if you didn't mention it, if you just kept quiet, it would go away. It was abundantly clear to me that it was not going away, it was not going to be relegated to the past. The important thing is how people came to perceive it and judge it and look at it and bring some maturity to their outlook. You can't change the past, but you can

change the way you look at things and deal with it.

If you don't learn anything by what happened here, then it's pretty hopeless. If we don't learn anything from history, we're going to repeat it. Bad things happen in a lot of communities, and you'll never change the fact that it's always there. But it's what we make out of it—the way we look at it and see where we were wrong, and vow never to let it happen again. The value of history is to ultimately improve our lives and our communities. Everybody has a stake, everybody is a stockholder in their community. If I live in a community, its aspirations, its history, its problems become mine, as a citizen in that community. People had a complicity in what happened here in 1964, because they were members of this community. They elected crooked politicians. They had corrupt law enforcement people. The public bears the responsibility for that.

You can't shut out a segment of your community; the less you communicate, the more difficult the situation becomes. There needs to be some citizen effort made, some way for people to be heard.

The memorial marker for the three civil rights workers went up last fall, and I don't think that's the last monument that will be put up around here. It's important that the community initiative put it there. People came forward in this community to work toward getting that, and I think it's a good thing for the community to do—to look at itself and say this *happened*. People don't want to be reminded of what happened here. There are people who think that monuments are useless and soon forgotten about. But I don't agree with that at all. It serves a purpose, you know: *don't forget this*. Don't forget what happened here. The community needs to do it. These are symbols that serve to stimulate the memory. There's more to the monument than what you see right there. It's what goes on inside your mind. There's more to an event than just what is depicted, and for younger generations, maybe it will prompt them to learn more.

Statement Asking for Justice in the June 21, 1964, Murders of James Chaney, Andrew Goodman and Michael Schwerner

June 24, 2004

Forty years ago, on June 21, 1964, three young men, James Chaney, Andrew Goodman and Michael Schwerner, were murdered in Neshoba County by members of the Ku Klux Klan.

The state of Mississippi has never brought criminal indictments against anyone for these murders—an act of omission of historic significance. There is, for good and obvious reasons, no statute of limitations on murder. This principle of law holds that anyone who takes the life of another person for any reason not provided by law is never immune from prosecution, no matter how remote in time.

With firm resolve and strong belief in the rule of law, we call on the Neshoba County District Attorney, the state Attorney General and the U.S. Department of Justice to make every effort to seek justice in this case. We deplore the possibility that history will record that the state of Mississippi, and this community in particular, did not make a good faith effort to do its duty.

We state candidly and with deep regret that some of our own citizens, including local and state law enforcement officers, were involved in the planning and execution of these murders. We are also cognizant of the shameful involvement and interference of state government, including actions of the State Sovereignty Commission, in thwarting justice in this case.

Finally, we wish to say to the families of James Chaney, Andrew Goodman and Michael Schwerner, that we are profoundly sorry for what was done in this community to your loved ones. And we are mindful of our responsibility as citizens to call on the authorities to make an effort to work for justice in this case. Continued failure to do so will only further compound the wrong.

We, the undersigned, call on those in authority to use every available resource and do all things necessary to bring about a just resolution to this case.

—The Philadelphia Coalition

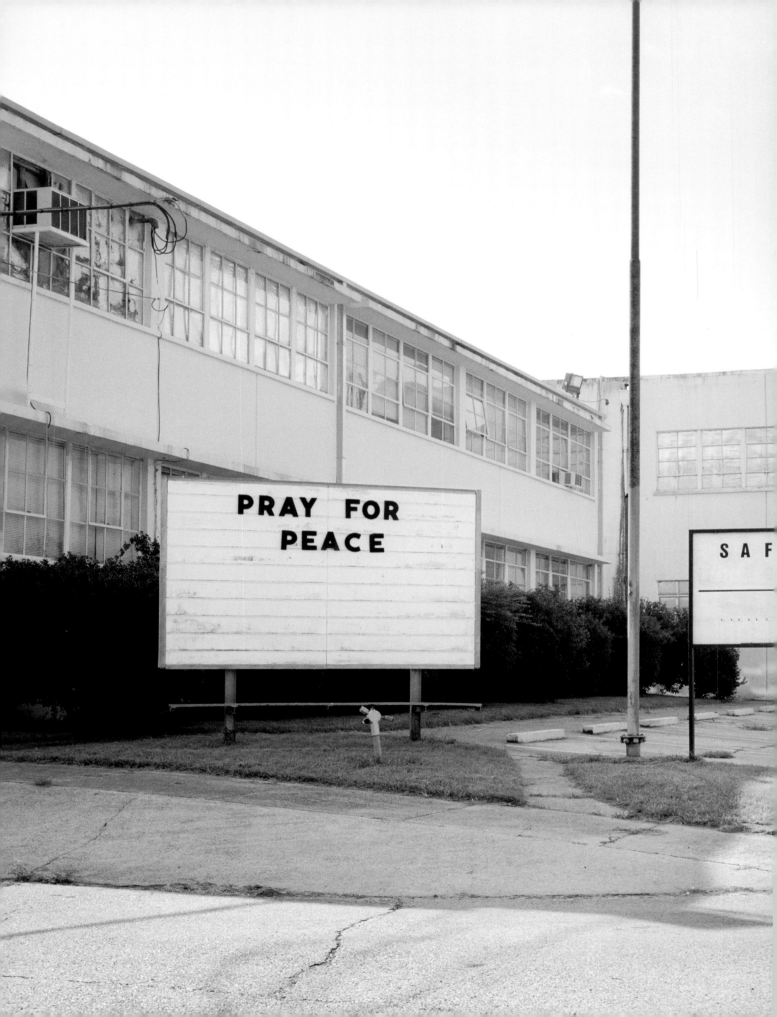

Wharlest Jackson worked with George Metcalf at the Armstrong Tire and Rubber Company in Natchez, Mississippi. On August 25, 1965, Metcalf, the president of the local NAACP, was injured by a bomb placed in his car at the Armstrong Company after receiving a promotion. On February 27, 1967, thirty-six-year-old Jackson, the local NAACP chapter's treasurer, was murdered when a bomb planted in his truck exploded while he was driving home. He had recently received a seventeen-cent promotion to a position formerly reserved for white employees. His son, Wharlest Jackson Jr., heard the blast from his home nearby and rushed to the scene to find his father dead in the road. It is believed that Jackson was murdered by Raleigh Jackson "Red" Glover, the leader of the Silver Dollar Group, a particularly violent Klan group that used explosives in the Natchez, Mississippi–Ferriday, Louisiana corridor. Red Glover is also believed responsible for the Metcalf bombing, with accomplices Kenneth Norman Head and Sonny Taylor, all members of the group.

No one has been convicted of either crime. The community erected a memorial marker for Wharlest Jackson on Minor Street in Natchez in 2011.

Denise Jackson Ford
Natchez, Mississippi
May 19, 2011

I don't know how much I'm going to say today. This is still very much alive for us.

There were five of us, four girls and a boy. Life was fun. We knew how to play. We were a family. As we were growing up, we went to Sunday school, and both my mom and my father were involved in all of that. Daddy would take us down to his hometown in Florida, which is where we spent our summers with our other relatives. My grandfather was a farmer, and he grew watermelons and oranges. We looked forward to it every year.

My mom worked in different places cooking. She taught us how to sew. She would do quiltings. She loved to collect vegetables. We would get out of school, walk into the house, get your pan, get your pot, and we would shell peas for days. She would preserve fruit. We had fig trees, pears, apples. A lot of canning, preparing vegetables to put up for the cold months.

When my daddy would get off work, we used to play jacks together. He took us to church on Sunday; he taught us how to fish.

We came through the era when the KKKs were very high here in Adams County. On Fridays or Saturdays we would walk downtown and see them in the white sheets, and if we were walking on the side of the street, we had to move out of the way or whatever, so we came up through the era of that kind of scenery. Once my parents became involved into the NAACP and things were high and out of the ordinary, they used to tell us, "Be care-ful where you go, always watch your back, always travel in groups," and so forth, because things were out of hand here. I remember all that kind of stuff. Places we couldn't go, things we couldn't do.

My daddy's involvement as treasurer in the NAACP was only talked about between my mom and dad. I must have been about seven or eight when he was the treasurer of the NAACP. My father also worked for a funeral home. I remember him coming home, when he was ready to count his money or do his bank deposit. He would sit us down and teach us how to do the money and so forth. We would wrap money and coins. He was a believer that anything you want in life, you have to work for it. He was preparing us to be better, preparing us for the real world.

I knew of George Metcalf when I was growing up. After his car was bombed [in 1965], my mom told my father she wanted him to separate himself, because she didn't want anything to happen to him. But my father took care of Mr. Metcalf. He made sure he had a way from work to home; he wasn't going to stop his relationship with Mr. Metcalf because of the bombing.

* * *

February 27, 1967. The only thing I remember when the bomb went off, how my mother called and said it was my daddy. We only lived a block away, so you could see the lightning from the explosion.

When my mother called out that it was my father, we knew something tragic had happened. I was only eleven. Everybody was just crying. It was around 8:30. When she left the house to find daddy, she took us all with her.

There were two hospitals here, the general hospital and the charity hospital. The ambulance passed up the general hospital and took him to the charity hospital. When my mother made it to the charity hospital, she had to follow the blood stream on the floor to find where he was, and she doesn't know which officer it was, he told her they didn't care who she was, she had to get out of there. She told them that was her husband and she needed to get where he was.

This case has been ongoing for forty-something years. Every time someone tried to open it and investigate, it would close. This is the first year when it really came to the forefront: people are trying to help us get the message out and see if anybody will come forward. We're still in limbo. There is still nothing, but we're hoping people will come forward and share what they know and talk. I don't know who did it, only what they say. Someone by the name of Red Glover.

I don't know if we will ever come to closure of this case. People are dying every day. The only closure we will get is the closure within our hearts. After this interview, I don't plan to talk about this again. Every year we do a memorial in honor of him. This year, I finalized a goal of mine to place a marker in the memory of the late Wharlest Jackson Sr. because of what he stood for—not just for my family but for all families.

My father stood for justice, and righteousness. He was a man of high stature. He wouldn't let anybody turn him around from what he saw that was of good. He never said no; he always did his best. I walk on the standards he taught me daily. Do your best at whatever you can do and you will make it in

this world. I came to closure, because I gave it to God. I prayed about it and asked the Lord to take the burden and tears out of my eyes. He gave me the strength to move on, because I could see that nothing will ever be done about this case.

The sheriff's department, police department, and the FBI failed us because they knew back in 1967 who to go after and they chose not to. The FBI is failing us on a daily basis.

I'm on a daily walk. If closure comes, the true closure, I will rejoice, and if I don't get it, I'll keep moving on with my life and hope that my sisters and my brothers will as well. True closure would be taking the perpetrators before a judge.

I've worked in the school district in Natchez for thirty years and been in contact with a lot of the Klansmen and such, and they know that I know, that I know. I want people to understand that it was a hard road to travel, but we traveled it. With God first, man second. We need the knowledge of what transpired back then—knowing how we got where we are now—because people stood and sacrificed their lives for us. People sacrificed. They opened the way for voting and holding public office, so we need to utilize these opportunities. So many people sacrificed.

My mom had to raise five kids by herself. She had her mom here to help her. She was still hurt, very hurt, that no closure ever came to this case. In order to move on with her life, she remarried and moved to California. To get away from Natchez. She came and visited us every summer, but she didn't have to deal with those people. The only closure she got was knowing that one day someone was going to come and testify and really tell what transpired back then. That's what we are still waiting for.

One December, a supervisor in Natchez called me. He had gotten with other [Adams County Board of Supervisors] members to approve raising money for a marker for Wharlest Jackson by the next February's memorial event. When the time came, the money was not there. I said, "OK, what must I do," and I wrote an article. The paper published it for me, and the money started pouring in. When we got the money for the marker, in 2011, we installed it on Minor Street in Natchez. I accomplished what I wanted to do, and the people of Natchez supported us. I was elated. My closure is to know that I have this marker in his honor.

I can't hold people now accountable for what their people did back then. I want to let kids know that we are living in a different time now. If I reach just one person then I've accomplished my goal.

Historical marker for Wharlest Jackson Sr. on Minor Road, Natchez, Mississippi, 2018.

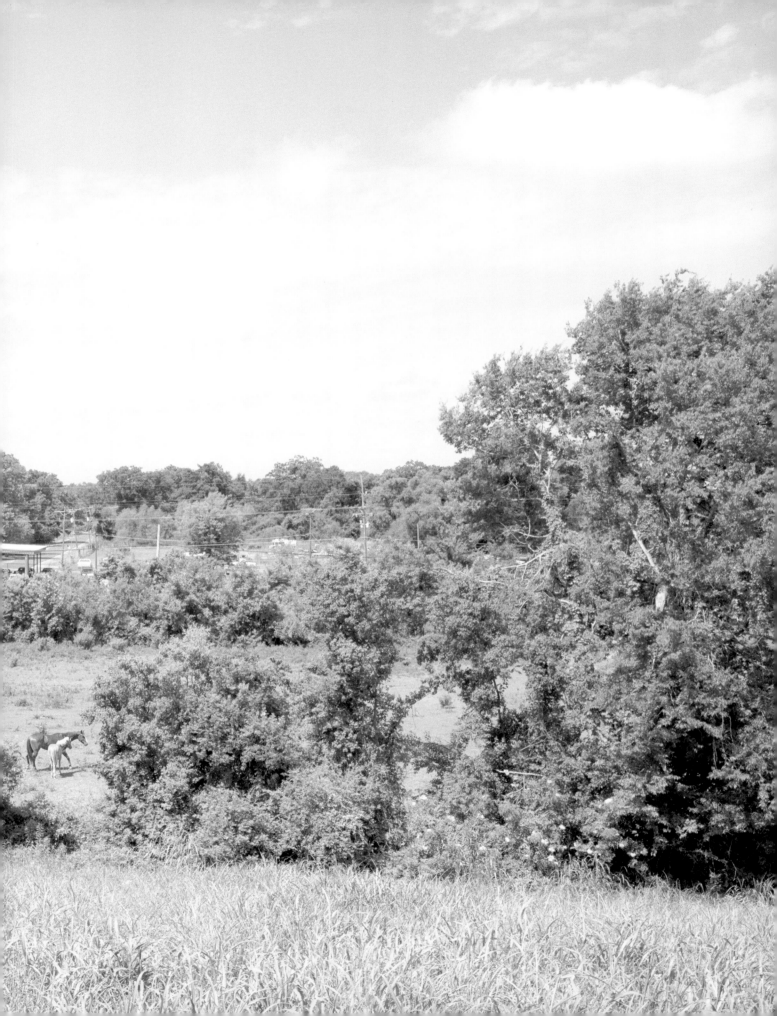

Joseph "JoeEd" Edwards disappeared on July 12, 1964. Edwards's mother, Bernice, reported him missing to the Vidalia and Natchez police departments. His car was found in front of the Dixie Lanes bowling alley on the Ferriday-Vidalia highway in Concordia Parish, Louisiana. Earlier that night, a witness saw an unmarked white police car follow Edwards's car on the road from Vidalia to Ferriday and pull him over. Edwards wasn't seen again.

Edwards worked as a porter at the Shamrock Motor Hotel, in Vidalia, Louisiana, where the Silver Dollar Group was formed in 1964 by Klansman Raleigh Jackson "Red" Glover. A white registration clerk at the motel, Iona Perry, told her boyfriend, James Buford Goss, a probation officer, that Edwards had tried to kiss her. Goss in turn told Police Chief Johnnie Lee "Bud" Spinks, who told deputies Bill Ogden and Frank DeLaughter. An FBI Klan informant and Silver Dollar Group member, E. D. Morace, reported that Kenneth Norman Head had told him that Spinks went to Red Glover to ask that Edwards be "taken care of" and that Head, Glover, and Homer Thomas "Buck" Horton had murdered Edwards.

The night Edwards disappeared, two black churches, Bethel Methodist Episcopal and Jerusalem Baptist, were burned south of Natchez in Kingston, Mississippi, by the Sligo White Knights. Dewey White, a white man who had earlier defended a black friend's right to enter a café and be served was beaten by Klansmen in Concordia Parish, and later in the day of July 12, Charles Eddie Moore's body was found in a Mississippi River backwater by Parker's Landing in Warren County, Mississippi.

The FBI began investigating Edwards's disappearance in 1967. During the investigation into Wharlest Jackson's murder, the FBI came to understand that the Klan and law enforcement were in league, so they extended their investigation into other crimes, including the murders of Henry Hezekiah Dee, Charles Eddie Moore, and Clifton Walker.

The FBI reopened the Joseph Edwards case in 2010. When they closed the case again in 2013, they listed the following suspects: Silver Dollar Group founder Red Glover and members Kenneth Norman Head and Buck Horton, Police Chief Bud Spinks, deputies Bill Ogden and Frank DeLaughter, and probation officer James Goss, all of whom are dead.

Stanley Nelson, an investigative reporter at the *Concordia Sentinel*, has written extensively about his investigation into the life and murder of Joseph Edwards and is still trying to locate his body.

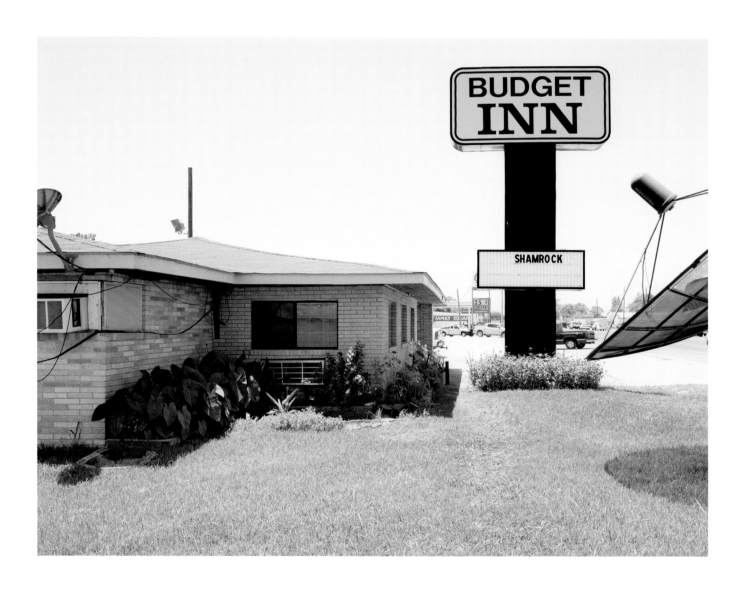

Frank Morris, the owner of a shoe shop in Ferriday, Louisiana, was badly burned when Klansmen set fire to his shop and home on December 10, 1964. When he heard breaking glass and tried to get out the front door, he was ordered back inside by a man with a shotgun, and the shop was set alight. Fifty-one-year-old Morris died four days later from third-degree burns.

No one has been convicted of this crime, though several suspects were identified at the time. In 2007, the FBI reopened the case, closing it in 2014. Morris is believed to have been murdered by Klansmen, including suspects Arthur Leonard Spencer, Silver Dollar Group member Coonie Poissot, and Deputy Sheriff Frank DeLaughter, a suspect in Joseph Edwards's disappearance.

Concordia Sentinel editor Stanley Nelson has thoroughly investigated Frank Morris's life and murder and has written many pieces on civil rights–era cold cases from the 1960s in Concordia Parish, Louisiana, and Adams, Wilkinson, and Franklin Counties in Mississippi.

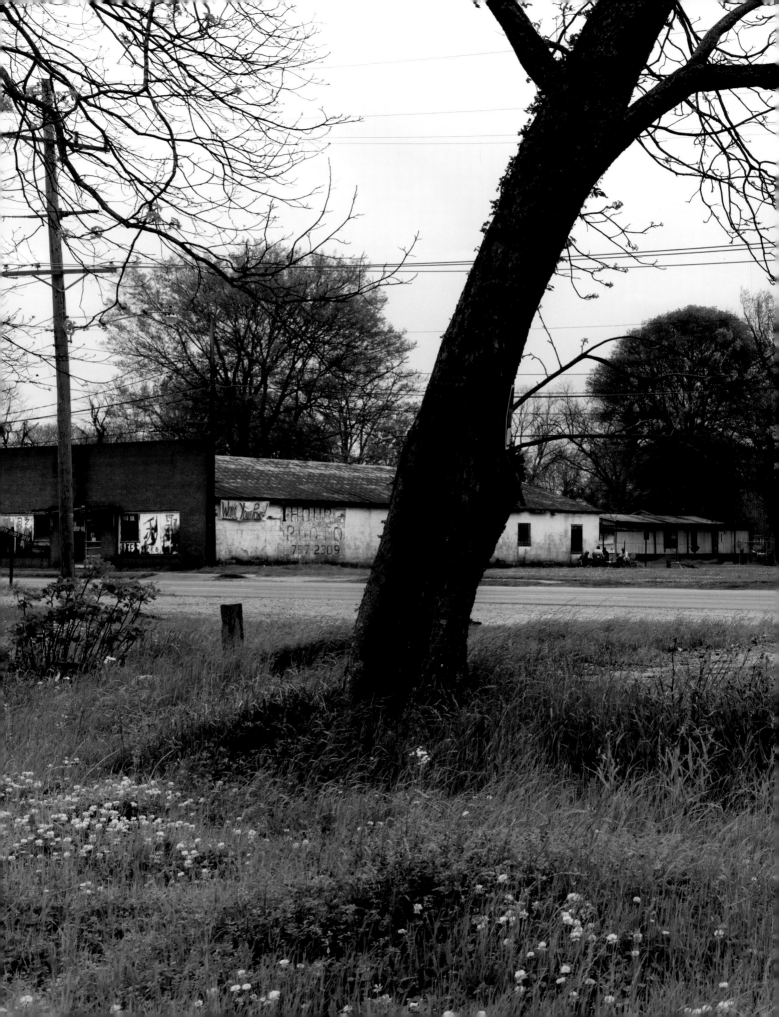

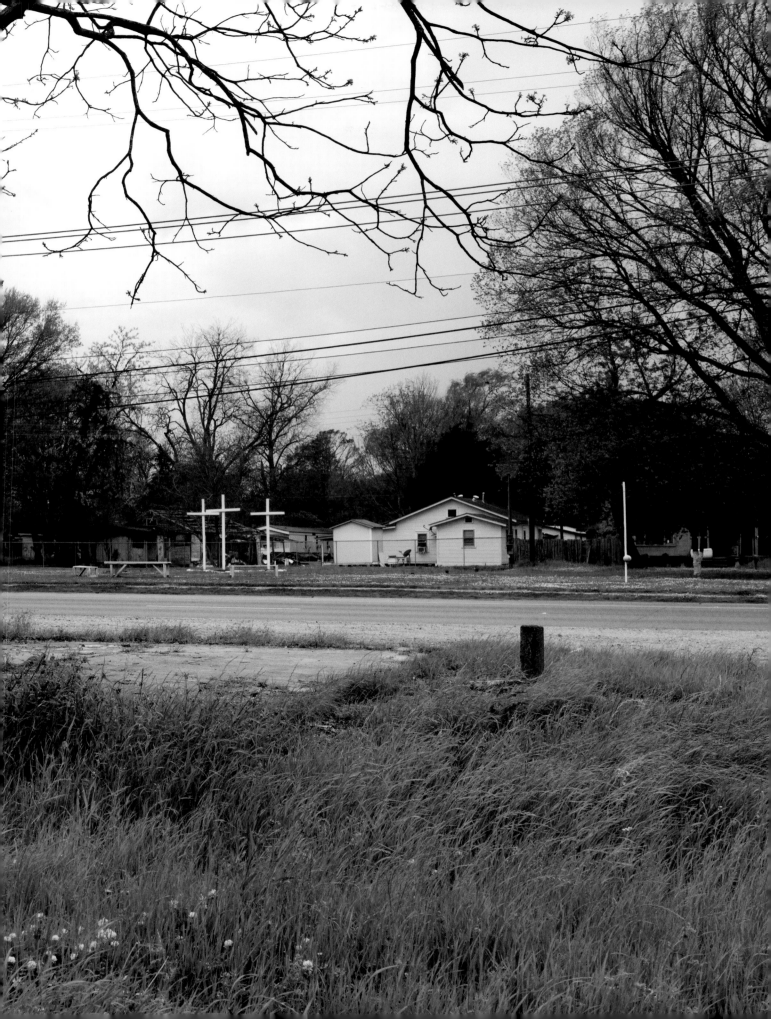

Hand-drawn map with details about the location of Frank Morris's shoe shop, Ferriday, Louisiana, 2007. Courtesy of Stanley Nelson.

china berry TREE

"Tin can Alley"

Alley

Frank's shoe shop

Mr. Spurlock's store cold, cold. Beer

I'm facing the shoe shop

Georgie Boy's Cleaners

Pastime's Grocery (show window)

(show window)

John Lee's Grocery store

Wall's Fish Market

June 11, 2008

Dear Mr. Nelson,

My husband has been telling
me about your articles probing into
the unsolved murder of Frank Morris.
He is the managing partner of a
waste disposal company in Natchez
and subscribes to The Concordia
Sentinel. He brought the May 28th
issue home for me to read. I've read
the article about the klan at least 3
times. Thank you, thank you for
what you are doing! If all of the
wicked, hate crimes could be
taken out of the _secret_ places and
stand in the light, this country
could be healed! You have a
stalwart spirit. One man _can_
and _does_ make a difference.
Know that there are _many_ of us
who join you in your crusade for
justice, if only by reading,
weeping, and praying!

Sincerely,

█████████████████████

Stanley Nelson
Ferriday, Louisiana
May 19, 2011

I'm editor of the *Concordia Sentinel* in Ferriday, Louisiana. Ferriday is a town of around 3,000 people, more or less. It's probably 70 percent black. Back in the 1960s it was probably fifty-fifty white and black. Ferriday was founded around 1900 as a railroad town and later had a sawmill, and it's been a rough time in town since its beginning. This used to be Helena Plantation. Slavery was big along this river, and Reconstruction here was difficult. White people remained in charge. That's changed now, but you know, Ferriday is a town that still has some wounds to heal. I think it's stronger with older blacks—I think that they are somewhat upset that young black people have no idea what they went through in those days. But I think that the coverage we've done over the last four years has opened up discussion. People are talking about it, and I think it's educated both races, as it has me. I had many misconceptions about both races and about that era.

The big jolt in the South was integration of schools. In our school system here, blacks got the secondhand books that came out of the white schools, and secondhand equipment; everything was secondhand or third rate. You know, they were studying books in the '60s that might have been twenty or thirty years old. Most of the Klan members were uneducated, illiterate white men, who with integration and the voting rights act were certainly going to have to compete with blacks. Blacks were always just a little bit lower than they were in their minds. And you know, some people just have to hate.

* * *

The Mississippi Klan was born in Concordia Parish. The Original Knights, particularly as the civil rights movement began, gained a foothold and spread through the state and started recruiting in Mississippi. So that became a realm of the Original Knights that grew into the White Knights, and then later split off into the United Klan. Concordia has always been a place, Natchez too, where you could gamble, you could drink as much as you wanted, and you could find prostitutes anywhere. Since the French came here. Concordia's been considered a wild place. Wide open is the word.

By the 1960s we had a situation here where there was an enormous criminal element that was mob influenced, and we had a sheriff's office with deputies who were either directly involved with the Klan or were right on top of everything that was going on with the Klan. Frank DeLaughter, who was this chief deputy, came to Ferriday in 1956 and was hired as a dispatcher for the police station and as a jailer. Not long after that, he became a Ferriday policeman, and in the early '60s he was hired as a deputy. He was notorious for beating people senseless, taking them to the jail. Tying them up, taking their money, taking their possessions from them. Wouldn't charge them with anything. Just hold them. White people, black people, it did not matter. After he beat you, he typically would say, now go back home or get your ass out of this parish. And if you ever say anything about it you know I'll come after you.

That was the situation in Concordia. It was lawless. There was fear. Fear of the sheriff's office. Fear of the deputies. And you know, I often think about that,

if something happened to my brother or my father or daughter or whoever, and you live in this, who do you go to? There's nobody to go to. You keep your mouth shut.

So when Frank Morris was murdered and all these things started to happen, the FBI came in here, and you read those 302s [interview memos], one after the other: under no circumstances does this person want to be identified, and under no circumstances will he or she testify in court. It was that fear, and it was real.

I was a little suspicious at the beginning of how you could be fearful over something that happened forty years ago. But older people are. There was a widow of a man who was very active in civil rights and he was beaten. Three or four years ago I was talking with her, interested in doing a story. She said, oh no, I do not want a story written. I asked why. She said, oh, those people are still around here, and I live by myself. I didn't argue.

I remember this elderly black man who I met through a friend. I had been trying to get to talk to him. Finally, after a good bit of negotiation he agreed to it. I met him at a location. Got there, and he was just as nervous as he could be. He said his wife just did not want him talking about it. He was sorry. This is about the Joseph Edwards case, and he wouldn't say a word.

I've been threatened, but so far, knocking on wood, nothing has happened. I've had two witnesses who talked to me who were threatened with death. Our publisher got a death threat. Our office was broken into. I've had lots of insinuations about, son, you better watch what you're doing.

* * *

Two years ago I got a call from this lady here in Ferriday, and she said, just what do you think you're doing? I said, what do you mean? She said, this Frank Morris, just day in and day out. And don't you know that things are different now? Just what do you hope to accomplish? I said, well, I hope that we can solve this murder. And she said, you can't do that, you're just a reporter. She hung up the phone.

I just wanted to understand what was going on. In 2007, the Justice Department released a hundred-plus names of people murdered. The publisher walks in the office and she says, last night on TV I heard about this list, and there was a guy from Ferriday on there. So I call the Southern Poverty Law Center and talk to Penny Weaver. She faxed me 150 pages within thirty minutes, and I wrote my first story on Frank Morris within two hours of having heard his name for the first time. I really thought I'd write a story or two, that would be it. The files were all redacted, but I kept reading about how he was burned in a fire and that the fire was purposely set with him in the building.

When I was in high school we were coming back from a football game on the bus and we came across this terrible two-vehicle wreck. There was this man, his wife, and young child in this Volkswagen Beetle. And when that crash happened the car erupted in flames. I watched those people die.

So Frank Morris really hit me. I thought, my God in heaven, how can somebody do that to somebody else on purpose? How do you set somebody on fire? I wanted to know what in the world it must have been like for Frank Morris when he saw those two guys that night. And then I went outside that shop and wanted to know, how in the world do you go to a man's business and just burn everything he owns down and have no regard for his life? I want to understand, how do you do that? I also felt that if the newspaper, and at this newspaper, me, if we didn't try to find out what happened, who would? Nobody else was in a position to do it. And more than that, I felt like it was our responsibility. It would have been immoral to walk away from it. I was just determined.

Most people have no understanding of what it's like for those families to live in this limbo of anguish all these years. It's just impossible to understand. For those families, just to know one person cares, you just can't put a price on what that means. So you can't do this kind of work unless it becomes personal, and maybe it's trying to do something decent with my own life.

* * *

I felt that it was important to put a real face on Frank Morris, because he was admirable. He was a kind of guy you are supposed to embrace in your communities and protect. We had not lifted a finger for Frank. So I wanted people to understand who he was, and you have to write about that a lot to get them over the nervousness of this race issue or anything involving civil rights.

People in the South feel like we're picked on a lot. So when this started back in 2007, they're going, oh God, we're fixing to get blasted again, and my family didn't have anything to do with that. It's a defensive reaction. Some people think, that happened forty years ago, why is it important to figure out what happened? Why bring it up? But as time passed and I began to write more and more, people start asking me questions, white and black. And I think when black people realized that I was going to stay with this, it opened some of them up to me. I could not have done any of this by myself, because I would not have had the resources, time, or the knowledge of knowing where to go. I mean, I'll tell you right now, I'm not the smartest guy in the room, but I'm persistent.

I'm sure that there are some people that still would wish it would go away, but I think people came to respect Frank. I hope we've made them think, what if it was my father? If we don't care about a man who was hardworking, who hired a lot of people, who was patriotic, who gave back to his community, who provided a service that a poor town like Ferriday needed, shoes, who do we embrace, who do we care about? I mean when you had six kids and you were poor and you were making maybe twenty-five dollars a week, you had to keep each one of those kids, if you were lucky, in a pair of shoes. They needed to last. Frank Morris could do that; he was one of the most important people in a lot of families' lives. I heard a lot of women, black and white, say they couldn't have made it without Frank.

There's no statute of limitations on justice ever. You just got to go after the people that did that to him.

I carry this letter in my wallet dated June 11, 2008:

> Dear Mr. Nelson, my husband has been telling me about your articles probing into the unsolved murder of Frank Morris. He is the managing partner of a waste disposal company in Natchez and subscribes to the *Concordia Sentinel*. He brought the May 28th issue home for me to read. I've read the article about the Klan at least three times. Thank you, thank you for what you are doing. If all of the wicked hate crimes could be taken out of the secret places and stand in the light, this country could be healed. You have a stalwart spirit. One man can and does make a difference. Know that there are many of us who join you in your crusade for justice, if only by reading, weeping, and praying. Sincerely,

And it's a lady from Natchez. It makes me know that people out there that are normally silent really do care, and that this person is a white person makes me think the stories are working. This is a potential juror.

If you can get people to face a serious social issue as well as a serious criminal issue and get people to start talking about it, I think it changes your community, and it changes the perspective. If people can look and see how much better we could be if we go back and face the issue, whether anybody's convicted or not. Sometimes in your life you know when something is really important, and you know that you are probably going to have to sacrifice something to get through it. You're also dealing with very difficult crimes

where there's very little evidence left, where the FBI penetrated somewhat but walked away without really knowing what went down. It's hard to solve a murder. It's really hard to solve a murder that's four decades old.

I sincerely wanted to find out what happened to Frank Morris, and if anybody was still around, I thought they should pay. But there was something deep in me personally—I wanted to understand how human beings can be that way to one another: the people that pick on somebody because they can. Because they know they can get away with it. Because they're hateful, disgusting human beings who have something really deeply wrong with them.

The first thing I ever heard about the Silver Dollar Group was in Don Whitehead's book *Attack on Terror: The FBI Against the Ku Klux Klan in Mississippi*. He reported that the Silver Dollar Group was formed at the Shamrock Motel in Vidalia, Louisiana, at a time when the Mississippi Klan had ordered a moratorium on violence because the FBI was so embedded in Mississippi at the time.

So over coffee, they're talking, and according to Whitehead, one of them says, well, you know, the hell with the FBI, I'm not afraid. If I want to go out, his words, and kill a nigger, I'll do it. If I want to kill a FBI agent, whatever I want to do, by God, we're not going to have integration, we're not going to have civil rights. They were frustrated with their local Klan, with the Original Knights, the White Knights, the United Klan, because they didn't think they were being violent enough. They hated the White Knight moratorium on vio-

lence. So supposedly their idea was we'll just form our group and we'll do this stuff.

Through the Freedom of Information Act, we were able to get the Wharlest Jackson file, the investigation called Wharbomb; it was through Wharbomb that the Silver Dollar Group was really exposed. Not all the Silver Dollar Group guys were involved in murders, but most of them were involved in beatings and wrecking crew action. Most of the murders didn't start out to be a murder. I think Joseph Edwards started out as a beating to teach him a lesson, probably run him out of the parish, that went too far. Frank Morris probably was intended to be an arson only. They didn't think he was going to be there, but once they saw him there they didn't stop, because they were into it and they couldn't stop. Dee and Moore, it got out of hand. Earl Hodges probably went too far. Very few that you find, like the three civil rights workers in Mississippi, began as premeditated murder.

We had a real problem in Concordia Parish because the sheriff's office was corrupt, and the Klan operated with impunity and did whatever they wanted to. While the FBI was trying to solve these crimes, it was imperative they neutralize the violent Klansmen however they could. So the FBI brought in these enormous numbers of agents and began these day-to-day surveillances, nighttime surveillances. I entered this really skeptical of the FBI, but I can tell you that these were good investigations. They were also fighting a lot of local people. Over here, they were fighting all the established police force, basically.

The documents also reveal that James Ford Seale, who killed Henry Dee and Charles Moore, admitted to being in the Silver Dollar Group to the FBI, to having attended this meeting in Concordia Parish in June of 1965. The only meeting where there were members from both sides of the river and were more than three or four at one time. They all met at this fish fry in Concordia, where they planned the George Metcalf bombing and where they experimented with explosives. So Seale admits to having been at that fish fry but says he doesn't remember anything about explosives being experimented with.

All this information's obviously in FBI records somewhere. Through the Freedom of Information Act, the files they give out are often so redacted that it's sometimes really hard to decipher. All of the informants are not named, but I was able to figure out, I would say, 60 or 70 percent of the informants by process of elimination. I read thousands of pages; by the time you start reading like the fifth time, stuff starts coming to you.

What is the FBI doing? I can't answer that, because I truly don't know. I occasionally will see their tracks somewhere, but I don't know, they won't talk about it. This transparency is not that transparent. You know, there's a frustration, for instance, with the Frank Morris case, which has now had three case agents, all of them good people. Once they get to kind of learning the case, they transfer them somewhere else. There's no continuity. They'll get fighting mad with you if you bring up stuff like this, but there is no continuity. If it were me, I'd put two or three agents down here and work on all of

these cases here, and that would be all they do. The FBI is big enough; they've got the money to do it. I don't know why they made their decisions. I don't know what they know. It's a lot easier to write a story with people saying things—it's a whole different ballgame when you have to prove it in court.

* * *

When I learned about Leonard Spencer, the suspect in the Frank Morris case, I went to see him one afternoon. One thing I wanted to talk to him about was Coonie Poissot, because the witnesses that I talked to said that Poissot was also involved. So I wanted to talk to him about it, just to start talking. I like to go slowly. He lives at the end of the road, in this rural parish, Richland Parish, in the middle of a cornfield. He came out, set on the porch, and denied ever hearing the name Coonie Poissot before, but his son and daughter said Coonie was like their grandfather. He denied any knowledge of the Frank Morris murder, had never heard of it before. But we did spend a good bit of time talking about the Klan and how wrecking crews operated.

Wrecking crews were part of the Original Knights. They were the secret hit squads appointed by the leadership of the local Klaverns. They rarely did a job in their own area. Typically, they would be asked by an outside Klan to come and do a job, so local people wouldn't recognize them. So the Original Knights, the White Knights, all of them, had a form of a wrecking crew.

You didn't know what you're going to do until somebody came and told you, and it would be, tonight you go do this, or tomorrow night you're going to go

do that. You may not have had any idea of why this is being done to the person who'd been targeted. You just did it, and it would range from burning crosses, to burning buildings, to extermination. All of the Silver Dollar Group guys had a wrecking crew experience.

You can talk to ordinary, general membership Klansmen who joined for political reasons and got out when it got violent. They don't know anything about wrecking crews or who was on them. The wrecking crews were very secretive. When they were chosen, they were told, if you ever talk about it, we'll kill you. Somebody will kill you.

So Leonard Spencer denied knowing anything about this guy named Coonie or knowing anything about Frank Morris's murder. I attempted to call him again but couldn't get him on the phone. Finally got him one day, and he told me to leave him alone. He didn't have anything else to say, and I said, well, listen I want to talk to you about some accusations that have been made, and he said, if somebody got something to say to me they know where I live. That's the last time I talked to him.

One thing I knew from being in journalism, and here for so long, is that cops know everything. They just know everything, hear everything. So I decided I was going to try to locate every living cop I could find from Concordia in the '60s, '70s, and '80s. I figured it was a good start but would be really hard and take a lot of time. I made a list and started calling. Last spring, I call Bill Frazier. I tell him who I am. I know who you are, he says. Said, you've been writing about Frank Morris. Yeah, I

said, I just wondered if you knew any-
thing about it. And he says, as a matter
of fact I do, and commences to tell me
this story about having worked on a
pipeline with his brother-in-law at the
time, Leonard Spencer, and talking to
him about the Klan. Frazier says, I just
asked him, did y'all ever kill anybody?
And Spencer said, yeah, we did acci-
dentally one time. We went to Ferriday
and burned this shop down.

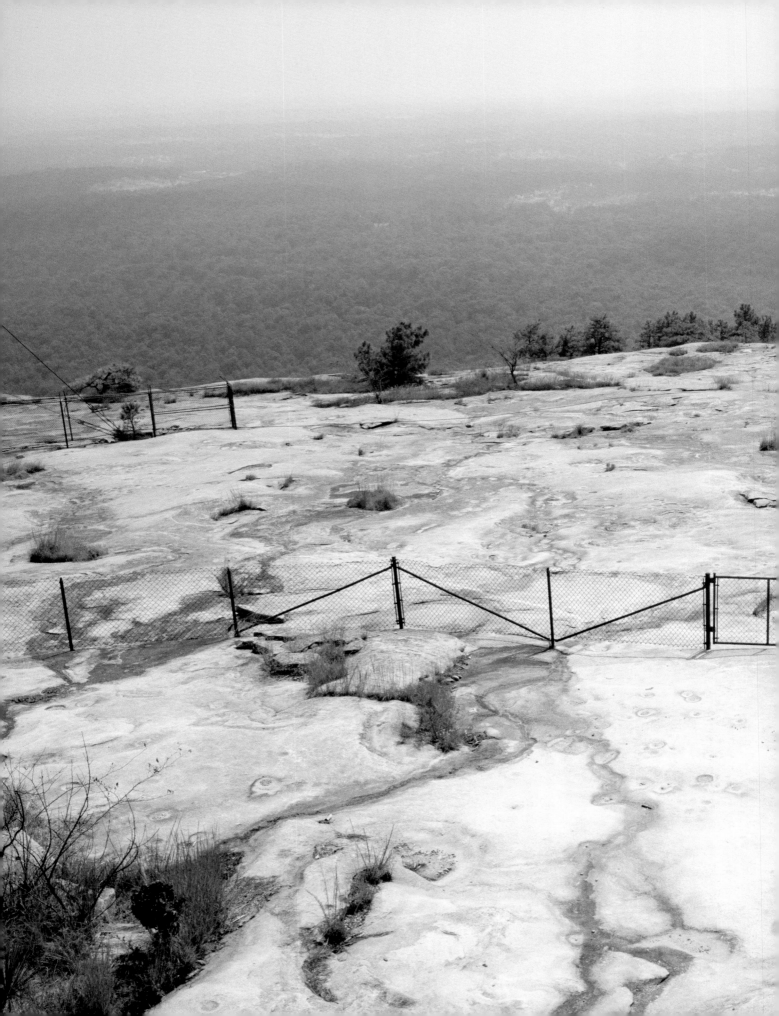

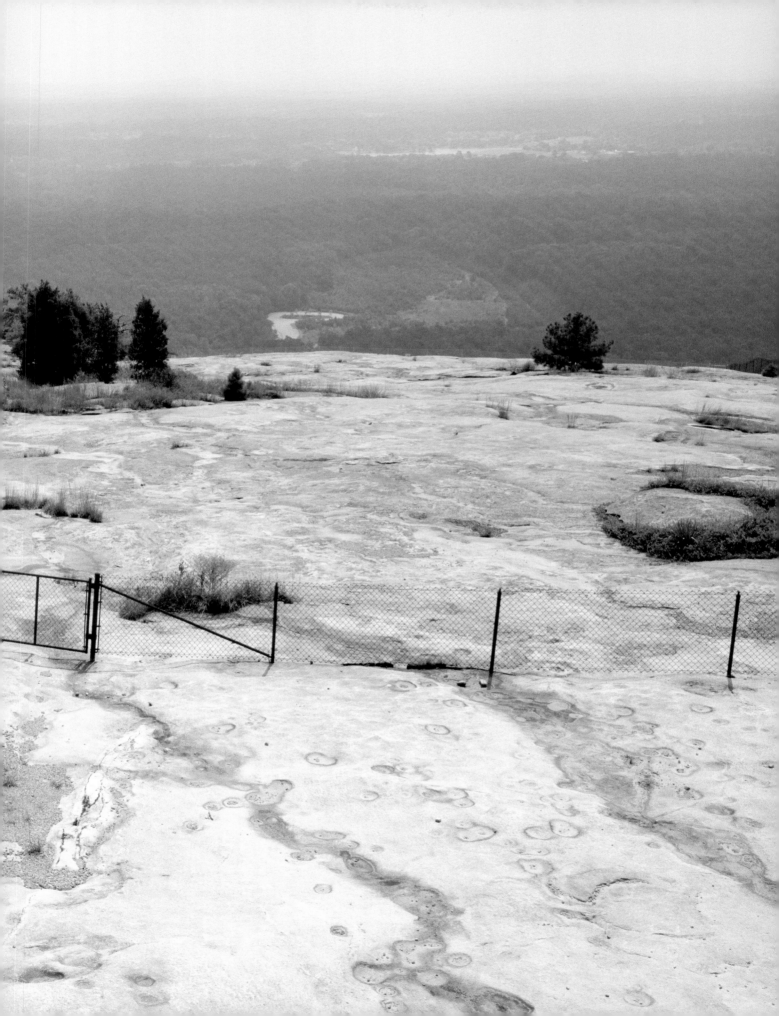

Inspired by D. W. Griffith's *The Birth of a Nation* and following Leo Frank's conviction and subsequent lynching for Mary Phagan's murder, William J. Simmons and the Knights of Mary Phagan inaugurated a second incarnation of the Ku Klux Klan on November 25, 1915, by burning a cross on top of **Stone Mountain** in Georgia. The Venable family purchased the property in 1887 and granted the Klan a perpetual easement that enabled them to hold events there, including an annual Labor Day cross burning that endured into the 1960s. Martin Luther King Jr. included Stone Mountain in his "I Have a Dream" speech: "Let freedom ring from Stone Mountain of Georgia."

Gutzon Borglum, who would go on to create Mount Rushmore, was an active member of the Ku Klux Klan when he began his carving on Stone Mountain in 1923. Borglum's work was destroyed after he got into a dispute with the Stone Mountain Confederate Monumental Association, and a new carving was begun by Augustus Lukeman. In 1928, work was suspended on the monument, and it remained uncompleted for thirty-six years. In 1958 the state of Georgia bought the property and condemned it to remove the easement, and in 1963, Walker Hancock was hired to complete the carving. The monument, which depicts Stonewall Jackson, Robert E. Lee, and Jefferson Davis, was dedicated in 1970.

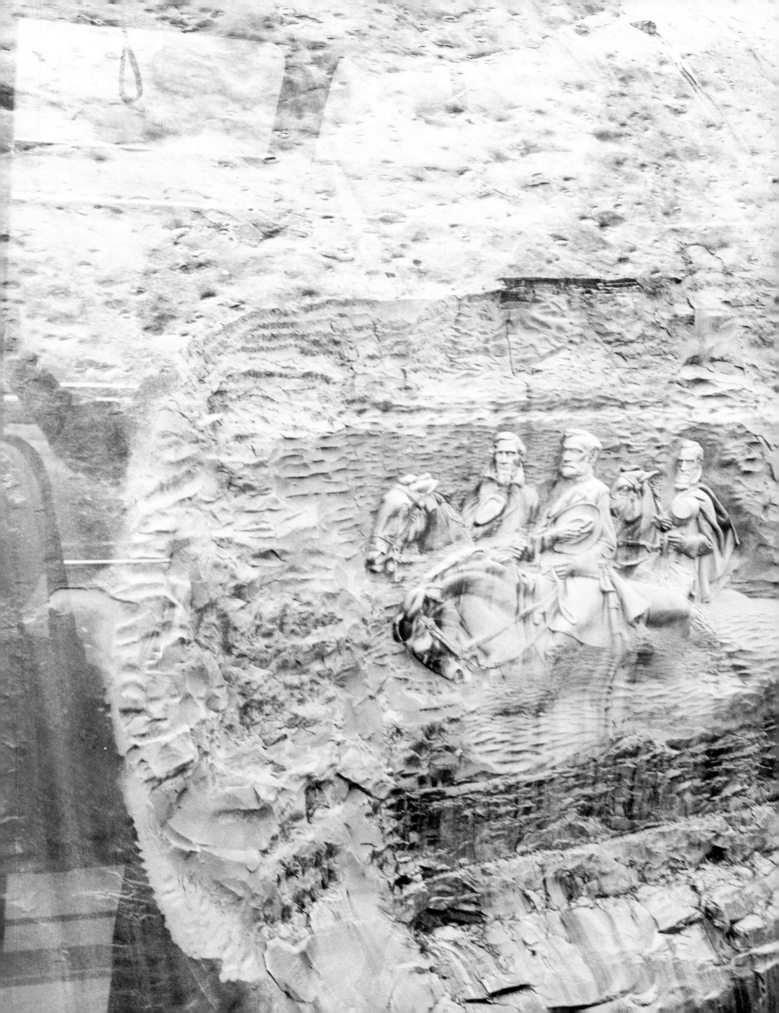

Koinonia Farm was founded in 1942 in Americus, Georgia, by Florence and Clarence Jordan and Mabel and Martin England as an interracial community where people could live and work together. During the civil rights movement, neither black nor white children in Koinonia were allowed to attend segregated schools. Koinonia withstood firebombing, night riding, Klan intimidation, and economic boycotts and still exists today as an interracial community dedicated to affordable housing for all. Habitat for Humanity was founded at Koinonia in the 1960s as a response to poverty in the rural American South.

Bridge to Freedom Memorial Park sign, Selma, Alabama, 2005.

On Sunday, March 7, 1965, approximately 500 nonviolent protestors led by John Lewis and Hosea Williams gathered at the **Edmund Pettus Bridge** in Selma, Alabama, to march to the state capitol in Montgomery in protest of the general nullification of the 15th Amendment and the laws and violence that kept African Americans from voting.

They marched in honor of Jimmie Lee Jackson, a twenty-six-year-old black veteran who was murdered on February 18, 1965, by state trooper James Bonard Fowler. Jackson had been protecting his mother, Viola, from violent state troopers during a civil rights protest in Marion, Alabama. (Fowler was charged with murder in 2007 and pled guilty to misdemeanor manslaughter in 2010. He was sentenced to six months but was released after five for health reasons. He died in 2015.)

Alabama police brutally attacked the marchers, and ABC News interrupted the network's broadcast of the television premiere of *Judgment at Nuremberg*—a Hollywood drama about the Justice Trial of 1947, during which Nazi leaders were prosecuted in international court for war crimes and crimes against humanity—to air footage of the marchers in Selma being beaten in what became known as "Bloody Sunday."

On March 9, Dr. Martin Luther King Jr. led approximately 2,000 people, including hundreds of clergy, to the Edmund Pettus Bridge, where they knelt and prayed but did not march. That night, James Reeb, a white thirty-eight-year-old Unitarian minister from Boston who had come to Selma for the march, was beaten to death by Klansmen in downtown Selma. President Lyndon Johnson spoke out: "There is no issue of States' rights or national rights. There is only the struggle for human rights. . . . We have already waited a hundred years and more, and the time for waiting is gone."

Marchers were granted a permit and federal protection to march, and on March 21 approximately 3,200 people left Selma for Montgomery, a number that grew to 25,000 as the group reached Montgomery on March 25. The protest led to passage of the Voting Rights Act of 1965, guaranteeing the right to vote to every American over the age of twenty-one.

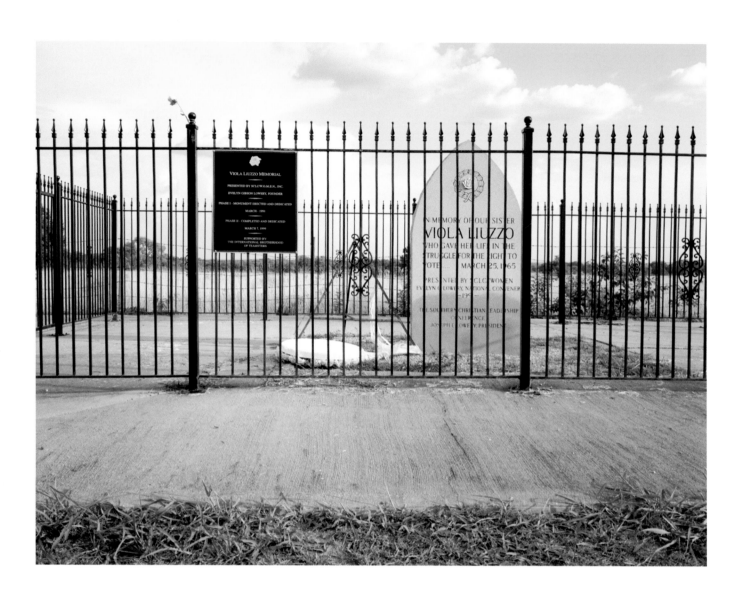

Viola Gregg Liuzzo, a white thirty-nine-year-old mother of five and member of the Detroit NAACP, drove from Detroit to Selma to participate in the marches in response to Dr. King's call, after she watched footage of Bloody Sunday on television. On March 25, 1965, she was driving marchers between Selma and Montgomery with Leroy Moten, a nineteen-year-old African American from Selma, when a car of Klansmen chased them and fired into her car, killing Liuzzo. Though Moten was covered in her blood, he was unharmed. He survived by pretending to be dead when the Klansmen approached the car.

Eugene Thomas, William Orville Eaton, Collie LeRoy Wilkins Jr., and Gary Rowe Jr. were the four Klansmen in the car. Rowe was a paid FBI informant. Wilkins was tried in Alabama state court twice, with the first trial ending in a hung jury and the second in an acquittal.

In December 1965 the Department of Justice then brought federal charges of conspiracy to violate Liuzzo's civil rights against Thomas, Eaton, and Wilkins, using Rowe's testimony. The charges did not specifically include Liuzzo's murder. (At the time, only state courts were able to bring murder charges as there was no federal murder statute.) The three men were given the maximum sentence, ten years in prison.

Liuzzo's family endured harassment and death threats in Detroit after her death, and FBI Director J. Edgar Hoover launched a smear campaign again Liuzzo, accusing her of drug use and a sexual relationship with Moten, in order to distract from the fact that the FBI informant in the Klansmen's car, Gary Rowe, may have been involved in the murder.

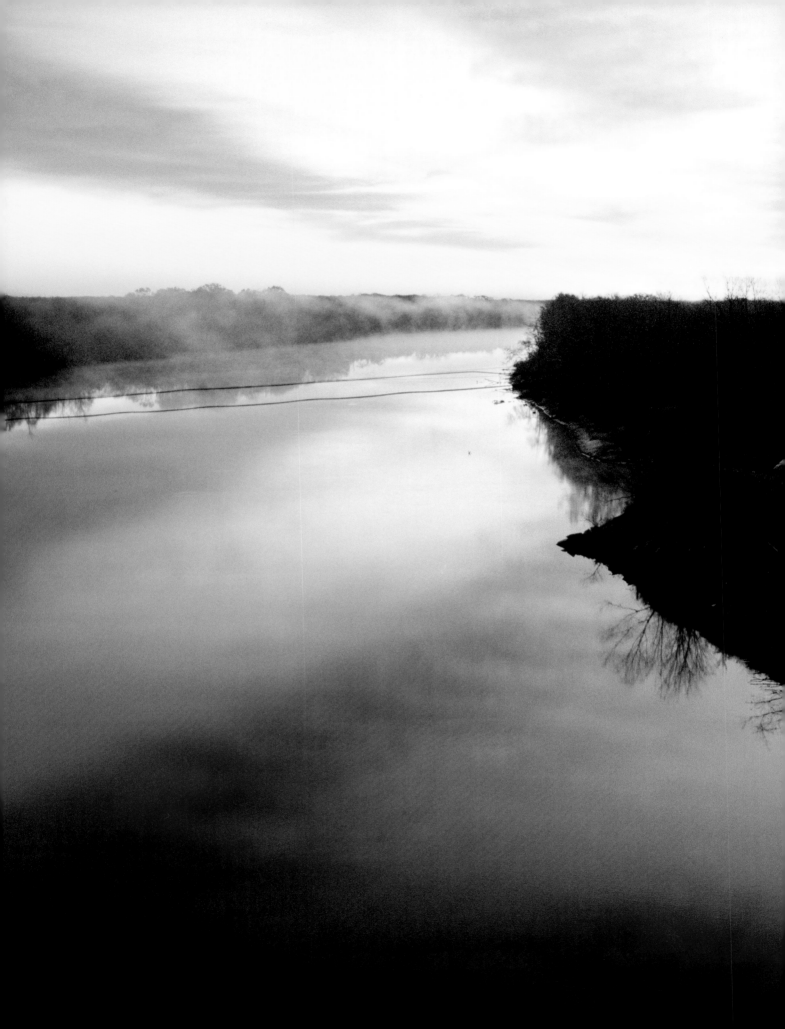

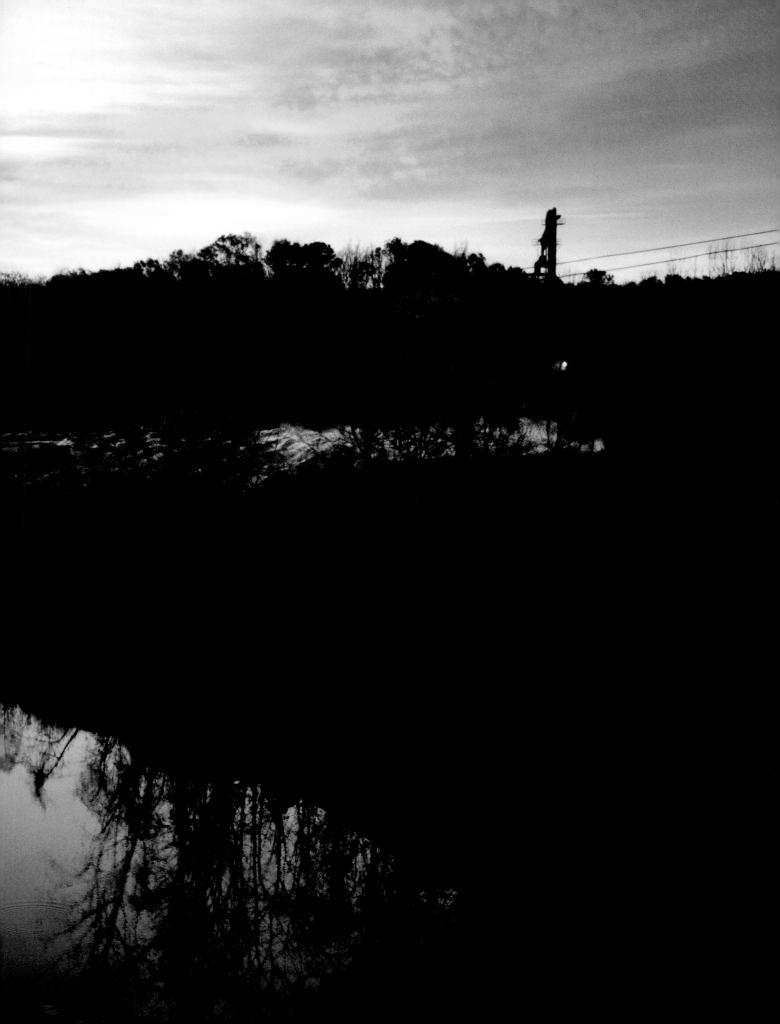

s Hunted In C

ole Here Now

hurch Debris;
U.S. Believes

Teen-Agers Held n Pistol Slaying f Boy On Bicycle

vo Birmingham area teen-agers were arrested last n connection with the Sunday afternoon fatal g of a 13-year-old Negro boy in Sandusky he slain boy, Virgil Ware, lived at 236 DeKalb-st, ky

fferson County Sheriff Melvin Bailey identified ects as Michael Lee 16, 1128 Skyline-dr, ky, and Larry Joe 6, 1224 Forestdale-

Make Statement

ng to Sheriff Bailey, the ects made the following t to arresting officers:

ere riding on our motor- esterday, Sept. 15, in the of Docena-rd and San-

Negroes OK Capitol Trek

To Take Wreath To Governor

A standing vote of almost 500

Troopers, City Police Ring Area

Negroes Plan 'Direct' Appeal To Kennedy

A fire bomb was tossed from a speeding car last night at 12:30 a.m. at a store in the predomi- nantly Negro section on Sixth- av and Beta Street but failed to explode, police said. The home- made bomb hit the sidewalk in front of the store but it failed to burst. Police reported that it was filled with gasoline.

* * *

BY LILLIAN FOSCUE

City police and bombing experts brought in by the

Thirteen-year-old **Virgil Ware** of Pratt City, Alabama, on the outskirts of Birmingham, was murdered on September 15, 1963, while riding on the handlebars of his sixteen-year-old brother James's bicycle near their home. Ware was shot twice by Larry Joe Sims, who passed them on a motorbike driven by Michael Lee Farley. Sims and Farley, both sixteen years old, had just attended a segregationist rally. They were charged with first-degree murder, but an all-white jury convicted them on the lesser charge of second-degree manslaughter. Judge Wallace Gibson suspended the boys' sentences and gave them two years' probation. In 1997, Michael Lee Farley called the Ware family to apologize; Sims called them in 2003. In 2004, a sign with Virgil Ware's name was erected on the street where he grew up.

A sixteen-year-old boy named Johnny Robinson was also murdered on September 15, when a Birmingham police officer, Jack Parker, shot him in the back with a shotgun. No charges were brought against Parker, who died in 1977.

On that same day, Birmingham's 16th Street Baptist Church was bombed, killing four little girls, all African American: Addie Mae Collins, Denise McNair, Carole Robertson, and Cynthia Wesley. The church was in the center of the city and had been at the heart of civil rights activities that year, as the meeting place for the leaders of the Southern Christian Leadership Conference's Children's Crusade, which took place in May, and for activists fighting for school integration, which had just happened the week before.

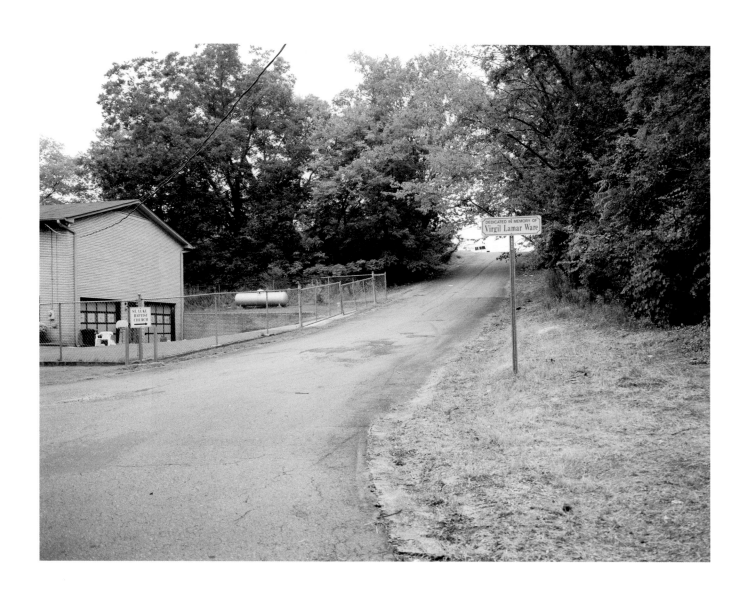

Vernon Dahmer was murdered on January 10, 1966, in Kelly Settlement, outside Hattiesburg, Mississippi, when Klansmen firebombed his home and attached store. Dahmer was the president of the NAACP chapter in Hattiesburg and a leader in the Student Nonviolent Coordinating Committee. Dahmer led the local fight for voting rights and helped black voters in Forrest County by letting them pay their poll taxes at his store. He was often quoted as saying, "If you don't vote, you don't count." On January 9, 1966, he offered to pay black voters' poll taxes on the radio. The next day his home and store were bombed.

Four of Dahmer's sons were serving in the armed forces and had a protective escort from the airport when they returned for their father's funeral. Fourteen men were arrested in the late 1960s, resulting in several convictions. Samuel Bowers, Imperial Wizard of the White Knights of Mississippi, and another Klansman were released with hung juries. Bowers, who had served six years in prison for civil rights violations in relation to the murders of civil rights workers James Chaney, Andrew Goodman, and Michael Schwerner, was retried in 1991 and sentenced to life in prison in 1998 for ordering the murder of Vernon Dahmer. Bowers died in prison in 2006.

Jerry Mitchell, investigative reporter for the *Clarion-Ledger* in Jackson, Mississippi, was instrumental in proving Bower's involvement in the murder.

Dahmer's wife, Ellie, erected a memorial on the site of the house and store with bottles that were found in the wreckage.

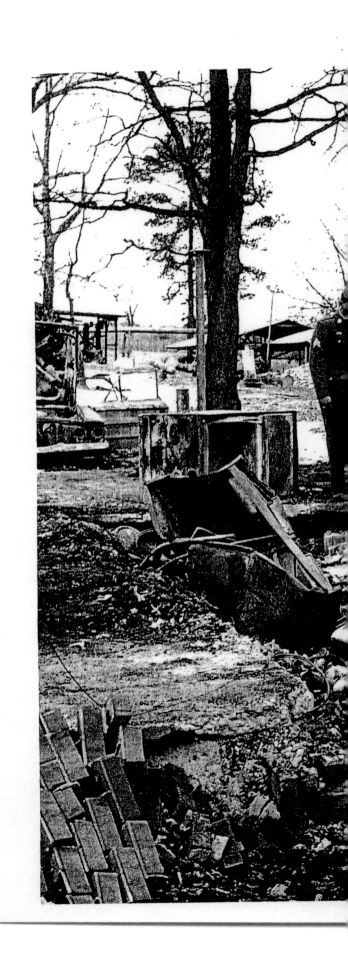

Vernon Dahmer's sons a few days after
the bombing, Kelly Settlement, Hattiesburg,
Mississippi, January 1966.

Vernon Dahmer's Son's A few days after the fire bombing

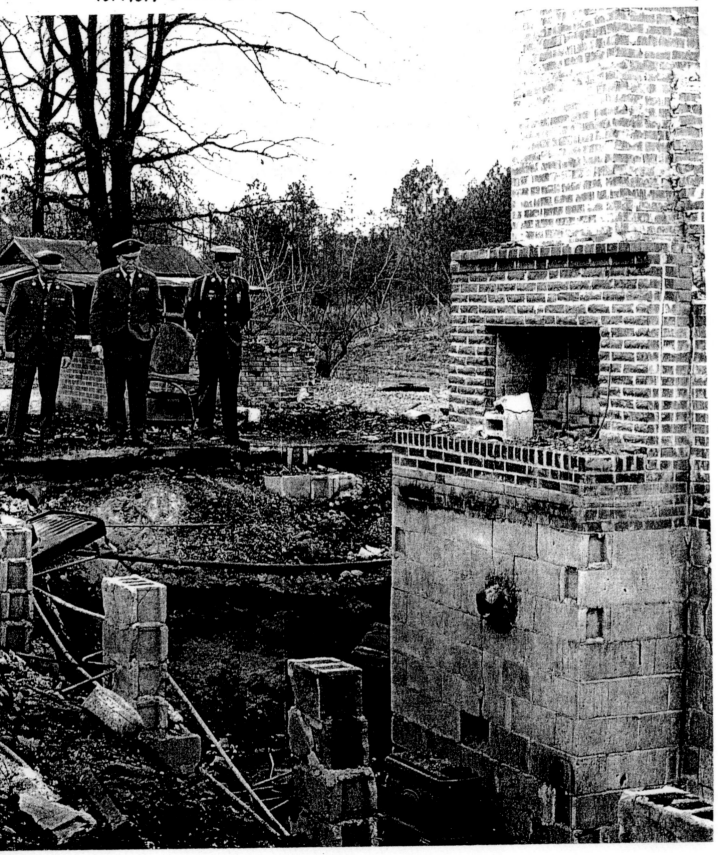

Left to Right

Sgt. George W. Dahmer, U.S. Army

Staff Sgt. Martinez A. Dahmer, U.S. Air Force (deceased)

Master Sgt. Vernon F. Dahmer, Jr., U.S. Air Force

Specialist 4 Class Alvin H. Dahmer, U.S. Army

WESTERN UNION

TELEGRAM

W. P. MARSHALL, PRESIDENT

(48).

1201 (4-60)

The filing time shown in the date line on domestic telegrams is LOCAL TIME at point of origin. Time of receipt is LOCAL TIME at point of destination

1966 JAN 11 PM 12 24

NSA044 AD167 NS

EST=

A WA145 DL PD=WUX THE WHITE HOUSE WASHINGTON DC 11 1140A

MRS VERNON DAHMER=

No. 25391

KELLY SETTLEMENT HATTIESBURG MISS=

da -12371P

MAY I EXPRESS MY DEEP CONCERN AND SHOCK ON THE DEATH OF
YOUR HUSBAND. HIS WORK WAS IN THE BEST TRADITION OF A
DEMOCRACY--HELPING HIS FELLOW CITIZENS REGISTER AND VOTE.
HIS FAMILY CAN BE JUSTLY PROUD AS HIS WORK WAS A FINE
EXAMPLE OF GOOD CITIZENSHIP.

=IT IS MY HOPE THAT YOUR FAITH AND THE SUPPORT OF YOUR
FAMILY AND LOVED ONES WILL ASSIST YOU IN THIS TIME OF
GREAT NEED.=

MRS. JOHNSON JOINS ME IN EXPRESSING OUR DEEP SYMPATHY=

LYNDON B JOHNSON=(

MEMORIAL REFLECTIONS

Vernon Ferdinand Dahmer, son of George
and Ellen Dahmer, was born in Forrest
County, Mississippi, on March 10, 1908.
His life was dedicated to the cause of
freedom. He was killed in action Jan-
uary 10, 1966.

His sacrifice on the altar of freedom
should inspire us to finish the task.

```
***********
*******
***
*
```

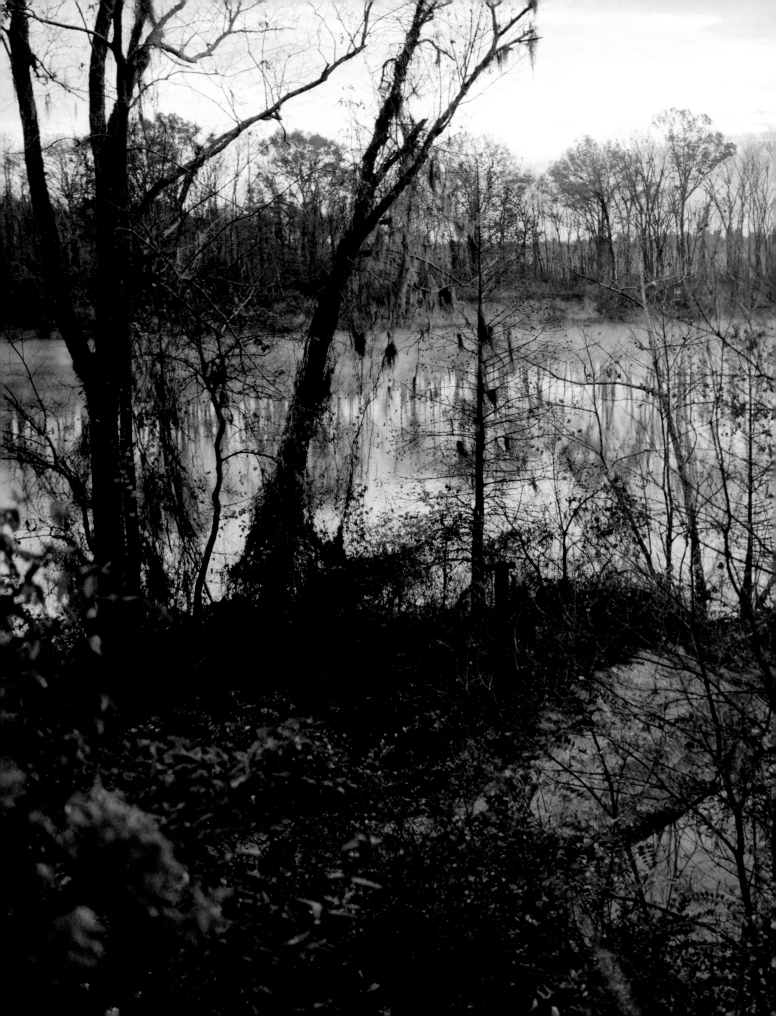

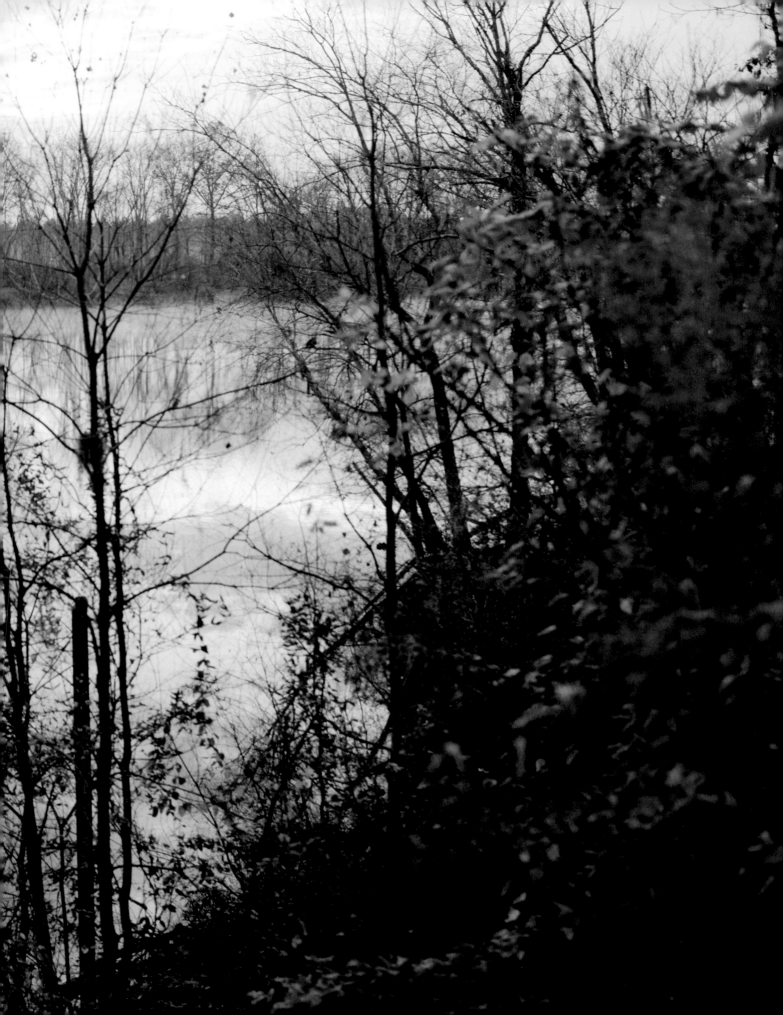

Afterword

This body of work began in the summer of 2002, when my cousin Andrew and I drove from the small town of Vernon, Alabama, where my extended family lives, to Montgomery, where my mother, Juliet, and paternal grandfather, Daddy Van, were born. I had never been there before, though I spent time every summer with my family in the rural northwest part of the state. My grandfather, a prominent southern preacher who worked mostly in Alabama, Georgia, Tennessee, and Florida, preached in Montgomery at a white church at the same time Martin Luther King Jr. was preaching in a black church there; he remembered waving to him while they were both in neighboring congregants' yards. Andrew and I were there so he could break up with his girlfriend. He dropped me off downtown, and I wandered around in the summer heat. I went exploring, making photographs, until I found myself in Court Square facing an ornate fountain and a historical marker. The marker, erected in 2001, read:

The city's slave market was at the Artesian Basin (Court Square). Slaves of all ages were auctioned, along with land and livestock, standing in line to be inspected. Public posters advertised sales and included gender, approximate age, first name (slaves did not have last names), skill, price, complexion and owner's name. In the 1850s, able field hands brought $1,500; skilled artisans $3,000. In 1859, the city had seven auctioneers and four slave depots: one at Market Street (Dexter Avenue) and Lawrence, another at the corner of Perry and Monroe, and two on Market between Lawrence and McDonough.

When I was in front of that Court Square marker, I was struck with the understanding of what it means to erase histories, and curious about what it then means for those histories to reemerge in a collective consciousness through historical markers. This marker was new. Had it not been there I would not have known that I was standing on the site where enslaved people were once sold and traded.

The language on a marker can never fully describe what happened there. How could it? It did make me want to know more. In college, I studied photography and political science, with a focus in constitutional law and civil liberties. In my classes, I found myself most compelled by the stories that led to the case I was studying, and I realized that being an artist would let me explore the histories and stories that lead to change, that speak to moments of power, personal or community transformation, and the genuine complexity of individual and community experience. When I visited Montgomery with Andrew, I was in graduate school studying photography, and I started thinking about the function of markers and memorials—how they facilitated encounters with significant and painful histories. Later, as part of my research on markers and memorials, I traveled extensively, stopping at roadside markers and visiting memorials, including the Oklahoma City bombing memorial, the Sitting Bull memorial, and Kelly Ingram Park in Birmingham.

In Kelly Ingram Park, sculptures of lunging attack dogs and high-pressure water hoses, familiar from the media images of the police response to demonstrators in Birmingham during the civil rights movement, infringe on the sidewalk. There I found that I was compelled to uncover what was left out of the dominant narratives of the civil rights era—what events were unmarked, uncommemorated. I asked myself, *What do I not know because it wasn't included in my education of civil rights or in iconic images from the time? What else was there besides sit-ins, protests, and marches centered on figures like Rosa Parks and Martin Luther King Jr.?* I began answering these questions for myself in 2005, when I started traveling to collect research, photograph sites, and record oral histories about civil rights–era atrocities and resistance outside the narratives I knew.

My mission with *Road Through Midnight* is to reframe these rivers, fields, and homes as markers of struggle. I was driven to do this project because I wanted to emphasize the resistance to oppression that took place outside of the downtowns and city centers—away from the eyes of reporters—and the retaliatory, systematic, and often state-sanctioned violence that occurred in response.

I have been asked why I do this work and if, as a white artist, I am allowed to do it. My answer is that I do not believe those who have been systematically oppressed bear the sole responsibility for acknowledging that oppression. I am also responsible for recognizing and naming the many forms of violence perpetrated by racist white people, Klan members as well as government actors, bent on oppressing black people and upholding the enforced racial segregation of Jim Crow in the American South. I am from the South, though I am careful to distinguish these acts as not relegated to the South. Civil rights abuses, lynching, and Klan activities were occurring around the country. But this book *is* a southern story.

* * *

There are many roads to Midnight. This book takes the reader on a journey through the southern landscape. The photographs are combined with texts that detail resistance to racist violence and systematic racism, foregrounding its victims. Focusing on the black victims of violence is a purposeful inversion of the headlines from the time, which often focused on the motivations and acquittals of white perpetrators. Throughout my research, I noted that investigative files often centered on whether the person murdered was active in the civil rights movement or if there was a direct or indirect reference to his or her sexual behavior—a shallow search for motive, highlighting the victim's possible actions instead of the perpetrator's violent racism.

In Pulaski, Tennessee, not far from where I grew up in Nashville, I photographed the law office where the Ku Klux Klan was founded in 1865. The original historical marker on the building has been unbolted, flipped around, and reattached so that only the marker's back is visible. I visited Money, Mississippi, and the banks of the Tallahatchie River where, in 1955, fourteen-year-old Emmett Till's disfigured body was found weighed down by a cotton-gin fan. I traveled to the Armstrong Tire and Rubber Company in Natchez, Mississippi, where Wharlest Jackson worked—in 1967, on the day that he received a promotion to a job that had formerly been reserved for white employees, he was murdered by a car bomb—and to Ringgold, Georgia, to the site where Mattie Green was murdered in her home by a bomb in 1960.

I returned often to visit sites, as I still do, to pay respects and see how places had changed over time, and I found that the physical signs themselves were mutable and unstable. In Selma, the "Bridge to Freedom" sign changed from a lovely hand-painted marker at the Edmund Pettus Bridge (named after the Confederate general, U.S. senator, and Klansman) to several substantial stone monuments honoring Bloody Sunday, and specifically marchers Marie Foster, Amelia Robinson, Hosea Williams Sr., and John Lewis. Another crossing of the Alabama River, at the Tyler-Goodwin Bridge, where Willie Edwards was murdered by Klan members in 1957, has no marker. The remains of the bridge are located at the dead end of a private road, shrouded by overgrowth. Only the vestige of a bridge marker was visible, and a stop sign marking the end of the road. I wasn't comfortable going there to photograph, and it took multiple trips over several years to make a satisfactory image. The first couple of times my car was chased by dogs. On one of my next trips, I threw Krystal burgers and Goldfish crackers out the car window to distract them so that I could get out of the car and take a quick photograph. With each visit, the foliage changed with the season, and the stop sign became more and more riddled by bullet holes until, eventually, it was gone.

Bryant's Grocery in Money, Mississippi, the site of the events that led to Emmett Till's murder, is now a collapsing shell of a building. In 2011, the Mississippi Freedom Trail organization placed a historical marker there. Since then, the front of the marker has been repeatedly defaced, the words gouged out with a blunt tool, and the vinyl text and photographs on the reverse peeled off, leaving an empty plaque. The sign at the site where Till's body was found on the bank of the Tallahatchie River is pierced with bullet holes. People continue to actively engage with these markers, in some cases literally erasing them.

When I first drove to Money, I stopped at a gas station to get directions to Bryant's store. As soon as I walked in, everyone turned around and looked at me, and I could feel the collective decision, from both black and white folks, to misdirect me. I understood and admired their resistance to an outsider with a camera. As I walked out to return to my car, a white woman came out and yelled across the parking lot, "What do you want?" I replied that they all knew what I wanted and that I wasn't interested in yelling about it across a parking lot. We walked toward each other, and she asked where I was from. When I told her Nashville, she said that the way they saw it, I was from the North, and they were from the South, and they'd prefer it if I went back to where I came from. I was surprised and asked, "You think Nashville is the North? Why do you want me to go back where I came from?" She explained that people there continue to feel exposed and misrepresented. We started to talk about my research and about her work hosting romance parties. Eventually, we reached some tacit understanding of each other, and she offered to take me to Bryant's. I asked for directions instead. When she asked me if I wanted to go by dirt road or paved, I chose paved.

I returned to Money over the years, not yet happy with any of the images I'd taken. On a visit around 2007, I approached the bank of the Tallahatchie River with a sense of disquiet, and I felt that the photograph was there. As I walked back to my car, a white man pulled off the road and asked me what I

was doing. I was alone and felt vulnerable being approached in this way and asked why he'd pulled over. He offered to sell me some bricks from the crumbling store.

In 2005, I pulled into Midnight, Mississippi, the hometown of Rainey Pool, who was murdered nearby in 1970. I was greeted by a homemade sign welcoming me. There were two boys in the road with their bicycles. It was quiet. In the relative calm of this scene, watching these two boys play, I thought about the vulnerability of black bodies in this country and in the context of this specific place. What does it mean to be disappeared from a place like Midnight? How are the reverberations of systemic violence—the direct involvement of law enforcement, the intervention of a state-supported segregationist spy agency, the failure of the justice system—felt? And what does it mean, in the face of this lack of justice, to keep working against that repression, when you understand the threat of violence and the lack of protection by the state? I felt a responsibility to understand this history, the lines that connect slavery to Jim Crow to the fight for civil rights to our current educational and criminal justice systems. Understanding the legacy of racial violence and inequality is the foundation upon which to understand the present. In a few of the images, signs that say "Pray for Peace" and "Prayer Helps" call for a response—they take us, who pass by these places, who read this book, out of the past and pull us into the present and ask us to *act*. As Myrlie Evers-Williams said in a 2007 address at Northeastern University's Crimes of the Civil Rights Era Conference: "We not only have to remember the past, we also have to make the link to the next generation coming along. If we don't, we will find ourselves in another kind of civil war, another kind of horror that we will not know how to take care of. As someone said, community is so important. We must have a sense of that, of protecting our rights, of saying, 'One who has will share with one who does not.' And that includes knowledge."

Starting out, I knew the importance of historical markers for teaching and marking sites, and of memorials for their potential to provide space to reflect and remember, but I didn't fully understand their deeper significance for both individuals and communities. As Denise Jackson Ford, whose father, Wharlest Jackson, was murdered in Natchez, Mississippi, told me, she was able to find the closure that an absence of justice had made impossible only when a group of Natchez citizens came together in 2011 to publicly acknowledge the importance of her father's life by funding and erecting a memorial to him. As Denise recounts, "I accomplished what I

wanted to do, and the people of Natchez supported us. I was elated. My closure is to know that I have this marker in his honor. I can't hold people now accountable for what their people did back then. I want to let kids know that we are living in a different time now. If I reach just one person then I've accomplished my goal."

* * *

Early in the project, in a conversation with Stanley Dearman, former editor of the *Neshoba Democrat* in Philadelphia, Mississippi, he said, "I've seen things in my lifetime. My mind will never be free." In his oral history, he told me how he and the community confronted their collective responsibility to the past, to remembering the murders of James Chaney, Andrew Goodman, and Michael Schwerner during Freedom Summer, on June 21, 1964. He elaborated on the formation of the triracial coalition in Neshoba County that got the case reopened and led to the conviction of Edgar Ray "Preacher" Killen on the fortieth anniversary of the crime. In talking about the community-created marker that was erected near the murder site in the fall of 2009, he speaks of the importance of acknowledgment and remembering in the healing process:

It's important that the community initiative put it there. People came forward in this community to work toward getting that, and I think it's a good thing for the community to do—to look at itself and say this *happened*. People don't want to be reminded of what happened here. There are people who think that monuments are useless and soon forgotten about. But I don't agree with that at all. It serves a purpose, you know: *don't forget this*. Don't forget what happened here.

Over the years, several cases have been reopened and the perpetrators sentenced: the killer of Medgar Evers; the killers of Vernon Dahmer; of James Chaney, Andrew Goodman, and Michael Schwerner; and of Charles Eddie Moore and Henry Hezekiah Dee. Journalists and the Department of Justice turned back to cold cases that had the possibility of resulting in a conviction and often put aside the cases with murkier files, double-jeopardy restrictions, and murderers and witnesses who had died.

One such case that has little such hope is the 1964 murder of Frank Morris, the owner of a shoe repair shop in Ferriday, Louisiana. Stanley Nelson, an investigative journalist at

Ferriday's local paper, the *Concordia Sentinel,* writes about local victims of civil rights–era racial violence in an effort to keep their memories alive in the community. Nelson has written often about Frank Morris, specifically about who Morris was and his importance to the community. When I interviewed him for this project, he said, "I felt that it was important to put a real face on Frank Morris, because he was admirable. He was a kind of guy you are supposed to embrace in your communities and protect. We had not lifted a finger for Frank. So I wanted people to understand who he was, and you have to write about that a lot to get them over the nervousness of this race issue or anything involving civil rights." He emphasized, "I also felt that if the newspaper, and at this newspaper, me, if we didn't try to find out what happened, who would? Nobody else was in a position to do it I felt like it was our responsibility. It would have been immoral to walk away from it." Nelson is now doing the same for Joseph "JoeEd" Edwards, a porter at the Shamrock Motor Hotel in Vidalia, Louisiana, who disappeared on the night of July 12, 1964, and whose body has never been found.

In 1966, Klan members firebombed civil rights leader Vernon Dahmer's home in Kelly Settlement, near Hattiesburg, Mississippi, gravely injuring Dahmer and his wife (Dahmer died a few days later). Dahmer's murderer, Samuel Bowers, was tried five times in the 1960s without a conviction; he was convicted in 1998 on new evidence gathered by investigative journalist Jerry Mitchell of the *Clarion-Ledger* in Jackson, Mississippi. Though the delayed justice is at the least bittersweet, there may be some benefits in obtaining contemporary guilty verdicts. In a conversation I had with Vernon Dahmer Jr. in 2009, he said, "In a way, that may have been better, because if he had been convicted in the 1960s, he never would have served any time. He would have walked in the front door and right out the back door."

In this book there is a petition addressed to the FBI in Washington, signed by residents of Rankin and Scott Counties in Mississippi. It is dated March 1965 and begins, "In regard to the death of Willie Henry Lee on Feb. 25, 1965. We the residents of Mississippi, who are all interested in knowing the reason for the killing demand an investigation. This man's body was found in Rankin County and nothing has been did about it, or no attempt to have been made for no sort of an investigation. We the residents of Mississippi don't feel that we can allow this sort of thing in Mississippi and nothing to be did about it." This is what resistance and courage look like when you know that you, your family, and members of your community are extremely vulnerable, in a climate of retaliatory violence—to articulate the violence and to sign your name. There are so many examples where communities appealed to the federal government—*please come, do something*—to address the complicity of law enforcement and local officials in racist violence and the absence of justice.

* * *

Throughout my research, I would cold-call people and introduce myself. I was consistently surprised to find that they were willing to make themselves available to speak with me, a stranger. I called Jim Ingram (no relation), who was a lead FBI agent in investigating the Freedom Summer murders and, after his retirement, assisted with the cold case investigation of the murders of Henry Hezekiah Dee and Charles Eddie Moore. He said he was "haunted" by the unsolved murders and described the agony of knowing who had perpetrated crimes and then seeing them acquitted by all-white juries. When I was just starting out around 2005, I contacted the Southern Poverty Law Center, and Penny Weaver, its communications director, responded immediately, inviting me to use its archive, where I returned over several years to look through the files about civil rights–era murders. I was interested in how the center decided who to include in their memorial and who to leave out. Penny gave me access to that research, which included FBI files, interviews the center did with family members of victims, and press ephemera from the civil rights era.

Family members agreed to meet and tell their stories. What stays with me still is their generosity in sharing what they experienced. There is a continued sense of urgency to share this knowledge. While the urgency to convict the killers from civil rights–era cases has lessened over the last decade as so many have now died, the need to visit archives, talk to people, and share knowledge lives on.

When I first contacted Vernon Dahmer Jr., explained who I was, and asked to meet, he told me his story was not for sale. I tried a couple of more times over the next couple of years to no avail. I knew I had to prove myself to Mr. Dahmer—I was sensitive to him not wanting to share the pain of his father's loss with a stranger. I hoped that, as I developed my project and body of research over time, he might trust me, once he realized I was serious about the work I was doing. More time also allowed me to get to know Jerry Mitchell, who gave me a reference. Mr. Dahmer eventually agreed to meet with me and set a day and time. When I arrived at his home outside

of Hattiesburg, Mississippi, I was welcomed into the living room. Mr. and Mrs. Dahmer sat across from me, and he asked me to explain myself, what exactly I was doing. I was nervous but had come ready to explain my interest and my process; I showed him my photographs and the histories I had written, including the one about his father. When I finished, he said, "OK, let's go."

We spent the day riding around in his pickup truck and touring his property (he owns much of what was once Kelly Plantation, where his family was enslaved). We then looked through each other's files—we had gathered different pieces of information—and he showed me family photographs. As we parted at the end of the day, Mr. Dahmer told me to "stay dedicated, stay focused, stay thankful."

* * *

I hope readers will make the link, as Myrlie Evers-Williams so eloquently says, from the past to the present, to answer the call to fight for equal rights and the protection of all individuals, the dismantling of white supremacist ideology, and the accountability of the state. *Road Through Midnight* is meant to be a memorial that will prompt readers to understand more about these histories, in a deep and reflective way, as we are still far from answering the call. I want to be clear that I am not providing a new history—these histories are known in families and communities, and many more resources are available thanks to the diligent, tireless work of family members, scholars, journalists, community members, and institutions that make these histories visible and accessible.

As I wrote in my preface, these legacies of power are inscribed in the landscape. The act of marking these sites of injustice in America, of loss of life to racial terror, binds us all. The violence must be named and the systematic elements of that violence must be understood if we are to understand how these legacies persist today and work against them. We must do the work of remembering.

The last line on Vernon Dahmer's memorial runs through this book like a road: *His sacrifice on the altar of freedom should inspire us to finish the task.*

NASHVILLE, TENNESSEE
2019

```
**********
 *******
  ***
   *
```

Acknowledgments

This work would not have been possible without the support and input of many. Juliet Ingram, thank you; I could not have done this without your faith in me and your generous support of the work. Jennifer Ingram, thank you for your complete belief in me.

I express my deepest appreciation to family members who agreed to speak with me: Denise Jackson Ford, Deloris Melton Gresham, Thomas Moore, and Charles Henry. And thanks also to Vernon Dahmer Jr., Wharlest Jackson Jr., and Anna Ruth Montgomery, who spoke with me but chose not to be recorded. I am humbled and honored.

To journalists Stanley Nelson, Stanley Dearman, and Jerry Mitchell, thank you for sharing your knowledge and for all you have done in the cause of justice and memory. Thanks also to David Mitchell and Ben Greenberg.

Many thanks to Penny Weaver, former communications director at the Southern Poverty Law Center (SPLC), who gave me access to SPLC files and research and without whom this project would not have gotten off the ground. Thank you, Lecia Brooks, former outreach director at SPLC, for all your help with this research, and thanks to Richard Cohen, former president of the SPLC. Thanks also to former FBI agent Jim Ingram, who returned my call and at a crucial moment encouraged me to research these cases that continued to haunt him.

To the librarians and archivists in small local libraries, thank you for working to maintain these important archives. I also express my appreciation to Dr. Rhea Combs and Carrie Feldman at the National Museum of American History and Culture for their assistance in licensing images for this book. Thank you also to Genevieve Oldani-Caruso at the Detroit Public Library.

To Deborah Willis, Hank Willis Thomas, Cheryl Finley, Eric Gottesman, Eliza Wilmerding, Amanda Herman, John Lawrence Seigenthaler, Jordana Moore Saggese, Ted Purves, Fred Ritchin, and Nigel Poor—all my thanks for your insights about language and form, for your friendship, and for encouraging me to keep going. Additionally, to Darius Himes, Whitney Johnson, Holly Stuart Hughes, Mary Virginia Swanson, Stanley Wolokau-Wanambwa, and Dr. Charles McKinney, thank you for your observations and advice.

Thanks also to friends for sustaining and inspiring me: Stacey Sharman, Will Waldron, Axel Waldron, Chris Anderson, Aspen Mays, Bethany Hurley, Brooks Hefner, Karen Muhlin, Adia Millet, Ryan Alexiev, Jorge Sanchez, Shane Aslan Selzer, Karl Peterson, Lindsey White, Teka Selman, and Dionne Lee; to my Tennessee people who took care of me when I came off the long stints on the road: Sally Anderson, Sumita Banerjee, Marette Beziat, Vesna Pavlović, Jodi Hays, Margaret Ingram Edwards, Conner Ingram, Richard Barnes, and the Thursday night group; and to my Birmingham folks: Amy Pleasant, Lisa McNair, and Jack Drake.

To CENTER in Santa Fe; Carla Williams, Deirdre Visser, and the cadre art grant; NYU's Department of Photography and Imaging Faculty Grant; and the California College of the Arts Faculty Development Grant. Thanks also to Michael Panhorst, Charles Guice, and Julian Cox for your early support.

Thank you, Lois Riggins Ezell and Dan Pomeroy of the Tennessee State Museum, PhotoNOLA, the National Civil Rights Museum, and Courtney Reid-Eaton at the Center for Documentary Studies for supporting exhibitions of this work, and to Trevor Schoonmaker at the Nasher Museum of Art at Duke University and Miranda Lash at the Speed Art Museum in Louisville, Kentucky, for including photographs in their show *Southern Accent* and for helping get the work seen by a larger audience. Thanks also to Mike Murillo for collaborating on audio production and the Hambidge Center for the time, and to Douglas McGray, Derek Fagerstrom, and Lauren Smith of *Pop-Up Magazine* for helping me understand the potential of audio for this project and for providing its initial debut.

Much appreciation to authors and scholars John Lewis, James Baldwin, Leigh Raiford, Martin Berger, Townsend Davis, James Loewen, Sarah Lewis, Kellie Jones, Howard Smead, and Don Whitehead.

Thank you to Thomas and Cindy Ingram for graciously supporting the publication of this work, and to the Department of Photography and Imaging at New York University's Tisch School of the Arts, especially Niki Kekos, Adam Ryder, and Caleb Savage.

And I express my thanks to all the friends and extended family who housed me in the Southeast along the way: Chad

Chappel, Van and Gloria Ingram, Abigail Cunningham, Rachel and Dan Lawrence, and Paul and Rebecca Click. A special thank you to Andrew and April Click.

To my teachers Pat Hoy, Lorie Novak, Tom Drysdale, Mark Jenkinson, Rebecca Solnit, Mark Thompson, Lydia Matthews, David Spalding, Jim Goldberg, and Larry Sultan, and to Mrs. Gray, Mr. Rogers, Dr. Gilmore, and Mary Catherine Bradshaw at Hillsboro High School in Nashville, many thanks.

To Alexa Dilworth, for her faith in me and in this work, for stewarding this book from early on, and for her patience and astute research and editing chops—it was a gift to have such a partner in creating this publication. Wesley Hogan, director of the Center for Documentary Studies at Duke University, and Tom Rankin, director of Duke's Master of Fine Arts in Experimental and Documentary Arts program, who along with Alexa edit the Documentary Arts and Culture series, were generous in their support for this book and provided valuable feedback on its content.

At the University of North Carolina Press, I am grateful to Lucas Church, who provided thoughtful guidance over the course of producing *Road Through Midnight*. I also thank managing editor Mary Carley Caviness and copyeditor Patricia J. Watson for their careful attention to the text, as well as Andrew Winters for his editorial support. A very special thank you to Kim Bryant for meticulously navigating the typesetting and production of this book, and to Dino Battista and Gina Mahalek for their skillful handling of marketing and publicity. I deeply appreciate all the efforts that have gone into making this book and getting it into the hands of readers.

I am grateful to friend and talented artist and designer Elizabeth Moran for beautifully translating my vision for this book.

To those I met along the way, to those whose names I never knew or have accidentally left out, thank you.

With *Road Through Midnight*, Jessica Ingram investigates a history of resistance and retaliatory violence in the American South and explores ideas of memorialization, those created both by official act and by individual and community action. In interlacing her own images with archival material and oral histories, she provides a pivotal example of how civil rights histories can be reinterpreted and reframed. In her afterword, Ingram reflects on her identity in relation to why it is important that she, as a white southerner, took on the extended project of making and sharing this new archive as a way to activate the living. Books in the Documentary Arts and Culture series have featured artists working across mediums to demonstrate the power of the long view; they have addressed aesthetic, cultural, political, and philosophical issues to provide a more substantial critical literature for documentary studies. Ingram has a distinctive way of connecting the past to the present, the personal to the communal. *Road Through Midnight* speaks to the ways in which documentary expression can unlock and expand histories to transform the way we regard both what has happened and what's happening now—as the fight for civil rights goes on and ideas surrounding memorialization have become part of the contested cultural and societal ground on which we walk.

Alexa Dilworth, Wesley Hogan, and Tom Rankin
Editors, Documentary Arts and Culture series

Road Through Midnight

Designed by Jessica Ingram and Elizabeth Moran
Set in Utopia and ITC Franklin Gothic types

The University of North Carolina Press has been a member of the
Green Press Initiative since 2003.

Cover image: River Road, Montgomery County, Alabama, 2006.
Photograph by Jessica Ingram.

Library of Congress Cataloging-in-Publication Data
Names: Ingram, Jessica, author.
Title: Road through midnight: a civil rights memorial / Jessica Ingram.
Other titles: Documentary arts and culture.
Description: Chapel Hill: The University of North Carolina Press: In association with
the Center for Documentary Studies, Duke University, 2020. | Series: Documentary arts
and culture | Includes bibliographical references.
Identifiers: LCCN 2019032103 | ISBN 9781469654232 (cloth) |
ISBN 9781469654249 (ebook)
Subjects: LCSH: Civil rights movements—United States—History—20th century. |
Civil rights movements—Southern States—History—20th century. | Ethnic conflict—
United States—History—20th century. | Ethnic conflict—Southern States—History—
20th century. | Murder victims' families—Interviews. | United States—Race relations—
History—20th century. | Southern States—Race relations—History—20th century. |
LCGFT: Oral histories.
Classification: LCC JC599.U6 I64 2020 | DDC 323.0973—dc23
LC record available at https://lccn.loc.gov/2019032103

DOCUMENTARY ARTS AND CULTURE
Edited by Alexa Dilworth, Wesley Hogan, and Tom Rankin
of the Center for Documentary Studies at Duke University

In a time when the tools of the documentary arts have become widely accessible,
this series of books, published in association with the Center for Documentary
Studies at Duke University, explores and develops the practice of documentary
expression. Drawing on the perspectives of artists and writers, this series offers
new and important ways to think about learning and doing documentary work while
also examining the traditions and practice of documentary art through time.

CENTER FOR DOCUMENTARY STUDIES AT DUKE UNIVERSITY
documentarystudies.duke.edu

```
**********
*******
* **
*
```

```
**********
*******
* **
*
```